MARYLAND LEGENDS

MARYLAND LEGENDS

FOLKLORE FROM THE OLD LINE STATE

TREVOR J. BLANK & DAVID J. PUGLIA
FOREWORD BY CHARLES CAMP

Charleston | London

THE
History
PRESS

Published by The History Press
Charleston, SC 29403
www.historypress.net

Front cover, top row: McKeldin Library stacks (Special Collections & University Archives,
UMD Libraries); Black Aggie 2.0 (Sam Lehman); and Morrill Hall, University of Maryland
(Special Collections & University Archives, UMD Libraries). *Bottom image*: Goatman's
woods/forest texture (Brenda Clarke). *Back cover*: Hell House (Mark Robinson); and Edgar
Allan Poe (J. Paul Getty Museum).

First published 2014

Manufactured in the United States

ISBN 978.1.62619.413.7

Library of Congress CIP data applied for.

To Barry Lee Pearson and Elizabeth Tucker

CONTENTS

LEGEND IN LITTLE AMERICA

The application of the phrase "Little America" to Maryland seems to have worked its way into the public mind to or from encyclopedias in the late 1940s and early 1950s, about the time that the state product maps filling the inner covers of such publications connected the state with its most dubious and unearned product: "Maryland (fried) chicken." The "Little America" title was especially honorific for a state that often was not awarded a piece of its own in state puzzle maps, lucky to be linked with only Delaware, where they really *did* raise chickens, rather than sharing puzzle-piece space with New Jersey and Rhode Island.

Maryland truly had to work harder than most states in postwar America. "Little America" suggested varied travel experiences for auto-tourists long before the 1970s, when the price of gas caused many travelers to look closer to home for vacation fun. Just about that time, however, state tourism agencies, in Maryland and elsewhere, sought to distance themselves from older slogans and sales pitches. By the early 1980s, Maryland's self-references to "Little America" dwindled to passing comments on the back of State Highway Administration maps.

In their way, "Little America" and "Maryland chicken" are legendary configurations and descriptions that might for a time have held sway, only to be displaced by waves of equally fanciful notions about the state and the stuff that makes it special. Legendary because they are presented as true by the people doing the telling—in this case, large numbers of mapmakers and tourism personnel—and because they represent a

fanciful embroidering of observable truth. "Little America" was a place that never really existed, and Maryland chicken was a food seldom sold and less seldom cherished.

"Little America" was a way of imagining America that predates Disney World and state quarters. The concept was largely topographical: Maryland has mountains, agricultural plains, a freshwater bay with fisheries, an ocean beach and a big city. It was also historical, boasting sites and institutions ranging from those of national importance, like the U.S. Naval Academy in Annapolis, to those of local interest, like the Barbara Fritchie House in Frederick. But the topographical hook invited a closer look that revealed six different places within one (little) state: western Maryland, central Maryland, Baltimore, the Chesapeake Bay and surrounds, southern Maryland and the Eastern Shore. As far as timing was concerned, in the late 1940s, "Little America" appears to have been largely accepted by outsiders as interesting (true) information about places in a place that had often been overlooked as a tourist destination. For Marylanders, this news came at precisely the moment that the isolation of western and eastern Maryland was being undercut and growing agricultural acreage in Prince George's, Howard and Montgomery Counties was being given over to urban and suburban settlement.

But there was certainly enough discernible truth to the concept to provide some level of belief. Maryland's mountains were then—and still are— exceedingly mountainous, even as highway construction softened hairpin driving experiences. And the beach: Baltimoreans' fondness for the life they lived "down the ocean" reinforced differences between their Ocean City (Maryland) and the *other* Ocean City (New Jersey) eighty-five miles away. Could any other states claim both of these attractions? Well, besides North Carolina, Georgia, Alabama, Virginia, New York, Massachusetts, Maine, California, Oregon and Washington, that is.

But let's not forget the chicken. "Maryland chicken" and "Maryland fried chicken" are foods that have interchangeably graced the menus of the state's restaurants, from diners to fancy places, for more than one hundred years. Over that span, the phrase has come to refer to virtually any kind of chicken cooked within the boundaries of the state. Restaurateurs report that people continue to ask for the dish and that they continue to serve it without regard for what either customer or cook imagines the other to expect. Other than eating the dish(es) on a hundred or more occasions over the years, I have only one tale to tell about the kind of chicken that seems to me to be closely connected to a Maryland place. On any given Sunday in the summer, MD

Route 404—the back road across Maryland's Eastern Shore from the Bay Bridge to Rehoboth, Delaware and Ocean City—is dotted with eat-and-run eateries put together by local Kiwanis Clubs, churches and other social institutions. These "eateries" are simply picnic tables dragged onto parking lots beneath shade trees. Cooking is done on split oil drums with grills across the top, charcoal fires built in the bellies of the drums. Chicken is cooked quickly and served with a piece of white bread. That's the menu. They don't *raise* chickens near these places, but the Perdue processing plant isn't far away (where the company's chickens, by contrast, are raised by contracted, off-site farmers).

Now, this isn't necessarily the definitive "Maryland chicken," nor does it represent the oldest or fanciest variety of that food. But it does suggest that almost everything that has been said about "Maryland chicken" may be seen as a commercial embellishment—a kind of story that is being told for particular purposes. Or that Marylanders prepare and serve food in ways that are generally detached from abiding historical notions about food and about themselves.

Which brings us, more generally, to legends and, not very much more particularly, to Maryland legends. I would argue that the partial truths of "Little America" and "Maryland chicken" direct us toward the commitments that enable these and other legendary notions to fly. A legend requires a skilled teller and a listener willing to believe. This configuration describes the business of tourism as well as whispered camp-out stories. The media employed in the dissemination of legends has changed over the past half century, but the change appears to suggest that legends adapt well to electronic expansion and that people are even more interested these days in stories that stroke their imaginations and challenge their credulity. What has changed, perhaps, is that if and when the truth is revealed, we are less likely than before to feel shame for having been taken in. Rather, we are all taken in by unlikelihood with such regularity that we hardly notice the bump of self-recognition that is its routine outcome.

When I was a kid, I always looked forward to George Washington's birthday because I knew that the morning newspaper published on that holiday would contain at least two or three advertisements from local car dealers offering cars for $17.76. I would have barely opened the paper before both my parents would have started in on me for gracing this fakery with even a glance. But in my mind, I was already speeding away in my $17.76 car (probably a convertible), delivering my paper route at sixty miles per hour.

Legend is like this—more the means of extending our imaginations than a personal hard sell. Legend is no longer a storyteller looking for an audience. Increasingly, we chase after the thin stuff offered for our consideration, already locating it within the richness of our imaginations and our dreams.

Charles Camp
MARYLAND INSTITUTE COLLEGE OF ART
ANNE ARUNDEL COMMUNITY COLLEGE

Acknowledgments

W orking on this project has been a wonderful homecoming for both of us, and we are greatly indebted to the many good folks who donated their time and energy to help make this book a reality. First, we would like to thank our families, whose unwavering love and support—even in contention with the long hours we frittered away at our computers, in libraries and archives and lost in piles of books and articles—never ceased. We are also grateful to our commissioning editor, Hannah Cassilly, and the wonderful staff at The History Press for their time and dedication to the continued development and successful completion of this project. Additionally, few individuals have inspired us Maryland-born folklorists to point our analytical eyes back home more than former Maryland state folklorist Charles Camp. It is our tremendous honor to have him pen this book's foreword.

We would both like to thank our mutual professor, mentor and friend, Simon J. Bronner, for his kind guidance and steadfast enthusiasm for all our research endeavors over the years. We must also recognize the many teachers whose time and guidance have left an indelible impression on us: Mabel Agozzino, Michael Barton, Warren Belasco, Erika Brady, Kathy Bryan, Gary Cross, Tim Evans, Henry Glassie, John Haddad, Jason Baird Jackson, Charles Kupfer, Jason Loviglio, John H. McDowell, Ed Orser, Anne Verplanck and Michael Ann Williams. They are role models of scholarship, pedagogy and support.

A number of friends and colleagues have been stalwart advocates for both of our scholarly projects. We would like to express our appreciation to

Heidi Abbey, Jade Alburo, Ron and Cathy Baker, Suzanne Barber, Donald Allport Bird, Kristen Bradley, Chet Breaux, Ian Brodie, Anthony Buccitelli, Rebekah Burchfield, Nicolas Cage, Nadia De Leon, Jim Donahue, Christine Doran, Bill Ellis, Brant Ellsworth, Vincent Furnier, Stephen Olbrys Gencarella, Spencer Green, Bethany Haesler, Matt Hale, Nic Hartmann, Brenna Heffner, John Heflin, Darcy Holtgrave, Robert Glenn Howard, Jonathan Jeffrey, Michael Owen Jones, Jeana Jorgensen, Rebecca Karr, Julia Kelso, Beth King, Andrea Kitta, Josh Kohn, Kara Lairson, Jeffrey Lebowski, Linda Lee, Tim Lloyd, Joanna Luloff, Joanne Magee, Sabina Magliocco, Derek Maus, Lynne S. McNeill, Jimmy McNulty, Jay Mechling, Montana Miller, Amy Milligan, Cliff Murphy, Susan Novak, Elliott Oring, Susan Ortmann, Christos Papakostas, Jared Rife, Marian Robbins, Casey Schmitt, Earl Simmons, Jennifer Spitulnik, Liberty Stanavage, Steve Stanzak, Kara Rogers Thomas, Tok Thompson, Jeff Tolbert, Sally Van de Water and Kristiana Willsey. We would also like to thank Debbie Kettles for sharing with us the Dwayyo encounter she experienced with her late husband, Richard Kettles, in the 1980s. We have been fortunate to work with gifted friends and colleagues in the International Society for Contemporary Legend Research (ISCLR) who have effortlessly provided warm enthusiasm and expert feedback in support of our research. We would like to especially thank Gail de Vos, Diane Goldstein, Mikel Koven, Ambrož Kvartič, Janet Langlois, Carl Lindahl, Jodi McDavid-Brodie and Yvonne Milspaw.

We are greatly appreciative of Beth Alvarez and Jason Speck, staff at the University of Maryland Special Collections, for their assistance in accessing the Maryland Folklore Archives and locating vintage images. In examining the folklore of the University of Maryland campus, we were assisted by several University of Maryland tour guides who graciously provided their insights into campus traditions and legendry. Accordingly, we would like to thank Joe Williams, Jason Moskowitz and Josh Ryan. Thanks are also due to Karen James and the permissions editor at the *Frederick News-Post* for allowing us to reprint the 1965 composite sketch of the Dwayyo in chapter 10 of this book. Likewise, Mary Mannix of the Maryland Room at the C. Burr Artz Public Library in Frederick, Maryland, was instrumental in helping us secure images and newspaper records pertaining to the Snallygaster and Dwayyo.

Numerous individuals permitted us to use their excellent photography and artwork in the book and on its cover. Special thanks go out to Sam Lehman (flickr.com/photos/sam-lehman), Allister Sears (allistersears.blogspot.com) and Aaron Patrick Vowels (Flickr user: ConspiracyofHappiness, flickr.com/photos/97964364@N00). Many of the photographs of Hell House were

taken by the late Mark Robinson, and it is our honor to reprint them in his memory. We are especially indebted to Ann Tabor, who generously provided these images for use in the book.

Several images reprinted in this book were made available by creative common licenses. In some of these instances, the photographers did not expressly endorse or reject the use of their work herein. However, in compliance with their wishes and the guidelines for reprinting their applicable intellectual property, we would like to point readers to the text of the Creative Commons 2.0 attribution license (available for download at creativecommons.org/licenses/by/2.0), namely for the image of Goatman's woods attributed to Brenda Clarke (flickr.com/photos/brenda-starr), which also graces the book's cover. The Creative Commons Attribution 3.0 unported license (available for download at creativecommons.org/licenses/by/3.0/us) applies to the crybaby bridge photograph taken by Dwight Burdette and the photograph used for Seven Hills Road by Daniel Case. We make no copyright claims for any of the images reprinted in this volume.

Last, but certainly not least, we wish to express our gratitude to the individuals for whom this book is dedicated, Barry Lee Pearson and Elizabeth Tucker. In the course of our young careers, we have been blessed to know a number of thoughtful, enthusiastic and deeply caring individuals. These two, in particular, are exceptional; they have moved us to embrace the world of folklore studies while supporting our critical first steps into the field and thereafter. Through their time and dedication, we have found strength and inspiration to bring to our own teaching and research endeavors. Simply put, Barry Lee Pearson and Elizabeth Tucker have meaningfully helped shape the folklorists we are and hope to be. It is our honor to dedicate the book to them.

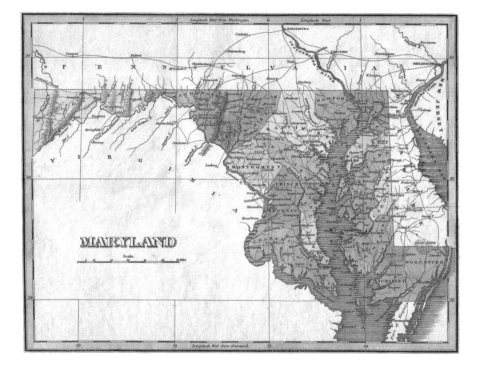

An 1827 map of Maryland by geographer Anthony Finley, *A New General Atlas*.

INTRODUCTION

WHAT IS FOLKLORE?

Maryland has often been regarded by its residents as a kind of condensed geographical version of the United States. Within its borders lie the Allegheny and Appalachian Mountains; the beloved Chesapeake Bay; seventeen national parks and nearly fifty state parks; over 1,500 listings in the National Register of Historic Places; numerous Civil War battlefields, monuments and scenic trails; major cityscapes and thoroughfares in the Greater Baltimore and Washington, D.C. metropolitan areas; as well as vast acres of bucolic rural landscapes and country farms, unique bay- and oceanfront boroughs and small towns of all varieties. And yet these physical places alone do not make the Free State special; it is the people of Maryland who shape and mold that honor through the collaborative production of regionally distinct folklore. Through the entry point of this rich body of expressive material, this book aims to draw particular attention to how legends (and the people who share and render them meaningful) do, in fact, exemplify part of what makes Maryland and Marylanders so inimitable. Of course, to have any measure of success in achieving this goal, we must first answer and explore an important question central to readers' understanding and enjoyment of this volume and its scope: what exactly is *folklore*?

For many, the word "folklore" has been improperly conflated as a blithe array of old wives' tales, urban myths and tall tales—entertaining narratives that are believed to be inherently fictitious or, at the very least, concocted of half-truths.[1] In reality, despite their widespread appeal, these genres account for only a small portion of what constitutes genuine folklore or the purview of folkloristics, the academic study of folklore.[2] The word "folklore" is derived from the German *Volkskunde* or "knowledge of the folk." It is a compound of two words: "folk" for people and "lore" for the inherited or cultural knowledge that they have acquired from tradition.[3]

To put it another way, folklore is the traditional knowledge of an individual and/or their community that is acquired through oral, print or technologically mediated communication. It is important to note that what makes something "traditional" is not necessarily its geographical origin or how long it has existed but, rather, how it achieves sustained relevance and meaningful enactment in local, regional or even national contexts.[4] Traditions are formulated, shared and deemed culturally viable—on large and small scales alike—through the complex processes of expressive communication and symbolic interaction that ultimately compose one's understanding of their own identities, experiences and place within a given context. Knowledge is invariably encoded and decoded by senders and receivers in the process of communicative acts.

Whether it is creating an intricate work of graffiti, telling a ghost story or cooking up a family recipe, all expressive communications and creative actions incorporate patterns from existing traditions, even as they adapt to create new expressive material. As folklore disseminates, it is repeated, revised and reinterpreted before shifting into new contexts where it obtains new meaning among new actors, which regularly leads to multiple variations of a single text. Folklorists call this process "repetition and variation."[5]

Folklore encompasses far more than just narratives, rituals and foodways; it highlights the human experience and all of the intricate components that fill people's lives with meaning. Importantly, the ways in which people make meaning—be it through creative expression or the forging of cultural values and traditions—reveal a great deal about how individuals and communities process and experience everyday life.[6] For instance, a crude joke uttered shortly after a major disaster or tragedy may speak to the teller's own anxieties or attempt to create a non-threatening expressive platform in a time of emotional stress.[7] Or another example,

perhaps more germane to the scope of this book: countless students at the University of Maryland routinely approach the bronze statue of the school's mascot, Testudo the diamondback terrapin, and touch his nose and/or leave miscellaneous offerings for good luck, especially before taking exams.[8] These superstitious practices have developed into a valued campus tradition for decades because of their perpetual reinforcement as positive ritual components of everyday student life at the University of Maryland. Accordingly, students who participate in these acts use the vessel of Testudo to symbolically affirm their own belonging within the college community as a bearer of its traditions while further bolstering the value of the superstitious actions that have been made socially revered among the student body.[9]

In sum, folklore is not necessarily a study of the past (or cultural "survivals") but, rather, the study of traditional beliefs and practices, conventional knowledge and expressive patterns as they surface in contemporary society via face-to-face interaction and technologically mediated means. How these traditions are received and subsequently change or remain the same over time is of central concern to folklorists, and the study of these phenomena also includes a consideration of how historical contexts shape and mediate the passing of tradition.[10]

OUR PURPOSE

This book follows in the intellectual lineage of George G. Carey's *Maryland Folklore and Folklife* (1970), *Maryland Folk Legends and Folk Songs* (1971) and *Maryland Folklore* (1989).[11] To this day, these books are the last professional word on legend in Maryland.

While nominally a statewide book, *Maryland Folk Legends and Folk Songs* is really a book of two extremes: western Maryland and the Eastern Shore. The rest of the state receives comparatively scant attention. We do not mean to denounce the work of George Carey, and, in fact, we know he would not object to the criticism. He mentions it himself in the preface to *Maryland Folk Legends and Folk Songs*:

> *A number of readers will surely object to this book because it is not geographically representative of Maryland folklore. And their objection is justified, for this collection does emphasize the Eastern Shore and Western*

> *Maryland. But that is because these are the only two areas where any*
> *extensive folklore collecting has been carried out.*[12]

Although a number of folklorists have collected in western Maryland and on the Eastern Shore, Carey is referring specifically to himself and Dorothy Howard. It is their collections that form the bulk of his book.[13] Carey taught at the University of Maryland, but much of his fieldwork covered the Eastern Shore and Chesapeake watermen. Dorothy Howard taught at Frostburg State University, where she and her students collected traditional material in western Maryland for decades.

This left the present authors—raised in Damascus and Frederick and schooled in Baltimore and College Park, respectively—wishing for a book that covered legend in *all* parts of Maryland, especially the areas where the vast majority of Maryland residents live. Now professional folklorists, we saw that it was not only the rural and mountainous spots but the entire state that teemed with folklore. Carey himself had hinted at this as a goal for future Maryland legend research. The legends he presents, he admits, are "by no means definitive, nor even geographically representative" and "smack of the past and cling to a rural environment."[14] But even at his early stage of writing and with his individual interests, Carey saw "absolutely no reason why the legend cannot be urban and why it cannot display modern appurtenances." Carey stated humbly that he hoped his interests would spur future research:

> *Though this collection of legends and folk songs is by no means definitive,*
> *nor even geographically representative, I hope it may serve as some sort of*
> *catalyst for the further gathering and publishing of folk materials in the*
> *state…Maryland has a very vital folk heritage, and there is still much to*
> *be done.*[15]

We have taken up Carey's call. While we touch on all parts of the state, the reader will find that we give preference to towns and cities such as Frederick, Bowie, College Park, Ellicott City and Baltimore. While no trained folklorist has written a statewide book on Maryland legend since Carey's last effort in 1989, there have been several volumes by interested amateurs. Some are useful, valuable and interesting, others full of creative writing and leaps of faith. In this book, we focus on folklore that has circulated actively in Maryland, either at present or in the past. As we have made every attempt to name our informants and document our sources, nothing must be taken

on faith alone. Furthermore, for every legend or theme we profile in this book, we strive to explain and apply folklore theory while also providing interpretation and analysis of the materials at hand.

THE SCOPE OF *MARYLAND LEGENDS*

The first section of this book explores traditions of the supernatural in Maryland, with specters ranging from haunted buildings and statues to haunted colleges and cars and from popular legend trip destinations that have been known across the state for years to one-time spookings reported and forgotten.

Most towns have an abandoned building whose eerie decrepitude has begun to take on malevolent tales. Ellicott City takes this legend to the extreme with Hell House. In chapter 1, "Abandonment Issues: The Legend of Hell House," we investigate the history of St. Mary's College and its devolution into a site of legendry. The chapter also includes rare photographs of the decaying grounds.

Chapter 2, "Out of the Woods and Into the Park: The Enchanted Forest of Ellicott City," explores the rise and fall of the second-oldest theme park in the United States. Aimed at children, the park forsook roller coasters and Ferris wheels in favor of an immersive fairy tale experience. While colorful and fun at the height of its popularity, as ticket sales declined, the park took on the eerie juxtaposition of childhood delight and gradual decay. The odd world embodied a new meaning and began to attract legend trippers, urban explorers and vandals.

Frederick Douglass, Brooks Robinson and Francis Scott Key all have statutes in Maryland, but Black Aggie may be the state's most famous sculpture. Chapter 3, "In the Shadows of Druid Ridge: The Cursed Statue of Black Aggie," looks at the history behind the creepy statue, its various resting places and the recent transfer of the Black Aggie legend to a new sculpture.

It is rare to discuss a local legend without also discussing local teenagers. And when teenagers come into the mix, so, too, do their cars. Reckless teenagers, unfortunate accidents and phantom cars are the heart of chapter 4, "Hell on Wheels: The Demon Car of Seven Hills Road," which takes place in Howard County.

There's just something about bridges. In chapter 5, "Bridges over Troubled Water: Headless Ghosts, Psycho Killers and Dead Baby Sightings," we

survey a legend type known as the "crybaby bridge" that exists across the United States but is distinctively shaped by its local cultural contexts, while also profiling the genre's variants within the state of Maryland.

The relationship between official institutions, like newspapers, and widespread folk beliefs, like ghosts, is tenuous at best. So what can we expect to find when we look at nineteenth-century supernatural coverage in Maryland's largest newspaper? In chapter 6, "Baltimore's Ghostwriters: The *Sun* Shines a Light on Maryland's Shades," we search through ancient issues of the *Baltimore Sun* dating back as much as 150 years. We find the *Sun* a willing reporter of ghostly activity but also an enthusiastic debunker of haunted hoaxes.

Colleges across the United States are known for their haunted halls and ghostly residents. With chapter 7, "Terrapin Tales: The University of Maryland's Campus Legends," we travel to the state's flagship university to find the legends swirling around the campus today. There, we receive a firsthand tour of the university's haunted landscape and other collegiate tales.

Our second section considers Maryland's diverse array of legendary creatures. Most of these are beasts, hybrids or cryptids, although one human's history of extraordinary deviance secures him a spot on this list. The first of the set is purported to be Maryland's oldest legend. The last only sprung up in the twenty-first century. The rest came about somewhere between the two. As we look at these legends, we attempt to describe the creatures themselves, explore the legends' relationship to other legends and trace the role of popular culture—especially newspapers—in their dissemination.

Chapter 8, "Loyal to the End: The Blue Dog of Port Tobacco," explores what may be Maryland's most enduring, continually circulating legend. Unlike the other creatures in this section, the Blue Dog is a phantom, his life cut short by a barbarous thief. Set in the once-thriving, now-tiny town of Port Tobacco, the legend is a murderous tale of underhanded treachery and fierce loyalty.

Chapter 9, "From Fakelore to Folklore: The Snallygaster of North Central Maryland," chronicles the story of Maryland's most famous monster. A product of a newspaper editor's imagination, invented to increase sales, the legend of the Snallygaster struck such a chord with residents around Frederick that the tale went from spurious newspaper fiction to authentic folklore. To this day, the Snallygaster lives in the oral tradition of Marylanders, even influencing other legends. Most notably, the Snallygaster has a rumored connection to the Dwayyo, the focus of chapter 10, "A Dog Has Its Day: The Dwayyo of Gambrill State Park." The *Frederick News-Post* dedicated

half a month at the end of 1965 to covering the existence and whereabouts of the beast, a half-man, half-wolf sighted several times. The reports both spooked and amused the community, but by 1966, the *News-Post* was on to other stories. By then, the coverage had secured an indelible place for the Dwayyo in Frederick County oral tradition, and sightings continue around Gambrill State Park.

In chapter 11, "Getting Maryland's Goat: The Goatman of Prince George's County," we look at the rise of a well-known creature from a different part of Maryland. The Goatman has been bedeviling Prince George's County residents since at least the 1960s. Notorious for attacking cars, killing pets and harassing lovers, the county got Goatman fever in the early 1970s when the cryptid made the local newspaper, accused of decapitating a poodle. Much of the impetus for the legend cycle can be traced back to a single person, George Lizama, and his 1971 "Introduction to Folklore" project, donated to the Maryland Folklore Archives and available for local reporters to review.

Chapter 12, "Strange Bedfellows: The College Park Cuddler," covers a perverse character who has become legendary in his own way. While not technically a creature, plenty wouldn't hesitate to call him a varmint, a monster or a beast. And although he is not spectral, he has his haunts and makes dark, empty houses eerie. The Cuddler beleaguers College Park and has never been caught or identified. A sexual deviant, his legendary status, nickname and bizarre tales all spring from kernels of truth.

Our third section considers the link between history and legend. One of the most important subjects to consider when studying folklore, history has a multifaceted relationship with legend. Historical legends include legends that began in the distant past and continue to this day; forgotten legends that must be remembered to truly understand a time and a place; and legends not from the past so much as they are *about* the past.

Chapter 13, "A Thin Line Between Victory and Defeat: Maryland's First Regiment, the Battle of Long Island and the 'Old Line State,'" tells the story of Maryland's nickname. The state's official moniker derives from a legendary anecdote about George Washington and the First Maryland Regiment during the American Revolution. The Maryland militia saved Washington's army at the Battle of Long Island, turning themselves into a fierce human speed bump while the rest of the troops escaped. Although a glorious deed in the telling, at the time, it was disastrous for all involved. Almost none of the Marylanders who earned the title lived to learn of it. But all Marylanders today take on the title through the power of the sobriquet.

During the Civil War, one patriotic Frederick woman stood proud with the Stars and Stripes while Stonewall Jackson and his Confederate troops marched through, a story told in chapter 14, "Bravest of All in Frederick Town: Barbara Fritchie and the American Flag." The story became legendary and made its way to Union poet John Greenleaf Whittier, who turned it into a poem. Barbara Fritchie reached national acclaim, but did she really wave the flag in Jackson's face? Or was it another woman? Did Jackson even pass Fritchie's West Patrick Street house? To this day, there's no clear consensus, but Barbara Fritchie still holds a special place in Fredericktonian hearts.

Some traditions date back beyond written records, while others seem so central to our lives that we cannot imagine them ever being extinguished. Our final chapter, "A Tradition Nevermore: The Edgar Allan Poe Toaster, 1949–2009," tells a story that is completely different. The Poe Toaster, that Charm City lover of Quarles, has both a definitive start date and a definitive end date. For over half a century, the incognito commemorator (and probably his progeny too) raised a glass to Poe's life and left a letter in his memory. Alas, the tradition is nevermore.

Of course, this book is not the last word on the legends of Maryland. Matters of space forced us to leave out plenty of fantastic narratives. For the aspiring Maryland folklorist looking for a place to begin, try Spring Grove Hospital;[16] Mary Surratt and Surrattsville; hauntings at colleges and universities across the state; the origin story behind the Assateague ponies; humorous and bizarre Maryland place names (e.g., Accident, Bloody Point, Boring, Charles Street Avenue Boulevard, etc.); the Snarly Yow of South Mountain; Zebra Day in Baltimore; the discovery of the Desiderata; Francis Scott Key and the authorship of the National Anthem; the Pirate Marmaduke Mister; the Baltimore Orioles' legendary shenanigans to maintain hometown hero Cal Ripken's consecutive games streak and the connection to actor Kevin Costner; the Loch Ness Monster's Chesapeake Bay protégé, Chessie; the chillingly haunted Hampton House; St. John's College's Liberty Tree; Civil War battlefields throughout the state; legends behind the delineation of the Mason-Dixon line; Ghost Light Road in Hebron; Maryland's most famous witch, Moll Dyer; and Cecil County's Pig Lady. Again, this list is merely a starting point.

Finally, we would like to strongly encourage readers to not skip over the chapter notes compiled near the end of this book, tempting though it may be. While they are somewhat dense at times, we must stress that they often encompass far more than mere citations. In fact, we have endeavored to provide therein additional insights, commentaries, supplemental readings

and other interesting tidbits that we couldn't otherwise squeeze into the main chapters. Readers wishing to discover an even deeper understanding of Maryland folklore most certainly should give these notes a look.

We dreamed for years of finding the time to take the temperature of the legendary in our beloved home state. We are happy to report that folklore is alive and well in Maryland, as it has been for centuries. These Maryland legends speak to regional distinction, regional pride and regional identity. We hope you enjoy reading about these legends as much as we enjoyed researching and writing them.

PART I

MARYLAND'S HAUNTED PLACES (OR, GHOSTS ACROSS MARYLAND)

CHAPTER 1

ABANDONMENT ISSUES

The Legend of Hell House
(St. Mary's College)

We shape our buildings, and afterwards our buildings shape us.
—Winston Churchill

It's not what you look at that matters, it's what you see.
—Henry David Thoreau

Atop a granite cliff overlooking the Patapsco River in Ilchester, Maryland, sits a once grandiose cluster of buildings now abandoned and decayed. From 1866 to 1972, these buildings served as St. Mary's College, a religious preparatory school for young men entering the priesthood. In the years to follow, as Father Time chipped away at the neglected site and folklore emerged to speculate on the reasons behind its desertion, the nicknames "Creepy College" and especially "Hell House" became synonymous with the place. Moreover, the ruins of St. Mary's College became a hotbed for "legend tripping," the ostensive action of trekking to the physical location associated with a legend to test its veracity and one's own mettle, typically in group settings.[17] The property's long history in Howard County and with the Catholic Church helped to inspire its eventual repurposing by hordes of young thrill-seeking trespassers who collaboratively made Hell House a staple of Maryland legendry.

The opening of the Baltimore and Ohio (B&O) Railroad in 1830 marks the beginning of the story behind Hell House. George Ellicott, Jr., grandson

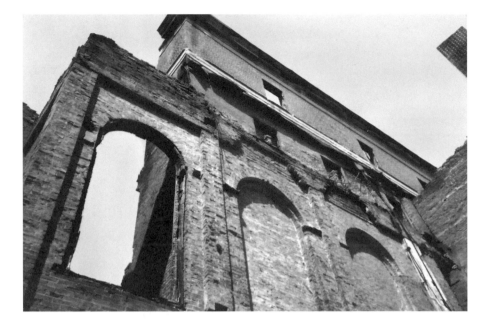

The crumbling façade of the "upper house" on the grounds of St. Mary's College/Hell House. *Photographs courtesy of Ann Tabor.*

of Andrew Ellicott—one of the founders of Ellicott Mills (later named Ellicott City)—maintained a homestead in Ilchester and thought its location ideal for a stop on the line. To attract passengers, he converted his stone home into a hotel and tavern, but B&O ultimately chose Ellicott Mills for its main stop in the area. As a result, train stops in Ilchester became exceedingly rare and even precarious since locomotives that *did* stop risked losing the momentum to complete their journey.[18] George Ellicott, Jr.'s business venture failed; he struggled to sell his property for years until the brothers of the Most Holy Redeemer, a Roman Catholic congregation better known as the Redemptorists, purchased the 110-acre plot for $15,000 on June 12, 1866, with the intent of establishing a seminary.[19] The Redemptorists had only arrived in America thirty-four years earlier in 1832, and the purchase paved the way for Baltimore to become one of the main provinces of the order. The first Mass was held on the third floor of Ellicott's old stone house on August 28, 1866.

Work began on the main "upper house" (the largest of the school's buildings) in March 1867. Based off the sketches of two Redemptorist brothers, the original building resembled American adaptations of French and Italian architecture of the Renaissance era. Stretching eighteen bay wide (with a central five-bay façade and cupola), five bay deep and four stories high (a fifth story was added between 1933 and 1934), and featuring English Garden Wall Brick Bond on a stone foundation, bricklayers laid over 672,000 bricks in eighteen months.[20] A beautiful sixty-six-step stone staircase ascended to the upper house, known by priests and students as "Jacob's Ladder." Classes began in September 1868. In 1872, the brothers added a frame to the old Ellicott tavern, known then as the "lower house," and the property became the church and school for the parish of Our Lady of Perpetual Help. The building burned down on June 14, 1968. The college was originally named Mount St. Clemens after the Redemptorist saint, but in an effort to encourage devotion to St. Mary under the title of "Perpetual Help," the brothers renamed the school St. Mary's College in 1882, following the dedication of a new, ornate chapel in the upper house.[21]

Joining the priesthood demanded great personal sacrifice. The Redemptorist Order required four years of high school, two years of junior college and a year of noviciation in Annapolis,[22] followed by vows of poverty, chastity and obedience. Before ordination, a candidate had to spend an additional six years in prayer and study at St. Mary's College. The towering buildings of St. Mary's College housed thousands of young men (as many as 100 to 150 at one time during its peak) on that journey until 1972, when it

The remains of the Redemptorist chapel amid the decaying grounds of Hell House. *Photograph by Mark Robinson; provided courtesy of Ann Tabor.*

permanently closed its doors due to dwindling enrollment. For several years after St. Mary's College closed, entrepreneurs, community groups and even state government officials sought to preserve the buildings. Alas, their efforts were fruitless, and the site fell into disrepair. But the story does not end there.

By the late 1980s and into the '90s, graphic details about the reasons behind St. Mary's abrupt closure in 1972 started to proliferate among teens and college students in the Greater Baltimore region.[23] Some claimed a student or priest cursed the grounds when he committed suicide following the discovery of an illicit affair or other questionable action. Others suggested that students had been murdered or died from a mysterious illness and were buried in the vast web of subterranean tunnels that ran beneath the college. The most enduring story involved a lustful rector who, despite efforts to reform, raped four nuns at the seminary.[24] Hesitant to report their superior, one sister finally spoke up after learning of a fifth victim. The archdiocese banished the old priest from the grounds, but he defiantly vowed to return. A short time later, a staff member stumbled upon a horrifying scene: five nuns facing one another, hanged, a pentagram drawn in their blood on the floor below; the old priest lay slumped beside them, dead from a self-inflicted gunshot wound.[25] In other variations, the old priest flees the scene,

evading capture, and the surviving nuns become possessed by demonic forces, leading them to massacre the remaining students and priests at the seminary. Instead of assaulting nuns, some versions alternatively explain that the old priest dabbled in the black arts, driving him to insanity and inspiring the murderous rampage. Sometimes female students replace the nuns in retellings, even though St. Mary's College only enrolled men.

The theme of satanic homage informed many of the subsequent stories. In the absence of official residents, rumors of drug labs or satanic cults meeting at the abandoned upper house to sacrifice goats and praise the Dark Lord persisted, as did the contention that visitors to the building's second floor would find satanic altars.[26] These stories began to fuel beliefs that satanists, witches, robed occultists and ghosts plagued the abandoned ruins of St. Mary's College, prompting its folk rechristening as "Hell House." In time, individuals and groups began crossing the "No Trespassing" signs to convene on the grounds to explore the ruins, to party and to vandalize.[27] Visitors reported seeing ghostly nuns and priests (especially one with bloody hands who apparently chased trespassers on occasion); feeling "cold spots" near particular parts of the site,[28] such as the top of the sixty-six-step staircase (sometimes referred to as the "ninety-nine steps to Hell"); experiencing strange weather events and shifting emotional states; seeing or hearing peculiar things, like flickering lights and faintly echoing voices; and spotting color distortions or spectral sights in developed photographs. However, the unifying experience shared most by legend trippers involved confronting or escaping the clutches of the property's eccentric caretaker, Allen Rufus Hudson, an infamous part of the legend of Hell House by the 1990s.[29]

Commonly called the "The Hermit" or "The Hillbilly" for his large frame and disheveled appearance, Hudson toted a shotgun and employed a pack of Rottweilers—and he was not afraid to use either on trespassers and vandals. Many accounts of unauthorized visits to Hell House report the sound of Hudson's dogs barking in the distance or the sight of them roaming freely along the upper floors of the decrepit buildings, their ominous echoes ringing through the cavernous space. Avoiding detection by the caretaker and his dogs became part of the allure of visiting Hell House at night. Those who did not escape fueled the caretaker's reputation as a madman living in the shadows of the abandoned St. Mary's College. For instance, victims sued Hudson in 1991 and 1992, alleging they were viciously beaten, falsely imprisoned, threatened and attacked by his dogs while trespassing; one interloper fractured his pelvis while fleeing the

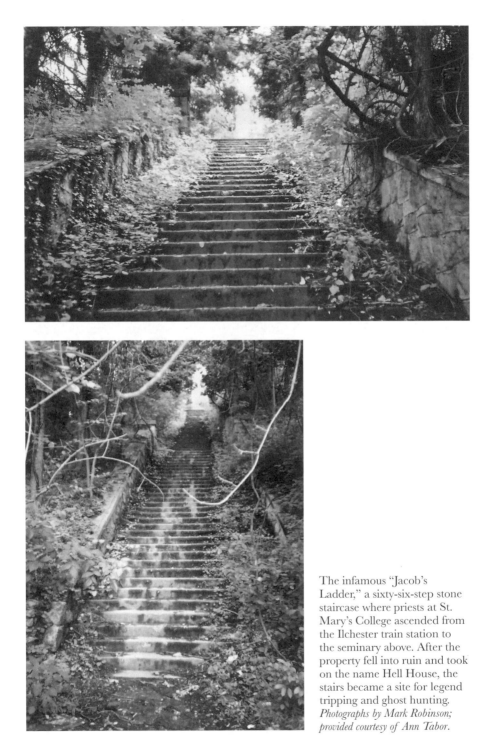

The infamous "Jacob's Ladder," a sixty-six-step stone staircase where priests at St. Mary's College ascended from the Ilchester train station to the seminary above. After the property fell into ruin and took on the name Hell House, the stairs became a site for legend tripping and ghost hunting. *Photographs by Mark Robinson; provided courtesy of Ann Tabor.*

scene.[30] On May 11, 1996, police arrested Hudson on the charges of assault, battery and assault with intent to murder after shooting a twenty-two-year-old Baltimore man. Earlier that evening, Hudson had caught the man and three friends trespassing and ordered them to leave. They returned around 6:30 a.m., armed with baseball bats, before meeting the caretaker and his shotgun.[31] Prosecutors ultimately dropped the charges against Hudson, but the message to teen daredevils was clear: visiting Hell House could be deadly. Late-night pilgrimages continued, albeit with elaborate precautionary measures in place. Fighting vandalism and property damage for years, the caretaker became the resident bogeyman.[32]

On Halloween night 1997, a little over a year after Allen Rufus Hudson's notorious brush with the law, the remains of the upper house went up in flames, gutting the majority of the building's extant architecture and leaving a large pit at the center of the smoldering remains.[33] Arson investigators immediately labeled the fire suspicious, but police made no arrests. Because of the significant damage to the building, Hudson was forced to vacate his property out of fear that a wall could collapse onto his adjacent abode. Many residents believed that the caretaker had actually died in the fire (or of natural causes soon thereafter), and some even claim that his spirit, along with those of his dogs, continues to guard the ruins. Nevertheless, the charred remnants of Hell House persisted in attracting visitors hoping to witness paranormal activity and participate in a local rite of passage. In 2006, the crumbling remains of St. Mary's College were razed, although parts of the old chapel and a decomposing stone structure (perhaps the remnants of the lower house) remain, as do the Jacob's Ladder steps, some stone-lined pathways and old basement pits. The grounds still invite occasional traffic from curious residents and ghost hunters.[34]

Popular culture scholar Marilyn Motz observes that the stories told about a place can override the visual impression the location presents, rendering it welcoming or foreboding in a given context, adding:

> *Legends about places humanize physical spaces and lay claim to territory regardless of legal ownership or official nomenclature. They alter the identity of a place and make it habitable, associating with it a history linking past with present and rejecting scientific knowledge and political authority.*[35]

A legend is etched with tradition, and its telling or enactment enlivens the nostalgia and wonder long associated with that tradition. In the ostensive action of legend tripping, participants collectively transform the

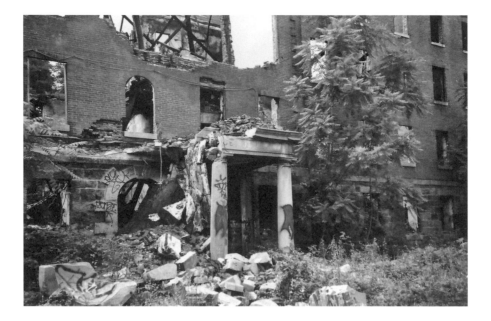

Exterior shots of the upper house at the abandoned ruins of St. Mary's College/Hell House, circa 2003. *Photographs by Mark Robinson; provided courtesy of Ann Tabor.*

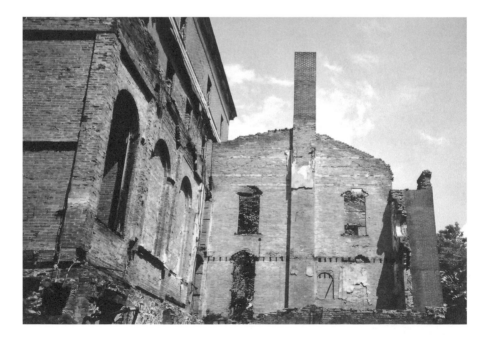

meaning of a building, a place or an object into one of deeper significance by connecting their own activities with the larger tradition that the story and/or pilgrimage reflects.

Once abandoned, the colossal St. Mary's College became a symbolic place of significance, brought to life through stories that imbued new meaning into the physical building and location and through the collaborative ritualization that made visiting the site central to the legend of Hell House.[36] From sacred religious retreat to supposed occult ritual grounds, the site has left an impression on the visitors whose mischief has shaped the folkloric meaning now attached to the location while underscoring the collective power of legend tripping in the development of a legend's value and scope.

CHAPTER 2

OUT OF THE WOODS AND
INTO THE PARK

The Enchanted Forest of Ellicott City

*They knocked at the door, and when the woman opened it and saw that it was
Hansel and Gretel, she said: "You naughty children, why have you slept so long in
the forest?—we thought you were never coming back at all!" The father, however,
rejoiced, for it had cut him to the heart to leave them behind alone.*
—Jacob and Wilhelm Grimm, Kinder-und Hausmärchen

*Imagination will often carry us to worlds that never were. But without it we
go nowhere.*
—Carl Sagan, Cosmos

When the Enchanted Forest first opened its doors on August 15,
1955, it became only the second theme park in the United States
after Disneyland, which had debuted just one month earlier, and was the
first establishment of its kind to open on the East Coast. Sprawling over
twenty acres[37] off Baltimore National Pike in Ellicott City, the park was
the brainchild of Mr. Howard Harrison Sr., who dreamed of creating a
place where the fairy tales he read to his grandchildren would come to life
and bring children and adults together for a day of family fun. Harrison
enlisted his family members, especially his son, to make the vision a reality.[38]
In partnership with artist Joseph Adler, the park was notably lined with
elaborate aesthetic spectacles drawn from the fairy tales of the Brothers

Grimm, Mother Goose and nursery rhymes: the Old Woman's Shoe; the Crooked Man's House; Hansel and Gretel's Gingerbread House; the Seven Dwarves' House; Humpty Dumpty; Old King Cole; an over-the-top castle at the park's entrance, complete with a moat, drawbridge and dragon; and Rapunzel, flowing braids and all, atop one of the castle's towers—just to name a handful of the attractions awaiting visitors. Admission was only one dollar for adults and fifty cents for children.

There were no rides in the amusement park sense (rollercoasters, tilt-a-whirls, Gravitrons, etc.). Instead, the Enchanted Forest had animals to ride and pet and a great deal of imaginative, interactive stations throughout the park. A number of slow-moving mechanical and motorized rides eventually opened, transporting visitors through various parts of the park. Needless to say, the park was of a different era, one in which make-believe was central to the thrill of visiting. The model worked for thirty-four years, but the Enchanted Forest finally closed in 1989 after years of steady decline in visitors to the park and persistent issues of vandalism and trespassing. Nevertheless, the park left a mark on local residents.[39] The park even served as the backdrop of a scene in Baltimore director John Waters's 1990 film *Cry-Baby*, starring Johnny Depp and Ricki Lake.

In the years following the park's closure, the Enchanted Forest's attractions fell into disrepair, and the abandoned kingdom became the inspiration for urban explorers, amateur photographers and vandals.[40] The creepiness of overgrown houses from children's stories coupled with the sheer emptiness and dilapidation of the property made the place a favorite haunt of teens. To this point, a former Ellicott City resident asserts that the Enchanted Forest was an appealing locale for "bored suburban kids looking for something to do…but with the added twist of a weird nostalgia." Of course, sometimes this boredom led to trespassing and other illegal activities, but even those adventures were etched with meaning and introspection. As one informant recalls, the Enchanted Forest provided a place for area youths "to poke around while doing something they weren't supposed to," but more importantly:

> *There was a certain mystique to it though, due to us all having childhood memories of the place and it since having fallen into disrepair. I remember a common theme in the way people talked about it: it was a creepy, decrepit reminder of youth. I think that was a lot of the draw to breaking in there, and the thought certainly captured my imagination when people talked about it. There's something about broken-down*

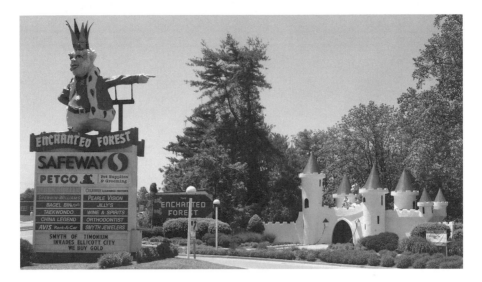

Old King Cole sits atop the Enchanted Forest Shopping Center with echoes of the abandoned park stirring in the background. *Wikimedia Commons.*

and overgrown statues of childhood fantasies that somehow gets at the feeling of lost youth.

In this context, the motivation for perpetual trespassing and symbolic congregation on the abandoned grounds of the Enchanted Forest is quite clear. The park not only represents an institutional barrier; it also represents a departure from the innocence and naïveté of childhood it worked so diligently to celebrate. Thus, the visual decay of a location imbued with so many conflicting memories and existing semiotic cues has inspired individuals to reclaim the site for expressive folk consumption. In service to these bourgeoning interests, efforts to preserve and relocate the Enchanted Forest's surviving structures took shape in the early to mid-2000s. As a result, a number of the surviving exhibits from the old Enchanted Forest have found a new home at Clark's Elioak Farm in Ellicott City.[41] The park's Old King Cole now perches on top of the sign for the Enchanted Forest Shopping Center, which occupies part of the land where the park once stood. Although the visionary theme park is gone, it remains a revered memory.

IN THE SHADOWS OF DRUID RIDGE

The Cursed Statue of Black Aggie

To look upon its grass grown yard, where the sunbeams seem to sleep so quietly,
one would think that there at least the dead might rest in peace.
—Washington Irving, The Legend of Sleepy Hollow

Sculpture is more than painting. It is greater to raise the dead to life than to create
phantoms that seem to live.
—Henry Wadsworth Longfellow

Whether cast from clay or bronze, the notion of a nonliving entity coming to life has long been a fixture of nightmares and legends.[42] The Druid Ridge Cemetery, off Reisterstown Road at the edge of the Baltimore city line in Pikesville, was (and in some ways still is) home to one such legend—perhaps Maryland's most infamous: the haunted, cursed statue known as "Black Aggie."

Originally seated against a gray stone block with the family name "AGNUS" scrolled across its base, the foreboding bronze sculpture features a heavily shrouded woman sitting alone, gazing out with a vacant look of silent torment on her face. The ominous placement of the woman's veil would often cast a dark, chilling shadow, obscuring her face from view without close examination. Grass never grew in the shadow of the statue. The mysterious figure drew grandiose folk speculation about its backstory. One such story held that the statue was cursed because a cruel husband murdered and buried his devilish wife there. But in reality, the statue's history is rather ordinary.

Black Aggie's story begins years before her saturnine casting ever graced the isolated cemetery plot she called home for sixty-two years. Author and historian Henry Adams, grandson of President John Quincy Adams, commissioned renowned American sculptor Augustus Saint-Gaudens to create a tranquil and flowing monument to his late wife, Clover, who had committed suicide in 1885.[43] In 1891, the completed Adams Memorial was placed unmarked in Washington, D.C.'s Rock Creek Cemetery. Popularly dubbed *Grief* by the public, the statue attracted great interest and admiration from laymen and artists alike. Before long, imitators and opportunists began to produce unauthorized replicas or recastings of Saint-Gaudens' original work for sale across the country. It is here, in this context, that the genesis of the Black Aggie legend begins.

Felix Agnus was a French-born entrepreneur, art enthusiast and decorated veteran of the American Civil War who settled in Baltimore with his wife, Annie Fulton, the nurse who had cared for his battle wounds. Agnus chartered an impressive military career, rising to the rank of brevet brigadier general. In 1883, he inherited the *Baltimore American* newspaper from his father-in-law, and in 1908, he founded the *Baltimore Star*.[44] An esteemed community leader, Republican activist and former sculptor himself, Felix Agnus sought a unique and beautiful monument to place at the family plot he purchased in the Druid Ridge Cemetery not long after the turn of the century. In service to this determination, Agnus acquired the statue that would become known as "Black Aggie" from sculptor Eduard Pausch in 1905. At the time of the purchase, Agnus did not know that Pausch's work was actually a near identical replica of Augustus Saint-Gaudens' famed *Grief*. It is rumored that upon hearing this news, Augustus Saint-Gaudens' widow visited the Agnus family plot and demanded that Felix Agnus remove the statue and sue the sculptor behind its unauthorized recasting. Indignant, Agnus refused to relocate the sculpture from its rightful home at Druid Ridge, claiming Eduard Pausch and his associates had hornswoggled him.[45] And so, there the statue remained. By the end of 1925, Annie Fulton and Felix Agnus, along with many of their relatives, had been laid to rest in the shadow of the enigmatic figure bearing the family name.

By the 1950s, the statue had caught the eye of local teens and fraternity brothers who notoriously convened at the site for initiation rituals and tests of valor.[46] Lurid stories and rumors proliferated, charging that anyone who dared to sit on the lap of Black Aggie at the stroke of midnight would be squeezed to death by her animated arms and dragged down to Hell. Others insisted that anyone who stared into her eyes at the stroke of midnight would

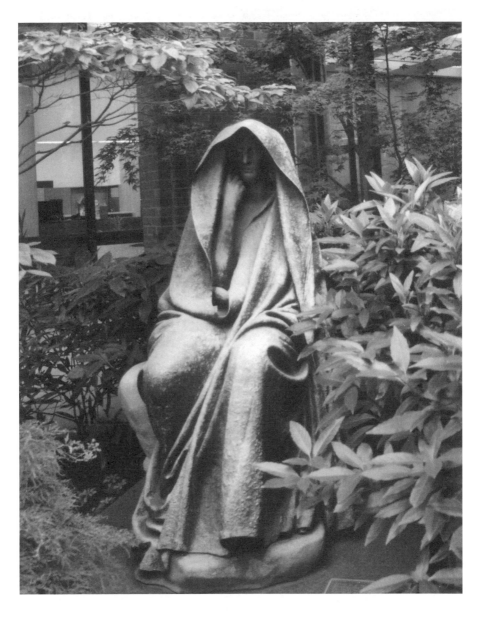

After years of vandalism, the statue of "Black Aggie" rests in her new home at the Dolley Madison House in Washington, D.C. *Courtesy of Allister Sears.*

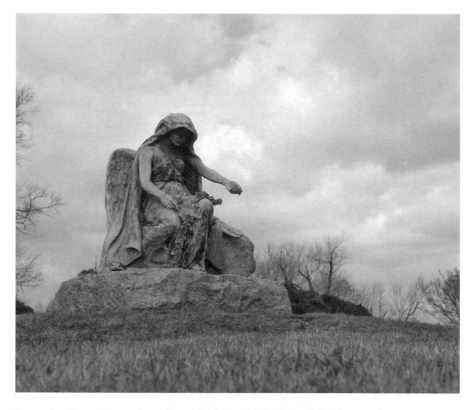

Located a short distance from the original site of "Black Aggie," this statue has assumed the starring role of the legend in its absence. *Photograph by Sam Lehman.*

see them glow red or green, possibly even bleed, before Black Aggie struck the visitor blind with her gaze. Pregnant women who sat on Black Aggie's lap were doomed to miscarry; unmarried single women would find themselves with child; and anyone who lived through the experience of sitting on Black Aggie's lap or gazing into her eyes was nevertheless cursed and resigned to die in the near future.[47] Some even claimed to see the statue stroll through the cemetery at night or hosting a congregation of ghosts at her plot.[48] Rumors of teens found dead or maimed at the hands of Black Aggie persisted well into the 1970s.

The perpetual visitation of Black Aggie over the years left a great deal of unwanted attention and vandalism in its wake. In 1967, the Agnus family donated the famed sculpture to the Smithsonian. After several years in storage, Aggie reemerged (and remains today) in the courtyard of the Dolley Madison House, located on Lafayette Square in Washington, D.C.

Her legend, however, appears to live on through another creepy Victorian-era statue found in the Druid Ridge Cemetery—a shrouded angel cutting garland with shears—not far from the original Agnus family plot. While the original Black Aggie is a distant memory for most Marylanders, its influence remains palpable. Repetition and variation have allowed the statue's symbolic meaning and expressive motifs to transfer to a new effigy and a new context, bringing the fun, reckless tradition of years past into the present.[49] And now instead of squeezing victims to death, the new Aggie uses her shears to stab or decapitate them!

CHAPTER 4

HELL ON WHEELS

The Demon Car of Seven Hills Road

Death has a hundred hands and walks by a thousand ways.
—T.S. Eliot, Murder in the Cathedral

Everything in life is somewhere else, and you get there in a car.
—E.B. White, "Fro-Joy," One Man's Meat

In towns with an abundance of winding country roads and bored teenagers, stories about perilous joyriding seem to abound. Automobiles are particularly valued legend motifs, serving as transportation to a special location while often becoming a functional part of the story or event that unfolds once there.[50] Therefore, it should be no surprise that a number of legends and legendary sites throughout the Free State require a set of wheels to be fully appreciated.

As the late folklorist Alan Dundes noted, legends "can spring anew whenever an appropriate personage, place, or event is deemed legendworthy by a folk group."[51] Just off College Avenue in historic downtown Ellicott City rests a long stretch of winding, hilly terrain known locally as "Seven Hills Road," unofficially named in observance of the seven crests along the route. At night, the surrounding woods usually cast the narrow thoroughfare pitch black. Uninhibited local teens and Baltimore-area college students tear down the road, attempting to go airborne off the hills, especially the third and fourth ones. Over the years, these shenanigans have supposedly resulted in countless wrecks and fatalities on the road.[52] There are extensive online

A looming, narrow road bodes misfortune for the treacherous driver. *Photograph by English Wikipedia user Daniel Case.*

forums composed of former and current area residents who discuss the details of wrecks they have experienced or witnessed on Seven Hills Road, as well as the individuals who have died while joyriding. These narratives seek to verify the road's danger while also acting as a symbolic deterrent to other thrill-seekers. But in a macabre way, like their oral tradition brethren, these personal narratives instead fortify the mystique of Seven Hills Road and its corresponding legend, calling upon daredevils to race down the treacherous road to test and prove its truth.

According to local folklore, if a speeding car dares to hit the seventh hill of Seven Hills Road at exactly midnight, a demon car will appear out of thin air and chase the occupants with its high beams on, riding their bumper until the end of the road, where it vanishes.[53] The "demon car" is usually identified as an old, black pickup truck, perhaps of 1940s or '50s vintage. Those who have survived the ordeal speculate the phantom driver is yet another victim of the road who died long ago of his own negligence

or someone else's. A minority believe that the phantom driver is more likely a local vigilante hoping to scare off reckless drivers, considering that numerous properties along Seven Hills Road have allegedly been vandalized and harassed for years.[54]

To be sure, the presence of "phantom vehicles" and "haunted highways" are common motifs in legends and popular culture.[55] A machine as powerful as an automobile commands respect, and folk narratives that highlight instances of their misuse often problematize their venerated status by introducing a ghostly figure or harrowing backstory—usually specific to a location—that also engenders a new threat of death or bodily harm to drivers in the present. The legend of Seven Hills Road certainly fits this mold, which underscores its traditionality, especially in a regional context. Sixty-seven miles to the north, in Hellam Township, Pennsylvania, lies the "Seven Gates of Hell" off Toad Road, where motorists are challenged to drive through seven progressively eerie markers on a legendary property; reaching the seventh gate will supposedly cause the earth to open up and swallow the daring driver down into Hell. In some variations, a phantom car appears and disappears when drivers reach one of the gates.[56]

Structurally, there is a slight correlation between reports of the demon car's antagonistic use of high beams and motifs found in the urban legend "Lights Out." The popular story warns of a gang initiation ritual in which a prospective member drives at night with his headlights off, waiting for another motorist to flash their brights in alert. As soon as one does, the initiate turns on his high beams and follows the Good Samaritan—riding his bumper—and does not stop until running the car off the road, presumably killing the driver.[57] Warning stories about this gang initiation ritual appeared online in the 1990s, and incidences localized to hundreds of communities throughout the United States.[58] While the stories proved false, they nevertheless influenced vernacular discourse. Therefore, it is feasible to draw some correlation between the motifs of the "Lights Out" tale circulating in the early to mid-1990s and those in the Seven Hills Road legend, which was beginning to surface around the same time.[59]

In any case, the story of a demon car that gives chase to wayward drivers is a cautionary tale about the consequences of mishandling an automobile in a hazardous setting, aimed at the teen and college-age constituents who embrace the serpentine road and its legend. After all, the symbolic value of Seven Hills Road has already formed in the area's youth folk culture— the warnings about its record for causing speed-induced death and dismemberment, coupled with the alluring temptation to defy and conquer

those threats through ritualized action with peers, render it an enduring social haunt. Still, the legend's supernatural threat of a pursuant demon car attempts to provide some additional trepidation for foolhardy risk-takers planning to whiz through those winding back roads.[60] In narratives about Seven Hills, however, the supernatural element also conversely attracts thrill-seekers who want to experience the legend and its traditions through ostensive action. Beyond the promise of experiencing the supernatural, drivers continue to fly down Seven Hills Road to push the boundaries of vehicular law and physics, test their mettle and participate in a local tradition.

CHAPTER 5
BRIDGES OVER TROUBLED WATER

Headless Ghosts, Psycho Killers and Dead Baby Sightings

A bridge has no allegiance to either side.
—Les Coleman

The oldest and strongest emotion of mankind is fear, and the oldest and strongest kind of fear is fear of the unknown.
—H.P. Lovecraft, Supernatural Horror in Literature

Whether it's the ghostly cries of a dead baby or the abode of a deranged creature, bridges are a magnet for folklore. "Crybaby bridges" are physical sites associated with a corresponding legend that tells of the tragic death of an infant and/or its mother at the scene. Invariably, the suicide or murder is the result of an unwanted pregnancy, severe postpartum depression, family strife relating to the child or a grisly accident.[61] In less common instances, the legend holds that a baby was discarded due to a birth defect or freakish disfiguration. As a result of these tragedies, the bridge transforms into a hotbed for legend tripping; visitors drive to the storied location under cover of darkness, turn off their cars and wait to hear the sound of a ghost baby crying in the night.[62] These types of narratives are found throughout the United States.[63] However, the individual locations and their contextual meanings distinguish Maryland's crybaby bridges from those of other states.[64]

One such example comes from Governor's Bridge, a historic truss bridge extending over the Patuxent River near Bowie in Prince George's

An iron truss bridge, visually and structurally identical to many of the crybaby bridges found throughout the state of Maryland. *Photograph by Dwight Burdette.*

County. Designed to connect Prince George's and Anne Arundel Counties, the ensuing dark, marshy path—eponymously named Governor's Bridge Road—spawned strange tales over the years, ranging from rocks pelting cars at night to severed hands scratching at cars stopped on the road.[65] Indeed, the densely shadowed area is deliciously creepy at all times of day. Governor's Bridge is also home to myriad rumors about horrific car wrecks, bouts of impenetrable fog, odd lights and sounds and occasional sightings of hanged corpses—including children—dangling from its frame. But its crybaby bridge story, which fits the classic mold, has imbued special meaning for legend trippers. According to local legend, an unmarried pregnant woman drowned her newborn in the river to avoid the scorn of family and friends. Now, visitors who park on or near Governor's Bridge after midnight hear the baby crying out for its mother. The legend has spread and localized to a scattering of smaller bridges across nearby Anne Arundel County and throughout Prince George's County, most notably in Beltsville at Beaver Dam Road and in Mitchellville off Lottsford Road, where the legend has circulated since at least the 1950s.[66]

Toward the end of Indian Bridge Road in Leonardtown, St. Mary's County, lies a crybaby bridge with two origin stories.[67] The most popular

rendition tells of a husband who returned home from World War II to his wife and infant child, only to realize that he had been away too long to be its father. Infuriated, the cuckolded veteran revved his car and trampled his wife and her bastard offspring, leaving them to die on the bridge.[68] Locals say that the ghostly cries of the lonely, adulterous woman and her eternally sobbing baby now greet legend trippers who convene at the bridge. The other, less circulated bridge legend claims that the cries emanate from the ghost of a slave woman executed and buried in the marsh below as punishment for murdering her master.[69]

Adams Mill Road in Westminster, Carroll County, also sports a crybaby bridge. Area residents tell of a nineteenth-century Ku Klux Klan practice where Klansmen ritualistically drowned black infants at the overpass.[70] Other legend variations echo the backstories of established crybaby bridge narratives, such as discarding children born out of wedlock.[71] Nevertheless, Maryland's bridgelore does not end with the spectral cries of dead babies.

And the Beat Goes On: The Legend of Heartbeat Bridge

In Ellicott City, there is a bridge off Bonnie Branch Road where an insane man cut out his wife's heart and threw it, still beating, into the stream below.[72] Locals drive to the old bridge at night, roll down their car windows, shut off their engines and listen in silent anticipation. On quiet nights, visitors can hear—and sometimes even *feel*—the murdered woman's heart still beating from below.[73] A less common variant tells of a forbidden love between a wealthy white girl and a slave. Rather than be kept apart, the lovers committed suicide by leaping off the bridge together. Thus, the heartbeats heard are those of two hearts beating eternally as one. Known affectionately as "Heartbeat Bridge," the legend employs the narrative and ritual traditions of crybaby bridge legends in modified form, linking the genre's structural and participatory expectations with a new location and context.

Honk If You're Headless: Summoning Big Liz of DeCoursey Bridge

The legendary "Big Liz" of Greenbriar swamp—the towering, headless ghost of a murdered slave woman—haunts DeCoursey Bridge near Cambridge, Dorchester County.[74] As the story goes, a wealthy slaveholder caught the muscular, industrious Liz spying for the Union during the Civil War.[75] The slave master, afraid of finding himself charged with treason by either prevailing side, ordered Liz to haul his considerable wealth to a nearby swamp and bury it underground. But as she placed the treasure in the hole, vulnerable and exhausted from carrying it such a distance, the slave master seized the opportunity, lopping off Liz's head and burying it along with the riches. Now on dark nights, thrill-seekers drive to DeCoursey Bridge—the legendary marker of Big Liz's final resting place in the Transquaking River. Once there, they turn off their cars, flash their high beams three times and honk their car horns six times.[76] Legend says Big Liz will emerge from the swamp with her head held beneath her arm, lumbering toward the offending vehicle.[77] Invariably, as Big Liz draws nearer and the driver turns the ignition key to flee, the engine stalls but turns over at the last second. The panicked driver hastily speeds away. Other variants claim that Big Liz will appear in the swamp when summoned, beckoning bridge visitors to follow her to the treasure, her eyes glowing red as burning coal.

Beyond Big Liz, Dorchester County is also known locally for "Suicide Bridge," which runs over Cabin Creek around the small town of Secretary, near Hurlock. Debuting around 1888, the bridge eventually became the site of numerous successive suicides, ranging from self-inflicted gunshot wounds and bloody disembowelments to diving accidents and drownings.[78] The extant bridge remains a physical embodiment of these narratives; its appeal is self-sustaining. But unlike the headless ghost of Big Liz or phantom cries from the netherworld, Suicide Bridge itself is the legend.[79]

The Bunny Man Cometh: A Legend with an Axe to Grind

The legend of the Bunny Man stems from two October 1970 reports published in the *Washington Post*[80] about an unidentified Fairfax County, Virginia man dressed in a white suit with long rabbit ears who crept up on a couple parked

off the main road and yelled, "You're on private property and I have your tag number!" He then hurled a hatchet through the passenger-side window and ran off into the night. The couple was fortunately unharmed. Two weeks later, near the location of the prior incident, a private security guard spotted a man in a rabbit suit chopping an unoccupied house's roof support beam with a long-handled axe. When approached, the man growled, "All you people trespass around here," as he whacked the wooden beam eight more times. He then threatened, "If you don't get out of here, I'm going to bust you on the head." As the security guard scurried to retrieve his handgun, the axe-wielding Bunny Man fled into the woods. The suspect escaped, and worried area residents continued to report sightings of a man roaming the streets in a rabbit costume.[81] In subsequent oral traditions of Fairfax County, the Colchester Overpass in Clifton, Virginia, became known as "Bunny Man Bridge," serving as the primary residence of the psychotic legend.

Because of the original story's geographical proximity to the Washington, D.C. metropolitan area (and the inevitable influence of repetition and variation), the legend spread to Maryland's Montgomery and Prince George's Counties.[82] Although the Bunny Man is not restricted to bridges in Maryland oral tradition, the Bunny Man legend proliferates in the same rural or suburban settings where complementary bridge narratives also thrive. The Bunny Man legend melds with Maryland bridge and creature legends to make rural, secluded areas unsettling.

In 1973, University of Maryland undergraduate Patricia C. Johnson interviewed thirty-three informants (most of whom were local teenagers) about the Bunny Man legend for a folklore class. She recorded fifty-four variations of the story, including fourteen different geographic locations. In the legends Johnson collected, the Bunny Man frightens couples, attacks parked cars and vandalizes local property. Despite the axe, Johnson's Bunny Man was not a murderer. A deranged, axe-obsessed man in a rabbit costume produced sufficient excitement to keep the legend relevant to local storytellers.[83] After the 1970s, the Bunny Man lived on in regional folklore, although the Maryland version began to merge with the legend of the Goatman (see chapter 11). As a result, some mixed reports claimed that the Bunny Man made appearances near the one-lane bridge on Tucker Road in Clinton (Prince George's County)—one of Goatman's main haunts.[84]

Bridges, by design, allow individuals to pass freely over physical obstacles—chasms, valleys, waterways and adjacent roads. They are an integral part of everyday life, so they are expectedly vibrant sources of folklore. Legends

about bridges do more than comment on a specific location; they reflexively encapsulate what the area means to the people who inhabit it. The presence of clear storytelling motifs demonstrates an awareness of narrative conventions while highlighting communal adaptation and innovation. But most importantly, bridgelore is an entry point to expression and group participation, binding individuals together as collaborative stewards of regional tradition.

BALTIMORE'S GHOSTWRITERS

The Sun Shines a Light on Maryland's Shades

For our purposes we shall, from this point forward, assume that the ages are right and examine the reports of the people concerning the returning dead as though we had never a doubt in our minds that what is said to have happened did happen. This is the folklorist's path.
—*Louis C. Jones*

The average newspaper, especially of the better sort, has the intelligence of a hillbilly evangelist, the courage of a rat, the fairness of a prohibitionist boob-jumper, the information of a high school janitor, the taste of a designer of celluloid valentines, and the honor of a police-station lawyer.
—*H.L. Mencken*

Founded in 1837, the *Baltimore Sun* boasts the largest circulation of any Maryland newspaper. Since the nineteenth century, the *Baltimore Sun* and its reporters, with their willingness to acknowledge the supernatural, have written ghosts onto the Maryland landscape. But these were not gullible, naïve or sensationalistic journalists. For over 150 years, the *Sun* has matched its willingness to share ghostlore with a willingness to shine a light on hoaxes, pranks and jokes. Investigating the ways newspapers use contemporary legends, folklorist Paul Smith found "entertaining" and "exposing" as two of the most common.[85] In the nineteenth and early twentieth centuries, the *Sun* was happy to entertain its readers with spectral happenings but quick to expose raging ruses.

In January 1855, a rumor was making the rounds in the city that a haunted schooner had arrived at Smith's dock in Baltimore. The ship's name was the *Exchange*, recently arrived from Savannah, Georgia. A story began circulating that the crew had seen "the most unearthly sight imaginable" on its latest voyage, and some had been thrown overboard. They had since abandoned the ship. In what amounts to an early legend trip, a group of Baltimore gentlemen volunteered to spend Friday night on the vessel. The overnighters reported strange sights and sounds but would go into no further detail, insisting anyone seeking more information spend the night on the ship himself. The *Sun* speculated the initial visitors were encouraging others to visit because they did not want to be the only ones who were fooled.[86]

Years later, in June 1883, businessman Mansel Tweed bought the late James Crow's quarry in Cecil County. Tweed's laborers, quarrying flint on Crow's old property, were spooked when showers of stones rained down upon them every time they attempted to begin their work. James Crow's son, Robert Crow, visited the farm, and when a stone fell at his feet, he, too, was convinced that the phenomenon was supernatural. At one point, a six-pound stone was hurled sixty-five feet through the air. The *Sun* surmised the phenomenon may be connected to a murder that had occurred on the farm in 1836, when the young Elizabeth Waggoner beheaded her father with a broadaxe.[87]

A couple weeks later, the *Baltimore Sun* reported on the phantom rocks again. The excitement in the quarry, eight miles from Elkton and two miles from Newark, Delaware, had lasted for about a month. Everyone in the surrounding towns had taken great interest in the haunted quarry. Thrill-seekers from across the country had even made the long trek to see the apparitions. Workers continued to experience stones falling from the sky, which they reported ranged from a few ounces to thirty pounds. Oddly, the stones were not the same type as those found in the quarry. Hot to the touch, they most often fell around 1:00 p.m. Although there were no reported deaths, rumors began to circulate about bloodstains throughout the quarry. Although some connected the event to the murderess Elizabeth Waggoner, others explained that the supernatural events were due to previous business dealings between James Crow and Mansel Tweed. Crow had refused to sell the quarry to Tweed, but Crow's widow had no such objections. She sold the land to Tweed soon after Crow's death. As the stones fell only on the workmen and always in great numbers, the community assumed this was Crow's spirit attempting to drive Tweed's men away. Crow's widow, on the other hand, was able to visit the quarry unmolested.

As the stone heaving continued for several weeks, the *Sun* sent a reporter to investigate on July 4, 1883. The reporter noted the quarry was small and its appearance perfectly ordinary. Seeing the Crow homestead on the far side of a cornfield, the reporter made his way to the house, hoping to talk to Mrs. Crow about the ruckus her husband's ghost was causing. He found her furious about the attention the stone showers had received in the papers, and she told him she did not want to talk to any reporters. As the sun began to set, Sam Crow, the genial seventeen-year-old son of James, walked out of the neighboring field with a sling over his shoulder. Although he was pleased by the haunted quarry rumors, Sam initially denied any intimate knowledge of their origins. But as the reporter pushed for more information, Sam gave up the whole story. Soon after Tweed opened the quarry, Sam threw down a bridle next to one of the workers, George Vansant. Amused by how easily startled Vansant was, the next day, Sam figured he would lob a few sun-warmed fieldstones at Vansant and have a good laugh. Although Vansant never deduced the source of the stones, some of the other workers did. They found the joke so side-splitting that workers vied for who would get to throw the next stone at Vansant. The brothers Ball and Mantz Bradford took up their duties with particular vigor. The workmen would send Vansant on errands and, while he was gone, load a nearby tree with stones. Upon Vansant's return, a shake of the tree would send a shower of stones cascading from the branches. Up to the day of the newspaper report, poor George Vansant still believed it was James Crow's ghost hurling stones at him.[88]

In 1904, the steamer *St. Mary's* and its crew made the *Baltimore Sun* for their ghosts and antics on several occasions. The report of the first "spirit" sighting came on January 31, 1904. Tremendous amounts of ice had compelled the *St. Mary's*, steaming for Baltimore, to spend the night at Drum Point, near Solomons Island in Calvert County. Enticed by the prospect of female companionship, three young officers braved the icy waters and rowed to Solomons Island hoping to meet girls. When the ship's purser,[89] T.B. Gourley, and chief engineer, William O'Donnell, heard of the plans, they concocted a prank to terrify the young officers. Solomons Island was a silent and eerie place at that time, its beach a sea of oyster shells. On the beach, dead men's bones were visible, sticking out from under graves of oyster dredges. After the three young officers departed, Gourley and O'Donnell followed them to the island. Choosing a particularly unsettling part of the beach, they constructed a figure and draped a sheet over it. After their work was done, "it looked from a distance like the ghost of a woman keeling over the bones

of one of the dead oystermen." As it was cold and drizzling, the duo left for the ship, content to watch the impending scene through a spyglass. A few hours later, the young officers returned to the beach in high spirits until they "turned a bend and in the gathering darkness saw the figure of a woman, all white, keeling over the bones of a man." The three screamed and broke into a mad dash. After a short distance, the bravest of the three, Thomas Weems, stopped, drew his pistol and turned on the spirit. Walking cautiously, his voice cracking with fear, Weems shouted, "If that's anything to hurt us, throw up your hands." When the ghost did not respond, Weems repeated the command. Still receiving no response, Weems discharged his pistol into the air and fled. The three young officers dove into their boat and rowed for safety, paddling as if the ghost was in pursuit. By breakfast the next day, each was accusing the other of the greatest cowardice. The crew was so amused by the prank that one among them penned a poem to mark the event and sent it to the *Sun*:

'Twas in the midst of winter of the year nineteen and four
The old St. Mary's *couldn't make her run to Baltimore.*
Her gallant Captain Davis drove her here and drove her there,
But all in vain, the ice, in mountains, plugged her everywhere.
He turned about and sought a berth, which all wise captains know,
That little wharf they call D.P., where strong winds never blow.
The harbor looks as peaceful here as whisky in a saucer,
But, truly, here is little peace, and very little law, sir.
For, you must know, along the shore grim coffins strew the sand,
Here you will see a dead man's foot, and there a dead man's hand.
Therefore, should you parade the shore, you must use circumspection,
Or you may tread upon the toes of ghosts who'll take exception.
The day I speak of, three brave youths set out on a flirtation
(There is no record of what chanced while at their destination);
For Solomon's they struck a pace along a corpse-strewn way.
They started for it bravely, (when they started it was day.)
I'll tell you what their names are first; 'tis proper they should shine,
Examples to such timid folk with nerves like yours and mine.
The first (and bravest, I believe,) was baptized simply "Jim;"
Nor is it per-adventure that his name will rhyme with "slim."
Next, "Tommie." But hereafter we must call him "Thomas." Why?
We all respect a fellow who can keep his face—and lie.
And last (but not the least of all), that youth who's Gourley's backer.

Somebody told me he was called "the bird that wants a cracker."
Well, all good things must have an end. Their girling had an ending,
And midnight was approaching fast, as homeward they came trending.
In silence and in Indian file the trio were progressing,
When, suddenly, there came a yell from Tommie—most distressing.
"Uuggh! Ah!" he cried. "There 'tis, there 'tis!" All knees began to quiver,
And each man, on his own account, made bee-line for the river.
'Tis said that Tommie pulled a gun, to prove he was not frightened
(This kind of proof will hardly go with people well-enlightened).
Thus each man swore he would not run from any ghosts or witches,
But no man volunteered to prove what happened to the stitches.[90]

Eight months later, the *St. Mary's* and its young officers were in the newspaper again. This time docked in Baltimore at the Light Street Wharf, Thomas Weems had returned from gallivanting in the city around midnight. After talking with his fellow sailors, he made for his stateroom. Shortly thereafter, Weems let out a shrill scream, and the entire crew came running, including Weems's Solomons Island compatriot, roommate and now local hero, James Leitch.[91] On the other side of the door, the crew could hear Weems yelling, "Ghost! Ghost!" at the top of his lungs. As Weems shot out the door and through the thick crowd of sailors, close on his tail was "a slim black shape about a yard long, which struck the deck and, the deckhands say, disappeared as if by magic." Although no one could identify the phantom object, no one volunteered to search the ship for it either.

Weems told his shipmates that upon entering his room and turning on the light, "a long black shape darted past his head and sprang from side to side of the small room." It moved so rapidly that Weems felt trapped, and that was when he had called out in fear, only later finding an opportunity to break through. One of the officers suggested the apparition might have been the ship's cat, but the cook assured the crew that the cat had been sleeping under the stove at the time of the incident. Other officers believed it was a genuine apparition, blaming the ship's former engineer, who had died a few years previous. Ever since, the ship's bell had a habit of ringing without being pulled, and the deckhands had reported spectral noises coming from throughout the ship.[92] In 1904, the *Sun's* reporters were sufficiently amused with the *St. Mary's* antics to feature the ship and its crew three times. Unlike the coverage of the *Exchange* and James Crow's quarry, the *Sun* seemed content to report the strange occurrence aboard the *St. Mary's* without any need to expose (even though the *Sun* knew the ship was full of pranksters).

Sensational stories sell newspapers, but journalists are also compelled to investigate and, when necessary, expose such stories circulating in the community. In these three stories, the *Baltimore Sun* walked a tight line, reporting on the fun and the fascinating but never losing its measured tone. The overall effect of the paper's decades of spectral coverage gives a sense that the *Sun* is willing to believe in ghosts but has yet to be convinced. Throughout the nineteenth and early twentieth centuries, the *Sun* acknowledged the possibility of ghosts but frequently tied supernatural happenings to ordinary people.

CHAPTER 7

TERRAPIN TALES

The University of Maryland's Campus Legends

*And yet not a dream, but a mighty reality—a glimpse of the higher life, the
broader possibilities of humanity, which is granted to the man who, amid the rush
and roar of living, pauses four short years to learn what living means.*
—*W.E.B. Dubois*

College is a refuge from hasty judgment.
—*Robert Frost*

C olleges and universities host a rich bounty of folklore, and prominent
among it is the legend genre. As part of the college experience, students
tell of witty classroom rejoinders, grim campus deaths and lurking college
spirits. In his book *Campus Traditions*, folklorist Simon J. Bronner writes that
the prevalence of folklore on college campuses may be due to the stress of
the college environment and folklore's ability to assist in adjusting to new
environments and new stages of life.[93] The college years are a unique time
in a young adult's life and a transitory time from one distinctive life phase to
the next. Bronner points out the ease with which college students form a folk
group: "Sharing a similar age for the most part, engrossed in the pursuit of
a degree and grades, in frequent contact with one another through classes
and residence, separated in status from faculty and administrators, and often
isolated from the support of family and friends found at home, students seek
the lore emerging from their common ground." Although traditions may
seem trivial compared to the other work done on campus, it is important

to consider the lore of "the most connected group on campus" because through it students "reveal much about their society and the future society they will shape."[94]

Where is University of Maryland campus folklore today? There are few "official" tradition bearers. The university's Student Government Association sponsors the Community Engagement Committee, whose job includes "further[ing] tradition at the University of Maryland." And in 2011, alumni and current staff members Margaret Hall and Linda Martin released *University of Maryland Traditions*, a fun and pretty look at Maryland traditions, past and present.[95] Seeking active legends representative of the folklore of the University of Maryland, we decided to query the ultimate purveyors of campus tradition: student tour guides. The Maryland tour guides boast a large repertoire of legendary material, some that they tell prospective students on their walks around campus and others that they keep among themselves. Among these narratives, we find stories that unnerve, embolden, warn, invigorate and motivate.

Ashes to Ashes, Hosts to Ghosts

Stories of the supernatural are a common legend subgenre found on most campuses. In the words of folklorist Elizabeth Tucker, campus ghost stories "entertain and educate students, offering a unique blend of excitement, mystery, and danger"; "initiate entering students into a new community and a new stage of life"; and "reveal much about the dangers and delights of college life."[96] Morrill Hall is one of the University of Maryland's haunted buildings. As the home of the old medical school, Morrill Hall kept cadavers in the basement, possibly used for dissection. During the Great Fire of 1912, flames ravaged every building on that part of campus except Morrill Hall. Some suspected it was the cadavers in the basement that warded off the blaze. Today, building occupants report strange odors of smoke emanating from the building.[97] There are also reports of marching sounds in front of the building. University archivist Anne Turkos explains that the sounds make logical sense. In the school's former military guise, the yard in front of Morrill Hall was the college's parade ground, where students would march off demerits for bad behavior.[98]

Near Morrill Hall, Maryland students refer to a circle etched in the concrete as the "Acropolis." Also known as the "Point of Failure," this is

A survivor of the Great Fire of 1912, Morrill Hall sports an unsettling façade. *Special Collections & University Archives, University of Maryland Libraries.*

the point where the lines from the surrounding, long-since-burned buildings converged. Students consider it bad luck to step in the center of the Acropolis, and tour guides love to warn the crowd against considering it. Prospective students who step on the center will not be admitted. Current students will

Left: Even in her worldly flesh, Marie Mount had an ethereal aura. *Special Collections & University Archives, University of Maryland Libraries.*

Below: Marie Mount's haunt, Marie Mount Hall, sits at the center of campus on McKeldin Mall. *Special Collections & University Archives, University of Maryland Libraries.*

Opposite: A venerable structure, the haunted Rossborough Inn is one of the oldest surviving buildings on the University of Maryland campus. *Special Collections & University Archives, University of Maryland Libraries.*

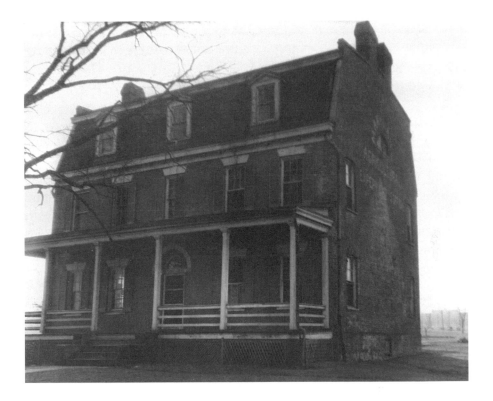

not graduate. And lest they think themselves in the clear, parents of students who step in the center will receive no financial aid.[99]

Another popular haunt at the University of Maryland is Marie Mount Hall. The building was named after Marie Mount, the dean of the College of Home Economics from 1927 until 1954.[100] Marie Mount was legendary for her dedication to the university. She was so committed to the school that on rainy nights, instead of heading home, Dean Mount would take her reprieve in the attic, where she would spend the night playing the piano. Her legendary dedication may have gone beyond the known world. Today, on dark and stormy nights, students can hear Dean Mount playing the piano in her attic.[101]

The Rossborough Inn, located at the front of the campus right off U.S. Route 1, is another of the university's haunts. Now used for office space, the odd building was erected in the 1800s and has served many purposes over the years. Its distinct look differentiates it from the college's other buildings. During the Civil War, when both Union and Confederate soldiers spent time on the campus, a woman named Miss Betty managed the inn. Interviewed by Mark DiAngelo, university archivist Anne Turkos

told of a manager in dining services named Larry Donnelly, who saw the ghost of Miss Betty in a yellow dress on several occasions in 1981.[102] Other workers confirmed the reports, and more have heard footsteps late at night walking through the building.[103]

Legend can be used for remembering, commemorating and dealing with major or traumatic events in a group's history. At the University of Maryland, one such example takes place in Washington Hall. On June 17, 1986, the Boston Celtics drafted basketball phenom Len Bias second overall into the National Basketball Association (NBA). After meeting with his new club in Boston, Bias returned to the University of Maryland and ate dinner with teammates before attending an off-campus party. In the early morning hours of July 19, 1986, Bias and friends walked to his Washington Hall dorm room, where they snorted lines of cocaine provided by longtime friend and drug dealer Brian Tribble. Bias suffered a seizure and collapsed from an irregular heartbeat; he was pronounced dead later that morning. Bias's death sent a shockwave through the university and the nation. Ever since, the upperclassmen in Washington Hall have said that late at night they can hear the spirit of Len Bias bouncing his basketball in his old dorm room.[104]

RUBBING TESTUDO THE RIGHT WAY

Not all legends are necessarily frightening or disturbing. Some simply contribute to the quilt work of a storied university. In front of McKeldin Library sits a bronzed statue of a diamondback terrapin. Football coach Curley Byrd recommended instituting the diamondback terrapin as mascot in 1932, changing the team from its previous designation as the "Old Liners."[105] One of the few animals indigenous to Maryland, the terrapin has become the symbol of the Terps. Latin for turtle or tortoise, *Testudo* harkens back to the Greek war formation.[106] Testudo's nose appears varnished to a level far beyond the rest of his body. Rubbing Testudo's nose brings good luck, and students will give it a cursory rub as they pass. Throughout the year, Testudo will wear a scarf, Mardi Gras beads and other holiday apparel. The ritual reaches new levels around exam time, when the rubbings become vigorous and Testudo takes on the decadent look of a hoodoo altar. Students make offerings of food, money and lit candles, all in hopes of upping their exam scores. The ritual reached a

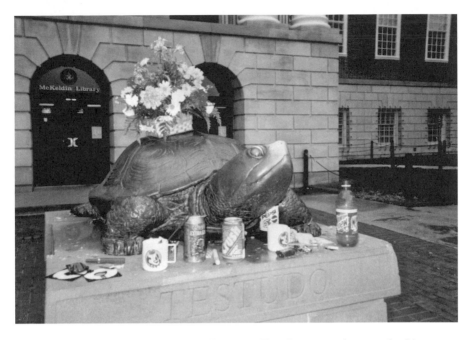

Superstitious students make good luck offerings to Testudo at exam time, turning his pedestal into a shrine. *Special Collections & University Archives, University of Maryland Libraries.*

dangerous pinnacle in 2013 when one of the candles caused the entire statue to go up in flames.[107] Testudo was unharmed.

Knowing the importance of Testudo to University of Maryland students, other schools have stolen the prized, formerly three-hundred-pound statue and held it for ransom. In 1947, days before another matchup in a heated lacrosse rivalry, Johns Hopkins students stole Testudo and held him in Baltimore. Two hundred students drove to Baltimore to retrieve their beloved statue. The incident caused a mini-riot, and the Baltimore Police Department had to be called in.[108] Johns Hopkins president Isaiah Bowman ordered his students to return Testudo. They did, after painting a blue "H" on his shell. Two years later, the University of Virginia made the same heist. Although undocumented, one campus legend insists that Florida State University stole the bronzed terrapin as well. Students woke one day to find their prized mascot vanished and soon received a picture of Testudo buried in the Florida sands near Tallahassee. To combat future robberies, the university filled Testudo with half a ton of cement.[109]

Other legends and traditions find their way around Testudo. Like many other colleges and universities, one legend states that Testudo will come to

life and fly off his pedestal if Maryland ever graduates a virgin. Other statues at other universities across the United States also stand waiting for virgins to graduate. These include the University of North Carolina's Silent Sam, the Torchbearer at the University of Tennessee, Ezra Cornell at Cornell University, James Duke at Duke University, Garibaldi at New York University and stone lions at the University of Missouri, the University of Michigan and the University of Cincinnati.[110] A traditional, cynical conclusion to the legend is that, of course, graduating a virgin is impossible because the tuition bill screws everyone. Admittedly crass, one interpretation ties these legends to maturation and adulthood. American society lacks strong rituals initiating adolescents into adulthood. College students inhabit an especially liminal place. High school students are children; graduates who join the workforce are adults. Where does that put those who choose to pursue more education? Although they are over eighteen and can legally vote and be drafted into military service, undergraduate students continue to spend their days much in the same way as they have since elementary school. Is it any wonder that reckless behavior, heavy drinking and sexcapades are rampant on college campuses? The legend of the virgin belongs to this preoccupation. It's not that every man and woman on campus is a degenerate whore. Rather, it speaks to the long-held importance of the virgin in folklore. There, we find maidenhood as a signifier of childhood. The loss of virginity leads to the onset of adulthood. Saying that no virgin leaves the university really means no child leaves the university. Students enter as children but leave as adults, ready to take on the world.

The Testudo in front of McKeldin is only one of several on campus. Others are scattered across the campus by the Comcast Center, Byrd Stadium, the Alumni Center, Gossett Team House and the Stamp Student Union. But these monuments are hollow, their noses less polished, their bodies less stolen. Students know the real Testudo lives at the base of the Mall, back facing the library, staring at the Main Administration building and directly into the office of the president, ensuring everyone is on task.

A JERK IN THE STACKS

Testudo is not the only legend living around the McKeldin Library. Inside, the large building's seven floors and many isolated nooks and crannies allow for solitude, even in a central and busy location. McKeldin has been known

for years as an ideal location for a romantic rendezvous,[111] but the library also attracts the more deviant sort. Between 2000 and 2002, McKeldin experienced a rash of indecent exposures—seven in two years.[112] Sometimes the incidents entailed mere flashing. Other times, coeds immersed in a textbook would look up to find themselves drenched in a stranger's semen. Police finally arrested Robert Lee Scott in April 2002, the man suspected in all seven incidents, and charged him with both assault and trespassing for ejaculating on the back of a female student who was studying on McKeldin's fourth floor. But the exposures continued. In May 2002, police received two more reports of men exposing themselves in McKeldin—while Robert Lee Scott was in jail. By this time, the tale of the McKeldin Masturbator had entered oral tradition.[113] Complaining in "College Park Perversions," Maryland student and *Diamondback* columnist Daniel Kobrin writes:

> *Still, no discussion of the university's sordid past would be complete without mentioning the word "McKeldin." This fable of autoeroticism has been told countless times to infinite people. It has taken on a myriad of forms, but the common plot always stays the same: A man in either a trench coat or sweat suit runs around the stacks of McKeldin. His muscles and tendons pump furiously as he engages in an awkward dance of sprinting masturbation. Finally, at the moment of climax he greets an unsuspecting book or female patron with a nasty surprise. This shrouded villain has famously become known as "The McKeldin Masturbator," and he might be in a study carrel on the sixth floor right now because he's never been caught.*[114]

Since the last library incident, the shadowy figure diversified his performance platform, taking up residence on the University of Maryland's Shuttle UM bus system.[115] On February 5, 2007, as a young lady climbed onto the No. 8405 Greenbelt Bus in front of the Stamp Student Union, a second passenger boarded, following her to the back of the bus. The rider attempted to make small talk, but the young coed ignored him, gazing out the window instead. Half an hour into the trip, the victim looked over to see her fellow passenger treating his body like an amusement park. As the student struggled to comprehend what she had seen, and to alert the bus driver, the self-flagellator disembarked and fled down Greenbelt Road. Although the University of Maryland typically uses the acronym "UMD," the bus fleet took the name "Shuttle UM." The campus body christened the new deviant the "Shuttle UMasturbator."

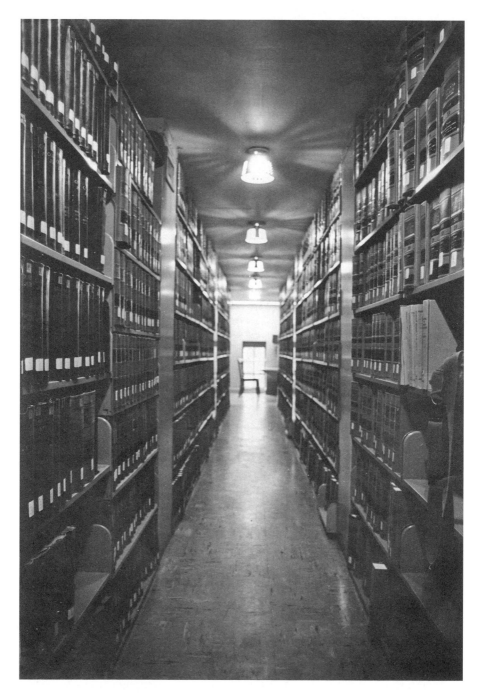

A place of learning and knowledge, the McKeldin Library's sheer size can make the lonely stacks eerie and forbidding. *Special Collections & University Archives, University of Maryland Libraries.*

On Wednesday, October 8, 2008, the McKeldin Masturbator struck again.[116] While in the reference stacks of the first floor, the assailant groped a female student and then began to play a jazz solo on his meat trombone in front of her. By the time the victim reported the incident to the front desk, the serial masturbator was on his way out the front door. Again, Robert Lee Scott could not be a suspect, as he was incarcerated at the time in the Prince George's County Correctional Center. The library's director of planning and administrative services, Jane Williams, went so far as to warn students not to study alone. The legend, crude as it may be, serves a purpose. The McKeldin Masturbator's frequent and sensational acts made him a University of Maryland legend. Although they may appear crass or celebratory, the legend and the nickname, in fact, serve a positive function, solidifying an abstract danger and warning students to be vigilant of a lurking campus threat.

Party Hard and You Shall Be Rewarded

In the early 2000s, another rumor made the rounds: *Playboy* had listed the University of Maryland as a top-ten party school. This rumor is found on many college campuses throughout the United States, becoming almost a badge of honor on campuses that cannot distinguish themselves in other ways.[117] Although *Playboy* did rank top party schools in January 1987, November 2002 and May 2006, the magazine did not start running the feature regularly until 2009, possibly in response to the popularity of the rumors.[118] In fact, Maryland *did* make the original 1987 list, although it came in a paltry twenty-first, beat out by insipid party schools such as the University of Virginia and Boston University. By 2002, Maryland was not even an honorable mention, and the university was left off the list entirely every year until 2013, when *Playboy* ranked Maryland the tenth-best party school in the nation.

Studying to Death

Also worth considering is the legend of Sara Bellum, a legend Richard Dorson would surely castigate as "fakelore."[119] Fakelore consists of literary creations

crafted to look and feel like folklore, while lacking the special qualities imbued in authentic folklore through community creation, maintenance and constant recreation. Instead, they are often the vision of a single artist. Nonetheless, fakelore can become interesting when it enters into oral tradition, regardless of its origins. Through its creation and propagation by a popular university professor, a plaque on Taliaferro Hall and a deadly exciting narrative, Sara Bellum has climbed the ranks from fakelore to nascent campus legend.[120]

On October 17, 1983, a midterm exam killed Sara Bellum. She had graduated from the prestigious Montgomery Blair High School in Silver Spring and had been voted "most likely to study" by her high school class. Sara entered the University of Maryland with the best intentions, intending to study hard and learn all she could. But things quickly changed when she got to campus. She became president of her floor in Centreville Hall. She rushed the selective Delta Delta Delta sorority. She shot the breeze with her roommates. She went to field hockey matches, football games and swimming matches. There just wasn't enough time to study!

The trouble started the night before Sara's first exam. She went to the library to study but was too distracted by all the other students not studying. She was too nervous to pore over her books and notes anyway. Feeling sick with dread, Sara slumped into Professor Sandy Mack's Introduction to Shakespeare midterm, praying for a miracle.[121] When she saw the first question, she knew none would come. Asked to compare two of Hamlet's four soliloquies, she began to sweat. Soon she was having a full-on panic attack. As Sara stood, she fainted, hitting her head hard on the back of a chair and then again on the floor.[122] Professor Mack sent for help, but it was too late. Sara was dead. Sitting alone in the classroom and reflecting on what had happened, Professor Mack noticed Sara's blue exam book still sitting on her desk. Curious, he opened it and found Sara's famous last words, the only words she had written: "I'd Rather Be Studying."

On Taliaferro Hall, where Sara Bellum is said to have died, an engraved plaque commemorates her final words. Sara Bellum, of course, is a play on "cerebellum," the part of the brain primarily responsible for controlling a human's motor skills. The legend was actually written by University of Maryland sociology professor Jon Pease in the 1980s as part of his "I'd Rather Be Studying" campaign—a contemporary of Nancy Reagan's heavy-handed "Just Say No" campaign of the same era. The legend would be more appropriately categorized as a literary fable (a story that teaches a moral) if it were not for the placard on Taliaferro Hall. The ambiguous signage has led to confusion on the campus, and many students believe

The site of Sara Bellum's legendary demise, Taliaferro Hall looks peaceful on a cold winter day. *Special Collections & University Archives, University of Maryland Libraries.*

that there really was a Sara Bellum and that she really did die in Taliaferro Hall. Overlooking the wordplay and hearing the legend in its oral form, it's not hard to believe. Students die on or just off the University of Maryland campus every year. But if slacking off was truly lethal, the American college campus would be a morbid place.

The beauty of folklore is its ability to connect a group to its past while simultaneously remaining relevant to the present. Many of these campus legends hearken to the past, but they are *of* the present. Although the legends are free to change, their themes will likely remain the same. The feeling of a connection to individuals from the past, the desire for good fortune during stressful endeavors, the maturation from childhood to adulthood and the need to balance a social life with an academic life are woven into the folklore of the campus. These legends flutter across the campus, connecting students to the college world and helping them navigate through it.

PART II

MARYLAND'S LEGENDARY CREATURES

LOYAL TO THE END

The Blue Dog of Port Tobacco

There is no faith which has never yet been broken, except that of a truly faithful dog.
—*Konrad Lorenz*

For where your treasure is, there will your heart be also.
—*Matthew 6:21*

The legend of the Blue Dog—which locals claim is Maryland's oldest—has been circulating in regional oral tradition for over two centuries and first appeared in print in a *Cosmopolitan* magazine article published in 1888.[123] The story originates in Port Tobacco, a town settled in the seventeenth century. By 1727, it had become a vibrant seaport off the Potomac River with access to the Chesapeake Bay and Atlantic Ocean, and for much of the early to mid-eighteenth century, it was home to Maryland's second-largest river port. Port Tobacco also served as the original county seat for Charles County. The Pennsylvania Railroad established a station in nearby La Plata by 1873, which bypassed Port Tobacco and ultimately contributed to a sharp decline in the town's population, prompting the county seat to be moved to La Plata in 1895. Port Tobacco was also a hotbed for Confederate sympathizers and spies during the Civil War and even served as part of John Wilkes Booth's escape route following the assassination of Abraham Lincoln. By 2010, the United States Census Bureau reported that thirteen people resided in Port Tobacco, making it the smallest incorporated town in the state.[124] Nevertheless, the town remains proud of its local lore and wealth of historic buildings (many

of which are cataloged in the National Register of Historic Places), and many Charles County children and adults frequently tell the legend of the Blue Dog. Oral versions of the tale contain numerous variations, but most carry several distinct and unifying themes that render the story both unique and local. The following is an amalgamated rendition of the legend as told by locals.

On a cold, moonless night in February, sometime after the American Revolutionary War, an out-of-town soldier named Charles Thomas Sims arrived at one of Port Tobacco's bustling seaport taverns, boasting to fellow patrons of his gold and deed to an estate. After several hours of drinking, Sims headed out of town on Rose Hill Road with his faithful dog—either a bluetick coonhound or English mastiff—alongside him.[125] But a local man named Henry Hanos, who had overheard Sims telling of his newfound riches, followed him down the quiet country road that evening. Beside a large rock, Hanos murdered Sims and his loyal canine companion, stole Sims's gold and buried the treasure beneath a holly tree before absconding into the night. The next night, upon returning to retrieve the gold and deed, Hanos was frightened off by a snarling phantom creature glowing with a blue sheen and red, penetrating eyes: the ghost of Charles Thomas Sims's dog. Soon after, Hanos fell ill and died under mysterious circumstances. Locals believe that the Blue Dog continues to guard his slain master's treasure near the large rock where he perished on Rose Hill Road, in the shadow of the picturesque Rose Hill Manor, a Georgian-style home on the National Register of Historic Places. Port Tobacco residents say they can still hear the dog howling in the night. On October 31st and especially on February 8th—the supposed anniversary of Sims's death—locals report the Blue Dog patrolling the site of his master's demise.[126]

As with many folk narratives, the details vary from account to account.[127] Some accounts describe Charles Thomas Sims as a peddler or thief or suggest he inherited or stole his treasure. Other versions indict a gang of highwaymen as Sims's killers instead of Henry Hanos. Some renditions suggest that merely encountering the Blue Dog is an omen for impending death.[128] Others say one must gaze into the dog's eyes, and still more claim that merely hearing his howl in the night is an indicator that someone has died. These variations add an additional layer of intrigue to the story while also serving as a deterrent to wayward thrill-seekers. But more explicitly, the legend serves as a dual warning against boastful and/or uncouth behavior and wanton greed. The allure of still extant treasure keeps the story alive, but the threatened presence of a spectral canine ensures that it will never be successfully retrieved. And so, the legend lives on.

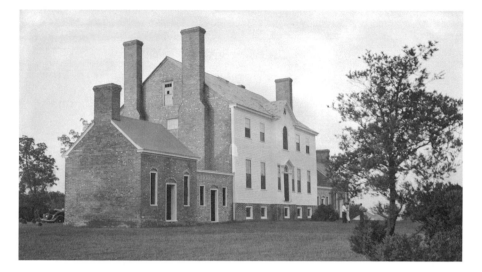

Rose Hill Manor, also known as the Dr. Gustavus Brown House, overlooks the fabled site of Charles Thomas Sims's murder at the hands of Henry Hanos. *Library of Congress, Prints and Photographs Division, Historic American Buildings Survey, 1937.*

Indeed, the tale has captured the imagination of Charles County residents as a key part of Port Tobacco's folklore. The fact that so many details vary in the telling of the narrative speaks to the legend's vibrant traditionality and clear representation of the hallmark of genuine folklore: repetition and variation.

FROM FAKELORE TO FOLKLORE

The Snallygaster of North Central Maryland

I believe in everything until it's disproved. So I believe in fairies, the myths, dragons. It all exists, even if it's in your mind. Who's to say that dreams and nightmares aren't as real as the here and now?
—*John Lennon*

Fairy tales are more than true: not because they tell us that dragons exist, but because they tell us that dragons can be beaten.
—*G.K. Chesterton*

On February 12, 1909, the *Middletown Valley Register* newspaper ran the headline "The Colored People Are in Great Danger." The story details the poor fate of Bill Gifferson, an African American man attacked by a gargantuan, flying beast. Swooping down and carrying him off to a hill, the creature used its razor-sharp bill to pierce Gifferson's neck and drink his blood. A witness described the monster as having a tremendous wingspan, steel-like claws, a single eye in the middle of its head and a horrific, deafening screech. The article claimed the nocturnal, "vampire-devil" only feasted on African Americans, preferring "colored men to colored women."[129] The newspaper reassured the populace that the federal government had dispatched troops to confront the winged menace, and research scientists at the Smithsonian Institution asked that it be captured alive. President Theodore Roosevelt was reportedly so enamored with these accounts that he considered rescheduling an African safari to trek to

Maryland and hunt the beast himself.[130] The *Register* prefaced the Gifferson story with a letter from T.C. Harbaugh of Casstown, Ohio, penned three days earlier. Harbaugh had also seen a "gigantic monster" with a horned head, bronze-like objects for wings, a twenty-foot tail and an awful screech. Identifying the leviathan as a "Snallygaster," he ominously warned the creature was headed toward Maryland.

Between the initial February 1909 dispatch and July 1909, the *Middletown Valley Register* published Snallygaster sightings from nearby West Virginia to Cumberland in Allegheny County and from the outskirts of Carroll County to towns throughout Washington and Frederick Counties. The flying behemoth sucked whole bodies of water dry and harassed witnesses; firearms did not faze it. Other local papers carried the *Register*'s story, offering new, exotic factoids, such as the Snallygaster's hide being worth $100,000 per square foot because it was "the only thing known that will properly polish punkle shells [a fictional item] used by Africans of Umbopeland [a fictional nation] for ornaments."[131] Consequently, scientists and naturalists labored feverishly to locate the beast's lair. Further reports claimed the Snallygaster had laid a yellowish, barrel-sized egg somewhere around Gathland State Park or out near Sharpsburg. An intrepid search party set out to find and incubate the egg. The last perilous encounter with the feathered monstrosity occurred on March 5, 1909, at the Emmitsburg train station. Three men fought a fire-breathing Snallygaster for nearly an hour and a half after catching it pilfering coal. By July 1909, the sightings had ceased.

Twenty-three years later, on November 11, 1932, Marylanders spotted a mammoth winged creature near South Mountain—but the description seemed different from the Snallygaster chronicled in 1909: this reptilian bird had octopus-like tentacles and the ability to change color and size. Two men from Braddock Heights confirmed the features of the soaring colossus in a November 25, 1932 article in the *Middletown Valley Register*. Scientists suspected the "Bovulopus" was the hatched offspring of the earlier-reported egg. After all, the average lifespan of the species was twenty-five years, and its eggs took twenty to twenty-five years to hatch.[132] Unlike its parent, this incarnation of the Snallygaster terrorized indiscriminately while developing an appetite for poultry, children and even moonshine. In fact, a taste for the white lightning led to the Snallygaster's ultimate demise.

On December 2, 1932, the *Register* reported the Snallygaster flew over Frog Hollow in Washington County, lured by the intoxicating aroma of 2,500 gallons of illicit hooch. Swooping close to the vat, the beast became overwhelmed by the fumes and crashed into the boiling mash. The still's

bootleggers immediately scattered across state lines. Soon after, Hagerstown prohibition officer George T. Danforth and sheriff's deputy Charles E. Cushwa arrived to investigate the illegal moonshine operation. They were shocked to find an abandoned distillery and the scorched skeletal remains of the Snallygaster still bubbling in the pit, its skin completely corroded from the bootleggers' apparent overuse of lye in the mash. Danforth and Cushwa placed five hundred pounds of dynamite under the vat, lit the fuse and blew the Snallygaster and the confiscated booze to smithereens.

Even with the Snallygaster's explosive departure in December 1932, the fiendish brute continued to leave a mark on the psyche of Marylanders throughout the north central part of the state. Local newspapers ran stories drawn from the Snallygaster mythos well into the early 1950s.[133] For example, on the same day that the *Roswell Daily Record* (New Mexico) newspaper famously announced the capture of a "flying saucer," July 8, 1947, the *Baltimore Sun* yawned at the notion in the editorial "Flying Saucers Pretty Tame Beside Flying Snallygaster."[134] Two years later, a *Baltimore Sun* writer commented on a rash of livestock mutilations in Baltimore County by invoking the notorious creature in the article "Could It Have Been a Snallygaster?" The brief piece is an exercise in speculative deliberation, pondering the identity of a mysterious "varmint" that took the tail off of a cow near Gunpowder Falls and left behind tracks described as "having a center pad the size of the mouth of a water tumbler with claw marks extending out."[135]

By the early 1950s and into the 1960s, Snallygaster sightings posted in regional newspapers revealed a new physical description, likening it to an enormous, deformed bear or gorilla. Instead of flying, it walked on two feet and was known to attack dogs and farm animals. Some suggested the creature was a cousin or twin of the more dragon-like Snallygaster or that it was perhaps the beast's long-awaited hatchling from 1932. More puzzling, these new sightings did not typically occur in established Snallygaster haunts. Instead, Elkton in Cecil County, Rockville in Montgomery County and, by the 1960s, *especially* Sykesville in Carroll County played host. Folk conceptualizations of the Snallygaster began to fuse with emergent legends of the Dwayyo (profiled more extensively in the next chapter), another supposed hatchling from a Snallygaster egg.[136] Returning at the same time as the Bigfoot craze of the late 1960s,[137] the Snallygaster evolved in public consciousness to embody the contextual bogeyman of the day.[138] By the mid-1970s, the Snallygaster essentially faded away, appearing only in nostalgic retreads.[139]

Scene and Incident of Snallygaster's Reign

Courtesy Baltimore Post.

valopus Dies By ame Hand Which Caused Existence

(Continued from Page 1.)

forth, in charge of the Hagers-
prohibition office, accompanied by
t Charles E. Cushwa, who had re-
d information concerning the big
shine plant, arrived in Frog Hol-
Thursday morning, and much to
surprise, they found the plant
doned. But imagine their feelings
their eyes feasted on the monster
erged in the liquor vat. With a
ng of trepidation the two men
iously made their way to the vat
were greatly relieved to find the
ster cold in death.
hasty examination by the two
ts revealed that the mash had
a practically all the flesh from the
ster, only the skeleton of the beast
ining. This, it is explained, was
ed by a large amount of lye which

Edward M. L. Lighter. Charles F. Mai

Let us whisper it girls, but the man
who writes the best love letters doesn't
necessarily make the best husband.

READING NOTICES.

Card of Thanks.

Wé wish to extend our sincere thanks
to neighbors and friends for the many

northwest of Myersville,
conveyed unto the said Joh
by deed from Cyrus F. Floo
bearing date the 2d day of
1909, and recorded in Libe
302, Folio 58, one of the La
of Frederick County, said
containing 105 acres of lar
less, being the main port
farm.

Headline of the *Middletown Valley Register* on December 2, 1932. *Middletown Valley Historical
Society Microfilm Collection, Maryland Room, C. Burr Artz Public Library, Frederick County Public
Libraries.*

In truth, the 1909 reports of the Snallygaster were part of a whimsical hoax crafted by *Middletown Valley Register* reporter Ralph S. Wolfe and editor George C. Rhoderick in an effort to increase readership for their regional publication. Thomas Chalmers "T.C." Harbaugh, the Ohio man who first warned the Snallygaster was headed toward Maryland, was born in Middletown in 1849 and worked as a writer under several pseudonyms. Harbaugh lived in Casstown, Ohio, but made annual visits to Middletown; maintained an interest in the area (even writing a book about it); and was best friends with none other than *Register* editor George C. Rhoderick.[140] In addition to attracting greater attention for the newspaper, the Snallygaster sightings also coincided with contentious political battles of the day, possibly serving as a metaphor for more complex matters. For instance, the Straus Amendment to the Maryland Constitution, proposed by state Democrats in 1909, sought to disenfranchise (and thus solely threaten) African American voters—much like the Snallygaster.[141] Three days after Democrat Franklin Delano Roosevelt's landslide victory in the November 1932 election, the Republican *Middletown Valley Register* printed another Snallygaster sighting, relaying an unidentified witness's explicit belief that "the beast was an omen of ill for colored voters who deserted the Republican party…and voted for Roosevelt."[142] And in December 1932, less than one year before newly elected president Roosevelt made good on his campaign promise to effectively end Prohibition, the Snallygaster perished at the hands of illegal moonshine, a victim of its evil allure.

As for the origins of the beast itself, Wolfe and Rhoderick borrowed themes and tales from existing mid-Atlantic folklore. The word "Snallygaster" derives from *snollygoster*, a moniker ascribed to politicians guided by personal advantage rather than respectable principles (a correlation that further suggests the *Middletown Valley Register*'s metaphorical intentions in its initial reports). The word snollygoster is itself a bastardization of the German *schnelle geister*, meaning "quick spirits," a type of ghost found in German folklore. Like the neighboring Pennsylvania Dutch, German immigrants settled heavily around the area that became Frederick County, Maryland.[143] By extension, the motifs of German folklore—some of which include encounters with dragon-like creatures or the snatching of children and livestock—greatly influenced regional folk narratives and provided an excellent starting point for imaginative expansion.

Perhaps the most direct inspiration behind the *Register*'s February 12, 1909 Snallygaster story came three weeks earlier. From January 16 through 23, New Jersey newspapers widely reported a flying, red-eyed

The characteristics of the Snallygaster were well known in preexisting German folklore traditions, as demonstrated by the creatures appearing in Friedrich Justin Bertuch's *Bilderbuch für Kinder* (1790–1830, 12 vols.).

beast tormenting state residents. Like Maryland's Snallygaster, bullets and physical attacks had no effect.[144] Considering the geographical proximity of Maryland and New Jersey and the sensationalist approaches of early twentieth-century journalism, the fabricated stories about the Snallygaster were likely launched from the momentum of these tantalizing monster tales and adapted to incorporate the familiar motifs of German folk narratives and beliefs to better endear the creature with its Frederick County audience.

The legend of the Snallygaster falls squarely within the realm of what folklorists call fakelore.[145] Distinguished folklorist Richard M. Dorson coined the term in 1950 to describe "the presentation of spurious and synthetic writings under the claim that they are genuine folklore,"[146] further clarifying that the "essence of the concept of fakelore is the assertion by hucksters that the sentimentalized product they are offering a gullible public is genuine folklore."[147] The *Middletown Valley Register*'s various publications about the

Snallygaster relied on the newspaper's institutional authority to convey an aura of truth to its readers, duping them into believing that a dangerous, exotic creature lived right in their backyards. And while some readers caught on to the gag, many did not. Moreover, other area newspapers syndicated the *Register*'s stories, lending further credence to the hoax. As a result of these hijinks, north central Marylanders still tell stories about the beastly cryptid that roams the hills every twenty-some years. These tales are not the products of traditional narratives or authentic folk culture; they are Ralph S. Wolfe and George C. Rhoderick's literary creations, fakelore disseminated to increase profit. The impetus behind the Snallygaster's creation was ultimately manipulative and self-serving.[148]

Hoax or not, the Snallygaster struck a chord with Marylanders even after it left the front page. The enduring legacy provided the framework for new oral traditions about the Snallygaster in the 1980s and '90s. Families throughout Montgomery, Frederick, Washington and Carroll Counties continue to invoke the Snallygaster as a lighthearted warning for children to be home by dark or as a playful threat that it will "get" those who do not go to bed on time. Farmers occasionally blame the fabled creature for missing livestock. Regardless of origin or veracity, the Snallygaster holds *meaning* for Marylanders—its fundamental intangibility appeals to the imagination; its romantic, unknowable qualities enliven narratives. The integration of German folklore traditions further perpetuates the legendary creature's place in north central Maryland. Rising from the bowels of fakelore, the Snallygaster has been embraced as the region's bogeyman of choice—perhaps its most transformative evolution to date.

A DOG HAS ITS DAY

The Dwayyo of Gambrill State Park

*As she was going through the woods, she met with a wolf, who had a very great mind to
eat her up, but he dared not, because of some woodcutters working nearby in the forest.*
—Charles Perrault, "Little Red Riding Hood"

*And a jolly ho, ho, ho.
For Rudolph has the virus,
A cold in his bright red nose.
So please don't hurt the Dwayyo,
Tell everyone you know,
That Santa needs his help this year,
Cause it doesn't look like snow.
Now the Dwayyo is a puppy,
That grew and grew and grew.
And like poor little Rudolph,
His friends are very few.
But Santa is the kindest one,
And knew that they were sad.
Now the Dwayyo is the newest friend,
So let us all be glad.*
—*anonymous*, Frederick Post, *December 16, 1965*

Frederick County has a long history of strange beasts roaming the countryside.
As far back as 1882, Madeleine Vinton Dahlgren documented the Snarly

Yow and the Dog Fiend in *South Mountain Magic*.[149] The Snallygaster ravaged the *Middletown Valley Register* in 1909 and again in 1932.[150] Folklorists Annie Weston Whitney and Caroline Canfield Bullock reported on the Phantom Dog, the White Lady and the Headless Horseman in *Folk-Lore from Maryland* in 1925.[151] And writer Mark Opsasnick, among others, has been tracking Bigfoot in Frederick and other parts of the state for decades.[152] Although not as well known as the Snallygaster or Goatman, the Dwayyo is a legendary creature with a life in both print and oral tradition, and credible sightings flourished long after initial newspaper excitement died down.

In the 1980s, Frederick residents Richard and Debbie Kettles bowled every Thursday. The parents of two young boys, after bowling, the Kettleses would trek to "the Corral" at Gambrill State Park for secluded sex. A hopping party destination on weekends, the Corral was empty on Thursday nights. After one White Russian-fueled romp in the back of their Ford Bronco, the couple stepped away from the car to relieve themselves and freshen up. Bathed in the darkness of the surrounding forest, the Bronco's headlights lit their way. As Debbie squatted to urinate, the headlights illuminated a figure twenty yards away, staring at her. Seven feet tall, brown and hairy, it stood on short hind legs. At the top of its long, hairy torso, it had a doglike face and pointy ears. Debbie was staring at the Dwayyo; the Dwayyo was staring back. A noise in the distance broke their gaze. As the creature turned to look, Debbie caught a glimpse of a long snout and a bushy tail. "*Run*, Richard!" she screamed. "Run for your life!"

On his own and oblivious to the stalking creature, Richard ignored Debbie's cries and made no effort to return to the car. Jumping behind the wheel, Debbie gunned the engine and tore out of the Corral, leaving a naked and now frightened Richard running behind her. Still nude, the couple raced home to tell their boys what they had seen. The next day, Debbie called the *Frederick News-Post*. But by the time the reporter returned her call, some of the excitement had abated. Others who had reported seeing strange creatures in Gambrill State Park were only belittled for sharing. Debbie realized the danger of going on record with what she had seen. At best, she would be the community laughingstock. At worst, neighbors would question her sanity and sobriety. Although the *Frederick News-Post* pursued the story doggedly, Debbie remained firm in her resolve to keep it to herself. While never hesitant to delight family and friends with the account, this is the first time Debbie has allowed it to appear in print.[153] As of this publication, the Kettleses' encounter is the last known Dwayyo sighting, bookending a trail that dates back to at least the end of 1965.

George May of the *Frederick News-Post*[154] introduced the Dwayyo to the general public on November 30, 1965, in an article titled "Unknown Animal Battled by Anonymous Gladiator."[155] John Becker told the *News-Post* and Maryland State Police that on Saturday, November 27, 1965, in the backyard of his Fern Rock Road home, he was attacked by a black, "six feet tall" monster with "feet like a dog" and "a big, bushy tail." With his wife and children watching, Becker battled the beast until it fled back into the woods. Not knowing what else to call it, Becker labeled the creature a "Dwayyo."

Although the story received front-page treatment for the next half month, the skepticism came immediately. Sergeant Clyde B. Tucker of the Maryland State Police told the *News-Post* that not only did he not believe there was a Dwayyo, he also didn't believe there was a John Becker or a Fern Rock Road.[156] The state troopers had been unable to positively identify either. But the police did take the report as a precaution. Community reactions began in May's sensationally titled article, "'Dwayyo' Monster Is Still Running Loose," with the subtitle "Boy Sees Them 'Everywhere.'"[157] Since the initial report, residents had begun to worry, calling the newspaper and the police to inquire about the veracity of the story. One man called in asking, "Is this really true? I'm concerned thinking this monster could be roaming around loose in Frederick County." A Point of Rocks woman called to inquire, "Is this thing still loose? I was planning a trip to Frederick, but if that thing is still loose, I'm not leaving home." Other Fredericktonians brushed off the reports, speculating that John Becker had "been getting into the holiday 'spirits' a little too soon" and "hitting the bottle more than anything else."[158]

One Frederick hunter, on the other hand, was willing to give Becker the benefit of the doubt. The news reports made him rethink what he had seen recently in the woods around Middletown. On a hunting trip in the area, his dogs gave chase to something in the woods. "I saw it was black," the hunter remembered, "but I didn't think too much of it, believing it was a dog or maybe even a bear."[159] But after reading George May's *News-Post* article, he wasn't sure that it *wasn't* a Dwayyo. For one, he remembered the mysterious black beast trotted like a horse, not a dog or a bear. Rather than avoid the area, as some of the other interviewees claimed they would do, the intrepid huntsman planned to go search for the Dwayyo that week. Perhaps the most intriguing part of the entire article was *Frederick News-Post* artist Ed Mulls's composite sketch of what the Dwayyo may look like, placed centrally on the front page of the day's newspaper. The witness referenced in the headline who had seen Dwayyos "everywhere" turned out to be four years old.[160]

Boy Sees Them 'Everywhere'

'Dwayyo' Monster Is Still Running Loose

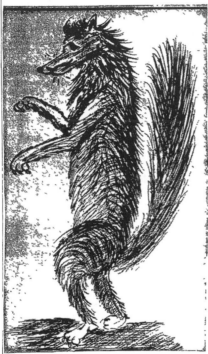

THE DWAYYO—This sketch by News-Post artist Ed Mull shows what the mysterious Dwayyo beast may look like. The monster is described as being six feet tall, black, has feet like a dog. and a big, bushy tail A man has reported seeing and fighting a Dwayyo in Frederick County.

By GEORGE MAY
Staff Writer

The mysterious Dwayyo is apparently still roaming loose over the hills and valleys of Frederick County.

Or at least the six - foot tall monster with the big bushy tail is in the minds of many of this county's residents

Since the first story about the Dwayyo appeared in Monday's paper, the rangy, black beast has been sighted by a hunter.

The Dwayyo, which no one seems to know anything about, came to light in a recent story

from a man identified as John Becker who said he fought the Dwayyo in his backyard

State Police have not been able to find a John Becker in Frederick County or a Fern Rock Road, the address given by Becker.

Since the story of the Dwayyo appeared. some residents of the area have become alarmed

"Is this really true?" a man asked on the telephone "I'm concerned, thinking this mon ster could be roaming around loose in Frederick County," he added.

A Frederick man, obviously not worried about a Dwayyo, said "I think the person who called that story in must have been getting into the holiday 'spirits' a little too soon.

A Buckeystown man was in agreement with another man questioned when he said; "Seems to me that the Becker man who said he fought the animal must have been hitting the bottle more than anything else."

Another Frederick man, asked about the Dwayyo, said, "Yeah, I heard about the Dwayyo. It reminds me of the snallygaster I used to hear about."

For those not in the know, a snallygaster is said to be a my-thical nocturnal creature, half reptile and half bird w h i c h preys on children and poultry. The snallygaster is thought to have originated in Middletown Valley

A Point of Rocks woman called the local state police several nights ago and asked. "Is the thing still loose? I was planning a trip to Frederick, but if that thing is still loose I'm not leaving home."

Another Frederick man call-ed the paper and said that while hunting around Middletown he thought he might have seen a Dwayyo

"My dogs started chasing something. and I saw it was black, but I didn't think too much of it, believing it was a dog or maybe even a bear," the man said.

"However, after reading the newspaper article. I'm not too sure it wasn't a Dwayyo. It

I don't know what it was, but I'm going looking for it this week."

A Mountaindale woman said she knows there is no such thing as a Dwayyo, but enjoyed the story.

A four - year - old Frederick boy said he knows there is such a thing. "I've seen lots of them," the youngster said.

When asked where, the boy looked around and with a sweep-ing motion of his arm said "everywhere."

Gordon L. Culler Serving In Delaware

Airman 3C. Gordon L. Culler has been graduated at Ama-rillo AFB, Tex., from the train-ing course for U.S. Air Force inventory specialists.

Airman Culler, son of Mr. and Mrs. Gordon L. Culler, RFD 4, Frederick, is a graduate of Fred-erick High School He is being reassigned to Dover AFB, Del, for duty with the Military Air Transport Service.

Based on reported sightings, Ed Mull drew a composite sketch of the Dwayyo for the *Frederick News-Post*. Reprinted with permission of the *Frederick News-Post* and Randall family, LLC, as published on December 2, 1965. *Microfilm Collection, Maryland Room, C. Burr Artz Public Library, Frederick County Public Libraries.*

Around 9:00 p.m. on December 1, 1965, the Frederick Police Department responded to a report of a Dwayyo locked in a house on Airport Road.[161] The caller claimed he had captured the beast a year ago and had been holding it in his basement ever since. "It looks like the picture in the paper," the man said, referencing Ed Mulls's sketch, except his was a baby Dwayyo, only two feet tall. When police arrived at the address on Airport Road, they found no Dwayyos, only a confused man who had not called the police. If the Dwayyo was a hoax, it was inspiring more pranksters.

A South Mountain woman called the *Frederick News-Post* to report that she and her neighbors had been hearing the Dwayyo for a while: "It cried like a baby and then screamed like a woman for months," the woman told the *News-Post* staff. "My husband tried to look for footprints, but none could be found."[162] Others theorized the Dwayyo was a bear, possibly the same one that had frightened a couple near Gambrill State Park earlier in 1965. Another man assured readers that his Middletown in-laws had seen the Dwayyo, and it was just a big dog.[163] Since there had not been much consensus on what the Dwayyo actually *was*, many individuals were certain they had seen it.

The story received a new level of intrigue, and perhaps credibility, when a man called the paper to confirm the existence of Fern Rock Road. Although the man did not know "John Becker," he had been on the little-known, small dirt road near the entrance to Gambrill State Park. By December 4th, writer George May had made the inevitable connection: "'Dwayyo' Could be a Modern Snallygaster."[164] But the description between the creatures couldn't be more conflicting: a flying reptilian bird and a woods-dwelling wolf-man. Still, the connection is more complex than the two sharing a species. A Burkittsville man told May that "the Snallygaster lays eggs which hatch every 20 years," referencing the Snallygaster reports that surfaced in 1909 and 1932, also taking place around the Middletown Valley.[165] By the Burkittsville man's calculations, the Snallygaster's "eggs should be hatching right about now." Although the Dwayyo's appearance would seem closer to Bigfoot or a werewolf (and there's no explanation why a Snallygaster would lay Dwayyo eggs), the suspected connection between the Snallygaster and Dwayyo has lasted in oral tradition to the present day.

On December 7, 1965, the *News-Post* received a letter from the mysterious "John Becker." At least, the note was signed by John Becker, although it was postmarked from Jefferson, Maryland. The letter explained that the Maryland State Police could not locate a "John Becker" because "John Becker" was not the author's real name. He chose to use a pseudonym

because he preferred to remain anonymous. Assuring all Fredericktonians that he was telling the truth and that he could offer his wife and children as witnesses, "Becker" repeated his description of the creature "as big as a bear" with "long black hair" that "growled like a wolf or dog in anger." Afraid the beast would attack again, Becker proposed "a search party organized to hunt this creature and destroy it before it really hurts someone."[166]

On the same day, George May reported that Frederick Community College and Frederick High School students were planning the first official Dwayyo hunt, garnering up to one hundred participants to sign up in advance.[167] Frederick Community College president Duval W. Sweadner went on record to say he thought the Dwayyo hunt was a hoax, as there was a day scheduled but no time or place. One prospective hunter said, "I don't know anything about it, except I'm planning on being there Wednesday night."[168] Although many signed up, only a handful of nimrods arrived at Frederick High School at 5:00 p.m. to begin the hunt. One Frederick man did report seeing a pickup truck full of boys wearing helmets and swinging machetes driving down West Seventh Street, making a racket and possibly hunting Dwayyos.[169]

George May's final report came on December 16, 1965.[170] The Dwayyo had not been seen for several days, and the excitement seemed to have ebbed. While there is no indication that he fabricated the reports, May did not take them particularly seriously either. He seemed content to publicize the Dwayyo happenings, while also basking in jokes, inexpert witnesses and alternative theories. Almost instantly, the Dwayyo had become a comic creature.[171]

Many other cultures have a fearsome pantheon of devilish creatures. The fairies in Ireland, the jinn in the Middle East and the kappas in Japan are but a few. But folklorist Richard Dorson notes that no similar tradition exists in the United States. Instead, "we yarn about, identify with, hunt for, depict, extol, and chuckle over these critters. Belief and dread are not wholly absent, but in contrast to the rest of the world, we engage in hoaxes, pranks, tall tales, and tomfoolery with our legendary creatures."[172] Although reported as conceivably true, fear never trumped humor in the Dwayyo news stories. Not wanting to risk his standing as a professional journalist, George May was sure to add humor or ridiculousness to each of his articles, never writing the reports dry. For example, he began his first article with the riddle: "What is about six feet tall, has feet like a dog, a big bushy tail, and is black?" He ended by mocking the United States–Soviet tensions at the time, saying no one knows if there is a Dwayyo, but if there is, "as soon as the Russians hear

about it they will claim they had it first."[173] In addition, May gave plenty of time—two quotes from two different sources—to the idea that John Becker was a drunk.[174] Recall that May even gave the final word in his December 1 article to a four-year-old boy who provided the inexpert witness testimony that he'd "seen lots of them… everywhere." May left space for amateur debunkers, such as the letter he received from a couple of eleven-year-old amateur detectives from Myersville who had done "research" and concluded the Dwayyo was a rabid Irish wolfhound.[175] And he quoted yet another child who told the paper he believed the Dwayyo was a story created by adults to convince children to behave before Christmas.[176] Furthermore, after leading his final article with "all I want for Christmas is a Dwayyo," May reported on the Dwayyo's new dog tags, made out in the name of John Becker and sent to the *News-Post* office. The Dwayyo news cycle ends comically with an anonymous bard's ode to the Dwayyo.[177] A creature that frightened Frederick residents for a few weeks had become another confirmed American comic creature.[178] After George May's final column, the *Frederick News-Post* went silent on the Dwayyo. Since December 1965, the mythic creature has continued to live in books, oral tradition and personal experience narratives like the one shared by Debbie Kettles.

A purist may discount legends perpetuated by newspapers as inauthentic, but since at least the 1970s, folklorists have been paying close attention to the interplay of folklore and newspapers. Commenting on the phenomenon, renowned legend scholars Linda Dégh and Andrew Vázsonyi assert: "It is not enough to acknowledge that mass media has a 'role' in modern legend-transmission. It is closer to the truth that the mass media are part of folklore—maybe the greater part."[179] Although a legend will always circulate "part of its way—presumably the lesser—on foot," Dégh and Vázsonyi point out that "the longer trail" is often "through the speedy modern vehicle" of the mass media.[180] Folklorist Paul Smith agrees, stating that "outside of the oral tradition, the major disseminators of contemporary legend are the news gathering agencies—i.e., newspapers, magazines, radio and television. Of these four institutions, possibly newspapers are the largest carriers of contemporary legends."[181] The Dwayyo was not a literary creation, as the first reports came from a police-documented source. But the legend was reliant on newspapers for its early circulation, and the way George May chose to run the story shaped the future of the oral tradition. More complex than a folk legend or a literary legend, the Dwayyo is a popular legend—a type of legend that thrives on the combination of print sources *and* oral tradition.[182] Accordingly, there seems to be no printed antecedent to the name

"Dwayyo." At the same time, we can be sure of the importance of text in the life of this legend. For example, the stability of the double "y" spelling would not last in a purely oral tradition, where the strange, otherwise-unknown word could be spelled in any number of ways.

Although the Dwayyo undoubtedly helped to sell newspapers, perhaps there is a deeper reason Americans are drawn to these types of stories. Folklorist Alan Dundes, never afraid to make a controversial interpretation, believed that our "ongoing searches for sea serpents or Bigfoot… [are] a reflection of our romantic search for escape from the overly scientific world in which we live."[183] While "scientific attempts to verify the existence of sea serpents or of Bigfoot creatures never quite succeed," Dundes speculates that "perhaps that is the point"—the romance of the unknown and the still-to-be-found on the American landscape is what draws us toward these types of legends.[184] In a world perceived as overly rationalistic, folk creatures like the Dwayyo live physically and intellectually outside the bounds of modern man.

CHAPTER 11
GETTING MARYLAND'S GOAT

The Goatman of Prince George's County

Even from classical times the goat has occupied a curious place in our most basic perceptions…The goat quickly came to represent beastliness in which the "beast without" "the dangerous other," quickly became "the beast within." From the earliest phase of our cultural heritage the goat, creature of mountain and forest, has been associated with fear of peripheries: woods and forests.
—*David Siddle*

And he shall lay his hand upon the head of the goat, and kill it in the place where they kill the burnt offering before the LORD: it is a sin offering.
—*Leviticus 4:24*

The Goatman of Prince George's County is another of Maryland's great uncanny cryptids.[185] A number of researchers have written about Goatman.[186] For our purposes, rather than question Goatman's veracity, we hope to identify key moments in the life of the Goatman legend and trace its diffusion and localization across Prince George's County. In this chapter, we follow the archival and newspaper sources that brought a local legend to the front of the state's canon. The Goatman legend is another example of a popular legend—a legend that's not exclusively oral nor purely literary. Instead, it spreads due to the dynamism between the two.

When twenty-one-year-old George Lizama turned in his "Introduction to Folklore" final project to Professor Gladys-Marie Fry on May 18, 1971, the University of Maryland upperclassman didn't know the effect his research

would have on the future of Maryland's Goatman legend. His lighthearted approach carried through to his final sentence: "In summary I found the project interesting to do and hard as $$%?/ to type." This typo-ridden paper was the catalyst to a series of events that put Goatman into Prince George's County oral tradition.[187] For his final project, Lizama investigated "The Goatman of Tucker Road." He collected eight Goatman legends, seven of one type. Lizama considered the following version of the legend, collected from eighteen-year-old Patricia Isidro, as representative of "the most common during my interviews":

> *Yes I've heard of the Goatman. Of course he died a long time ago. He was killed in a fire and burned to crisp* [sic]. *I'll tell you what I know. Tucker Road is a long tree laden road that is very, very narrow. A lot of the kids go out there to park and I think that's how the legend got started. It seems there lived an old man who had the face of a goat and the body of a man. At the time of a full moon he would come out onto the bridge to ward off people, because it was his bridge. He always had a kind of wicked grin on his faced* [sic] *and called out like a real goat would. I've heard where cars have gone off the road because of the Goatman and that a few people a couple of years back were even killed and no trace of them was found.*
>
> *Kids say that he always carries bricks and that lots of cars have come off the bridge with busted windshields and the strangest thing is that not a sound was heard of bricks hitting glass or the shattering of glass. He only comes out at night and when the moon is bright. People say that he used to be a goat herder and that after all his goats died he almost turned into one. Some of my friends say they saw his eyes glowing at them at one time or another, but no one has really seen him.*

Seven of Lizama's eight legends shared multiple motifs. Each included most, although not necessarily all, of the following: 1) The Goatman is an old hermit with the head of a man and the body of a goat *or* the body of a man and the head of a goat 2) who lives in a shack near a one-lane bridge on Tucker Road—a dark, narrow, treacherous road. 3) He may have been a goat herder in the past. 4) During one of the moon's liminal moments (e.g., full, eclipsed), 5) "baaing" like a goat, 6) he stands at the bridge and 7) throws bricks (or occasionally rocks) at passing cars. 8) He has damaged many cars and even driven a few off the bridge. 9) The Goatman may have been killed when some children set fire to his shack, and 10) the legend-teller has never seen him but knows people who have.

In Francisco Goya's *Witches' Sabbath*, the devil, in the form of a goat, initiates an infant into the coven. *Museum of Lázaro Galdiano.*

Lizama's eighth version differs from the rest. Twenty-year-old Josiah Proctor of Clinton, Maryland, lived closer to the legend location than any of Lizama's other informants. According to Proctor, the Goatman was a self-sustaining, old, black hermit with a long, white beard living in a little hut down by a bridge:

The Greek god of wild fields and groves, Pan lords over the satyrs and the nymphs as a half-man, half-goat. *Library of Congress, Prints and Photographs Division.*

Yes I've heard of the Goatman from time to time. You know that the road isn't very far from here. The legend is only partly a story[;] some of it is true. There really is a Goatman of Tucker Road. He is an old man, an old black man with a real long white beard-like a goat. He's a hermit who lives by the bridge in a little shanty. He grows all his food and hunts for his meat and in order to do so must cross the narrow bridge from time to time.

This is probably when everyone sees him and as they pass he smiles and then everyone in the car gets bent-out-of-shape and goes around screaming Goatman. I've gone down the road and never met up with him, but relatives have and they're all still alive.

Lizama donated his hastily typed but valuable project to the Maryland Folklore Archives. It would have fallen into obscurity like many of the other donations if it were not for an eager reporter looking for an eye-catching Halloween story. The *Prince George's County News*'s Karen Hosler visited the Maryland Folklore Archives—at the time merely a few University of Maryland filing cabinets. On October 27, 1971, Hosler announced, "University Archives Reveal: Boaman, Goatman, and Ghosts Still Haunt Area."[188] Despite the archived Goatman paper's placement of the legend on Tucker Road in Clinton, Maryland—Lizama's is the only Goatman collection at this date—Hosler chose to place the legend on Fletchertown Road in the larger Bowie, Maryland:

The woods around Fletchertown Road have other strange inhabitants, folklore records indicate. One is a Goatman, half-man, half-goat who supposedly once was a researcher at the Beltsville Agricultural Farm. The story goes that the man experimented on goats. One day he went insane and ran into the woods. He grew all his hair until it covered his body…other accounts say he lives in an old shack and beats upon parked cars with an axe.[189]

This is not to say Hosler fabricated the account. The legend almost certainly existed in both locations, but giving newspaper ink to Bowie encouraged ostension to begin in that location. This artistic decision— one word and about twenty-three miles—influenced the future of the Goatman legend. The detail that Goatman is possibly a product of the "Beltsville Agricultural Farm" (Beltsville Agricultural Research Center) also remained important.

Less than two weeks after her first story, Karen Hosler reported again. This time, the headline read "Residents Fear Goatman Lives: Dog Found Decapitated in Old Bowie."[190] The night of Wednesday, November 3, 1971, sixteen-year-old Old Bowie resident April Edward heard strange noises in her backyard on the edge of the woods. She, John Hayden and Willie Gheen reported seeing "an animal…six-foot, something like that, and hairy, like an animal…it was on two feet," adding, "I remember it made a high-

pitched sound, like a squeal."[191] The following morning, Edwards found her ten-month-old puppy, Ginger, missing. Baseball bats in hand, Hayden and Gheen set out to investigate. When they reached the Penn Central Railroad tracks, they found Ginger's severed head. Several yards away, they found the rest of her body.[192]

This grisly story sent an electric wave of excitement through Bowie's teenagers, as documented by University of Maryland student Clay Schofield in 1972.[193] A sign of the media's influence, Schofield found teenagers who had "heard" of the Goatman but almost none who actually knew the legend. In Carl von Sydow's terms, the newspaper was the "active tradition carrier," and Schofield was encountering the community's "passive tradition carriers."[194] The closest Schofield found is a rendition of the ubiquitous contemporary legend, "The Boyfriend's Death,"[195] with a "half-man, half-goat" as the antagonist, a common conflation among non-Tucker Road legend tellers. Although there were minor references to the Goatman harassing teenage couples, "The Goatman of Tucker Road" is distinct from "The Boyfriend's Death." Teenagers cruised Tucker Road, but its narrowness and lack of a shoulder made it difficult to park there.[196]

Prior to Hosler's report, the Goatman legend in the Bowie area may have been "an old one that periodically dies down, then revives," likely related more to local hermits than its contemporary variation.[197] Although it is uncertain, evidence suggests the legend was not as prevalent as residents would later claim. Informants who remember the legend "as one of the most popular long-standing legends in our town" are likely overestimating the tenure and strength of the legend prior to the newspaper articles of 1971.[198] For instance, Maryland folklorist George Carey just happened to publish a book about the state's legends shortly before Hosler's reports went to press.[199] Carey covers a wide range of Maryland legends but makes no reference to Goatman, despite teaching at the University of Maryland in Prince George's County.[200] Even if the Goatman was already known in the area, the dramatic rise and spread of the Goatman legend in the county can be directly attributed to Hosler's first two articles published in the fall of 1971.

Toward the end of 1971, general knowledge spread through Bowie of Fletchertown Road's "Goatman." Legend tripping began en masse. One Prince George's County youth remembers: "In our high school, we had a Goatman Squad, composed of a lot of guys in our high school who were determined to catch him. They sent out literature telling people what he was like, what he liked to eat, and so forth."[201] Following the local high school football game, a typical fall Friday night concluded with a Goatman hunt.

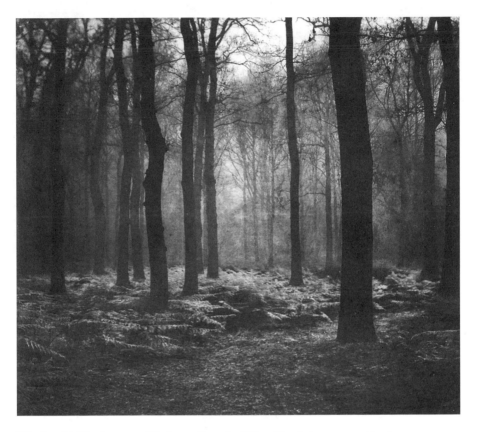

Whether it's Fletchertown, Tucker or Lottsford-Vista Road, the community always associates the Goatman with dark, wooded areas. *Artwork by Brenda Clarke.*

Two weeks after reporting Ginger's death, Hosler penned "Pranksters and Thrill-Seekers: The Real Monsters of Fletchertown Road," condemning the onslaught of legend tripping.[202] Now paved in beer cans, Fletchertown Road was hosting thrill-seeking teenagers almost every night. Hosler reported one egregious offense by the youths: ostensibly catching a glimpse of the Goatman, two cars and a truck blocked Fletchertown Road while the joy riders hustled into the woods for the final showdown. The Goatman escaped.

Even if Karen Hosler regretted the consequences of her article, other newspapers latched on to the sensational story. On the last day of November, Ivan G. Goldman penned an article for the *Washington Post* announcing "A Legendary Figure Haunts Remote Prince George's Woods."[203] If the *Prince George's County News*'s comparatively small circulation had been any sort of

detriment to the proliferation of Goatman's existence, Goldman knocked down these barriers. Despite the author's skeptical tone, the news spread far and wide.

At this point, it is possible to speculate on the legend's diffusion. George Lizama collected Goatman legends from Tucker Road for his folklore class. Needing a macabre "human" interest news story for the Halloween season, Karen Hosler examined Lizama's collection and reported the existence of Goatman, albeit in the Fletchertown Road area and with some changes. We can assume the gentlemen who found April's decapitated dog Ginger, John Hayden and Willie Gheen, read or otherwise heard this news story, both the part about a "half-man, half-goat" and Hosler's anecdote that Goatman "once picked up a dog and carried it into the woods" and that "only half the dog was found."[204] This same reporter covered the supporting "evidence" of Ginger's decapitation, driving Bowie teens wild—so wild the *Washington Post* took notice. When future legend tellers claim they "saw it in the paper,"[205] there is indeed a kernel of truth.

The Goatman legend also localized on Lottsford Road in Mitchellville, Maryland, completing the Goatman trinity. Like Tucker Road and Fletchertown Road, Lottsford is a long, dark, narrow, rural road surrounded by thick woods. A rash of homicides made the area ripe for planting the Goatman legend. Four bodies in the previous decades and fourteen more in the years to follow were dumped from bridges into streams on Lottsford Road. For example, police found thirty-year-old Bernard Carter in a stream under a bridge on Lottsford-Vista Road, his body riddled with knife wounds.[206] Little had changed a year later when the *Washington Post* ran the headline "Lottsford Road: Local Legend Says It's a Trail of Terror." The article argues that the road's "macabre reputation as a dumping ground for bodies" haunts the area, not Goatman. "It's a damper," local resident Shirley Hutchinson complained, "finding dead bodies in the road and all."[207]

Every violent city has its notorious dumping grounds. Baltimore has Leakin Park, where police lore tells of academy instructors reminding young recruits training in evidence retrieval that they are looking for a specific body, not just any body. New York has cement shoes and the East River. Las Vegas has shallow graves sprinkled throughout the surrounding desert. Washington, D.C., apparently, has Lottsford Road. Patrolling the road in his time with the Prince George's County Police Department, Mount Rainier police chief Dennis Husk remembers, "Every time [we]'d turn around, [we] were finding either a prostitute from the District or a dope dealer from downtown."[208]

Although Mitchellville's area youth parked and drank on Lottsford Road before, the rash of murders made the trips more exciting than ever. Mitchellville teenagers already knew of the "Hatchet Man," the local version of "The Boyfriend's Death" urban legend. The Goatman simply supplied the implicit antagonist. For example, after telling a typical Goatman-less variant of "The Boyfriend's Death," seventeen-year-old Stephen L. White commented, "I personally have never come in contact with the Goatman. I don't believe in the Goatman."[209] Similarly, seventeen-year-old Karen Snyder recited "The Boyfriend's Death" as well but concluded that the couple parked "down by Goatman's house," and therefore, "her boyfriend was killed by the Goatman."[210] Likewise, on Fletchertown Road, newspaper coverage increased the diffusion of the Goatman character while diminishing the legend's narrative. Passive bearers far outweighed active bearers of the tradition.

At the same time, University of Maryland student Carolyn Hoffman collected two legends on Tucker Road that were direct variants of Karen Hosler's November 10, 1971 article on the decapitated dog found on the Penn Central Railroad tracks in Old Bowie.[211] The informants had indeed "seen it in the paper," although oral traditions localized and updated their versions. In these versions, Fletchertown Road became Lottsford-Vista and the 1971 setting became "last summer," which would have been 1973 at the time of Hoffman's report.

In 1975, high school teacher Rose Anne Duley collected Goatman legends from her students. Clearly in tune with the complex mentality of American teenagers, she was not surprised that a student would shoot down the existence of Goatman in one breath and then excitedly tell his or her own version of the legend in the next. She insightfully observed that her students "can intellectualize the infeasibility of such a person as Goatman, but emotionally they still harbor the feeling that maybe it's true after all. They don't believe in Goatman, and every time they drive down Snake Road on a dark Saturday night they hope they're right."[212] Duley's meticulous collection gives a greater sense of the diffusion of the Goatman legend on Fletchertown Road and Tucker Road four years after Hosler's article. Here, we see two regional groups' distinct understanding of the legend.

The students from the Fletchertown Road area of Bowie tell one version of the Goatman legend. Among Duley's students, Karen Hosler's "University… Area" report lives in oral tradition. This includes the explanation that local scientific experiments on goats created Goatman, although not necessarily at Beltsville Agricultural Research Center, as Hosler had mentioned.[213]

Furthermore, this confirms that Hosler's second article had entered oral tradition. Goatman still decapitated dogs, but instead of leaving the head next to a railroad, he left it in a bag with his name on it. The villain was still a half-man, half-goat (though still no agreement on which half was which) that lived near a bridge in an old shack. Although dogs were his primary victims, he killed sheep and horses too, eating the body and leaving the head as his calling card.

Duley also interviewed a second regional folk group, her family from the Tucker Road area of Clinton. Hosler's article did not seem to have had the same effect on this area's Goatman legend. Relative Ann Duley recalled the same story Josiah Proctor told four years earlier: "I heard later that Goatman was really some old black bearded man who was half crazy and roamed the fields of that area." Another relative, Stephen Duley, recited a variant almost identical to the other seven variants collected by George Lizama at the beginning of the decade. Hosler's article seems to have shaped the "Goatman of Fletchertown Road" but not the "Goatman of Tucker Road."

University of Maryland student Mark Lawler collected a 1983 variant of the newspaper story from Thomas Lawler, a police officer. In his Fletchertown Road version, Goatman beheads a barking German shepherd with an axe and then leaves the severed head "upright in the middle of the owners [sic] backyard."[214] The animal and the manner of death correspond with the death of Ginger (the decapitated puppy), as reported by Hosler, but there remains a vested interest in embellishing the presentation of the decapitated head.[215] By the mid-1980s, Goatman was generally evil, leaving the possibility of attributing most malevolent acts to him. By the 1990s, the Goatman legend had lost its form. A young woman recalls a version where Goatman hides out at the Free State Riding Club and kills boyfriends. Her metacommentary on recent Goatman developments is the most revealing part of her rendition: "Lately, when I have heard the story, there is no more of that romantic stuff. It is just a thing that goes around mangling people. I hate when that happens."[216]

Documentation of the Goatman in the Maryland Folklife Archives ceases after 1993, but the cryptid's popularity in scholarship, literature, film and digital folklore was only getting started at that point. The Goatman has lived a charmed life in print, film, television and on the Internet. Writer Mark Opsasnick published the first investigation of Goatman in a 1994 issue of *Strange Magazine*. The Discovery Channel followed in 1998 with a segment of *Into the Unknown* dedicated to the Goatman, primarily based on Opsasnick's theories. Goatman received a second segment in 1999 on Discovery's

Animal X program. The *X-Files* comic book series starred Goatman (and two Goatwomen) as the tragic hero in the issue "The Face of Extinction." Additionally, "Goatman Hollow" in Prince George's County offers an interactive, Goatman-themed theatrical haunted house.[217]

The Goatman legend inspired several independent films. One ill-fated project, simply titled *Goatman* (2009), was to focus on Goatman's escape from the Beltsville Agricultural Research Center. The film never made it past the trailer. *Jimmy Tupper vs. The Goatman of Bowie* (2010) is part coming-of-age comedy and part *The Blair Witch Project* (1999)—a film that also inspired the making of *Return of the Goatman* (2012).[218]

The half-man, half-goat brings two images to mind: the satyr of Hellenic lore (top human, bottom goat) and Baphomet of Christian lore (top goat, bottom human).[219] Sporting horns, both are reminiscent of historical and contemporary popular depictions of Satan. Regardless of its form, at the heart of every Goatman legend is a being that refuses to live within humanity's moral and geographical boundaries. In this way, the Goatman is much like a standard villain. He is an antisocial personality who kills, vandalizes property, abuses animals and generally scares people. Avoiding petty misdeeds, the Goatman's crimes are only the basest of mankind.

Since 1607, Americans have raised goats in the mid-Atlantic. John Smith and other colonists brought goats to the New World to provide milk for the Virginia Colony; Marylanders have continued to raise them ever since. But despite being one of man's earliest domesticated animals, the goat faces much prejudice. As former Prince George's County resident and current Catholic priest Father Joe Jenkins points out, in a theological and psychological sense, thousands of Goatmen walk the earth.[220] These are the frightful few who keep respectable people inside at night, make us fear for our children's safety and cause us to distrust those who do not follow society's rules. In his Sermon on the Mount, Jesus warns his followers that one day the Lord will separate the "sheep" from the "goats." God will place the sheep on His right hand and reward them; He will place the goats on his left hand and condemn them: "Then shall he say also unto them on the left hand, Depart from me, ye cursed, into everlasting fire, prepared for the devil and his angels."[221]

Geographer David Siddle's work shows the long-standing, widespread disdain for goats.[222] Despite their practical utility compared to other domesticated animals, goats for centuries have held an unsavory reputation.[223] In "some deep dark places of our collective cultural subconscious," the goat has long "been associated with fear of peripheries: woods and forests."[224] While farmers worked in open spaces, poor peasants in remote regions

Part goat, part man, the satyr of Greek
mythology resembles descriptions of Goatman.
Library of Congress, Prints and Photographs Division.

continued to herd goats, symbolically conflating the two into a single
"dangerous other." Considering America's cultural and religious roots, the
"Judeo Christian iconography of the scapegoat represented similar murky
and deep sexually dangerous relationships with the outer edge, the periphery,
the unknown."[225] Siddle shows these feelings "persist to this day and are
still evident in cartoons, cinema, and many cultural references." They also
persist in the contemporary legend of the Goatman.

Sometime before 1971, a combination of historical, theological and
symbolic memories constructed the Goatman villain in the minds of Prince
George's County residents. The legend entered a second stage after Karen
Hosler's newspaper reports, when residents interpreted vague sensory data,
and the Goatman took on traits long associated with crooked-leg, horned
creatures in Western culture.

Making an astute observation over forty years ago, George Lizama
pointed out that "sections of the county being developed into modern

114

residential and commercial areas" make it "one of the few regions where the past and present live side by side."[226] Ivan G. Goldman also mentions in his *Washington Post* article that Prince George's County is "a long-settled, but still sparsely populated region—a place inherently apart from the Washington metropolitan area—yet within its geographical boundaries."[227] Father Joe Jenkins, too, remembers that in the 1970s, Prince George's County was "in the early stages of a transition wherein unchecked construction of homes, businesses, and roads were encroaching."[228] Intensive twentieth-century development quickly transformed the rural farm community into one of the most populous in the state and one of the most diverse in the nation in a matter of decades. The demonic Goatman may have been a symbol on which to project residents' anxiety about the encroaching city, demographic changes and the county's juxtaposition with the new murder capital of the United States, Washington, D.C., right in their backyards.[229]

While the general population assigned the Goatman all those human characteristics that are the wickedest and vilest, a set of young people, teenagers in particular, seemed to identify with the Goatman. Why were teenagers attracted to Goatman, a symbolic embodiment of surrounding evil? Adults fondly recount their younger days searching for the Goatman with friends.[230] We needn't think the teenagers had any interest in slaying or even capturing the Goatman. Like real hunting, the excursions included socializing, beer drinking and entering into liminal space, with little outcome-oriented judgment. Like sportsmen, the teenagers hunted not out of hatred but out of respect.[231] Legend tripping allowed teens to enter the Goatman's land and join the dark side, if only for a brief time, before eventually rejecting him and returning home. In that case, Goatman is more than a cryptid hominid. He is an idea that survives only on the fringes of society, in direct opposition to the values of American suburban life.

STRANGE BEDFELLOWS

The College Park Cuddler

One ought to hold on to one's heart; for if one lets it go, one soon loses control of the head too.
—Friedrich Nietzsche

A sick thought can devour the body's flesh more than fever or consumption.
—Guy de Maupassant

Definitions of folklore are often positive and inspiring, channeling human significance and creativity. For example, ethnologist William A. Wilson points out the "attempt to discover the basis of our common humanity, the imperatives of our human existence," as central to folklore.[232] Similarly, Richard Kurin places folklore as "a marker of community or group identity."[233] But there is a sordid side to folklore as well. Legends are free to attach themselves to the sleazy, the seedy and the shameful parts of life. Often based on sensational stories with a basis in true events, villainous characters take on legendary proportions. But even these seemingly boorish legends may function as a positive defense against a lurking threat in the community. Simon J. Bronner points out that campus folklore often has the ability to "open for scrutiny issues and concerns—of a place and a time in [students'] lives." Folklorist Elizabeth Tucker, specifically considering why macabre tales of student deaths could play an important function in college folklore, speculates that legends such as these give "a deeper understanding of historical and psychological horrors in relation to current social problems"

while "probing the nature of reality."[234] In this chapter, we look at a shadowy scoundrel whose character has grown to legendary status. The sensational stories of his despicable deeds transmit important information through informal news networks, warning the campus community of a looming threat.[235] Specifically, the legend functions as a tool against sexual assault by educating, warning and reminding women of a present threat in College Park, Maryland.

Between 2007 and 2008, the Prince George's County Police Department suspected a single man of committing over a dozen sexual assaults and Peeping Tom[236] incidents in downtown College Park. The student body nicknamed him the "College Park Cuddler." The *Washington Post* actually avoided referring to him as the Cuddler for a number of reasons.[237] As Amanda Hess explains in "The Sexist" column of the *Washington City Paper*: "The 'Cuddler' nickname occupies the space between fact and mythology. He is both a flesh-and-blood crime suspect and an archetype—a convenient shorthand for a pattern of crimes that the cops are unable to pin on one guy."[238] Still, the moniker is useful for students in distinguishing an otherwise amorphous threat.

Starting at the beginning of the school year in 2006 and continuing through January 2007, female students in the vicinity of the 7500 block of Rhode Island Avenue reported at least five Peeping Tom incidents.[239] In the early morning hours of September 13, 2007, an unidentified man crept into a house on the 7500 block of Dickinson Avenue, crawled between a sleeping female student and her boyfriend and proceeded to fondle the woman. When she awoke to find it was not her boyfriend touching her, the intruder fled, and the couple called the police. Later that same evening, the Cuddler made the short walk to the 4600 block of College Avenue, where he entered a second house. Slithering into a slumbering female student's bedroom, he planted a kiss on her forehead. He then crawled in bed with one of her housemates before moving to the basement and sexually assaulting a third victim.[240]

By March 2008, with a dozen assaults under the Cuddler's belt and three semesters of experience, the Prince George's County Police still had no leads, no suspects and no hope of solving the case. The police barely even had a physical description. They knew the suspect was a white male in his twenties, that he preyed on white females in their twenties and that he lurked around the neighborhood of rented, single-family homes near the University of Maryland, on the other side of U.S. Route 1. His modus operandi was breaking into houses, hopping into beds and cuddling or kissing the sleeping

occupants.[241] Police also knew the College Park Cuddler was either brazen or blind, as he did not seem to care if the victims' significant others were in the bed too. In the early hours of Sunday, March 3, 2008, on the 7300 block of Hopkins Avenue, another victim roused to find the Cuddler snuggling and kissing her while her boyfriend lay in the bed beside her, fast asleep. When the victim realized what was happening, the Cuddler made a quick escape. Later that night, just down the street on the 7500 block of Hopkins Avenue, another coed woke to find the Cuddler fondling her and masturbating while eight grown men slept drunkenly in the living room just outside her door. The police pointed to a pattern suggesting that every woman assaulted had attended or hosted a party the same night, believing that the suspect was using these occasions to identify and pursue his victims. But both women insisted they had never seen their attacker before. The victims gave the same vague descriptions of a 170-pound man in his twenties with dark hair and dark eyebrows.[242]

After an active year in which he had fondled numerous women and continued to elude law enforcement, the College Park Cuddler took some time off. Some suspected the Cuddler had graduated or dropped out and moved on to snuggle women in new locales. Others assumed he was sitting in jail, serving time for other crimes. Wherever he had been, the College Park Cuddler struck again on the morning of Friday, September 9, 2011. A female student in the Leonardtown apartments (a university property near Hopkins Avenue) awoke to find a stranger fondling her breasts.[243] She screamed, and the man fled. The victim initially planned to let the intrusion go unreported but soon changed her mind when she and her roommates noticed their apartment keys had vanished. Assuming they were in the possession of the Cuddler, the roommates called the police. Yet again, the victim had attended a party the night before.

On Tuesday, February 7, 2012, an anonymous user posted a cryptic note to TerpSecret, a blog where University of Maryland students can post their secrets anonymously:

> *I'm the College Park cuddler. Some may not understand why I like to get in bed with girls, but I think it's the sexiest thing ever. To be in bed with a girl who has no idea I'm there turns me on more than anything. I will strike again.*[244]

The campus went into an uproar as the message spread across Facebook and Twitter. Like the magazine cutout threat letters from the days of yore,

the University of Maryland had a full-blown, self-conscious serial snuggler on its hands. Site proprietor Sarah Tincher was torn between her promise of anonymity to TerpSecret users and the safety of the campus community. Tincher admirably admitted that, as a journalism major, the possibility of having her own Zodiac Killer–esque[245] correspondence excited her.[246] After the post sent a wave of excitement through the campus, the prankster chickened out, sending Tincher the following confession: "I was the one who made up the College Park cuddler secret. It was a joke. I'm a stupid college kid. Get over it." Alas, the real Cuddler was still on the loose.

The College Park Cuddler is not one of the cute characters often associated with folklore and fairy tales.[247] Nothing about his story is uplifting or inspirational. But he is a real person, perhaps more than one, and his actions have turned him into a legendary figure. While it may seem celebratory, the Cuddler's status does serve a positive function to the campus community. The legend reinforces basic warnings that often go unheeded, like locking doors and traveling in groups. In addition, it teaches new lessons, ones demanded by new surroundings, such as carefully monitoring party guests.[248] So while these tales may excite, entertain, and terrify, they also educate students, helping to guide them safely through a strange, new environment. This is the news of the campus, and informal student networks are sure to report it.

Newspaper articles and book chapters place an event on the permanent record, but they do not keep it fresh in the community members' minds. Emergent campus legends, on the other hand, keep important information fresh in students' minds. Through the back-and-forth narration and community reinforcement, students identify community problems, seek answers and recommend solutions. The College Park Cuddler is a symbolic embodiment of the threat of sexual assault against college women in College Park and across the country. This crude legend ensures coeds will be educated and prepared, both against this specific villain and against the kinds of threats he poses.

PART III

HISTORICAL MARYLAND LEGENDS

CHAPTER 13

A Thin Line Between Victory and Defeat

Maryland's First Regiment, the Battle of Long Island and the "Old Line State"

Colonel Smallwood's battalion has gained immortal honour.
—letter from New York, August 28, 1776

Smallwood's Battalion of Marylanders were distinguished in the field by the most intrepid courage, the most regular use of the musket, and judicious movements of the body.
—letter from Philadelphia, August 31, 1776

Maryland has four nicknames: the straightforward "Chesapeake Bay State,"[249] the perplexing "Free State,"[250] the uplifting "Little America"[251] and the oft-misunderstood "Old Line State." The last is often incorrectly attributed as a reference to the Mason-Dixon line. In fact, references throughout the nineteenth and twentieth centuries printed this folk etymology. For example, in William Shepard Walsh's *Handy-book of Literary Curiosities* (1892), the author asserts the Old Line State is "a sobriquet for Maryland, because of the boundary-line, known as Mason and Dixon's line between it and Pennsylvania."[252] Similarly, Frederick Beach and George Rines in *The Encyclopedia Americana* (1905) attribute the appellation to "a popular name for the State of Maryland, which in the early colonial days was the dividing line between the Crown land grants of William Penn and Lord Baltimore."[253] And Thomas Benfield Harbottle in his *Dictionary of Historical Allusions* (1903) writes, "The State of Maryland is so called with reference to the Mason-Dixon Line, which divides it from Pennsylvania."[254]

These speculations are incorrect. Rather, the origins of the state's nickname date to the American Revolution and the legendary actions of the First Maryland Regiment.

George Washington, a celebrated figure in American history and folklore, is synonymous with the storied exploits of 1776. But few Americans know the trials and tribulations of that fateful year. In 1775, the colonists had rousing victories in the Battles of Lexington and Concord and the Battle of Bunker Hill.[255] By contrast, save for a few hopeful moments such as the Siege of Boston and the Declaration of Independence, 1776 was a harrowing disaster for the burgeoning nation.[256] George Washington "won"[257] the Battle of Bunker Hill with New England's volunteer militias, ravaging General Thomas Gage's British troops as they marched straight forward and uphill.[258] But holding an irregular army together for an extended siege was its own battle. Colonial soldiers were brave but distracted, yearning for both American independence and to harvest their crops. Enlisted men were known to wander off when it suited them and wander back just as easily. As farmers and frontiersmen, American colonists were industrious workers and hardy survivors. But what they had in zeal and ruggedness, they lacked in military discipline.[259] Disease spread through the camps, and no one was sure if the ragged militia would perform when asked to go toe-to-toe with British regulars. One British army officer and parliament member boasted he could conquer the entire continent with five thousand redcoats.[260]

Beginning in 1775, under the command of General George Washington, American militias laid siege to the British in Boston. Well supplied with food but severely lacking in gunpowder, New England militia surrounded Boston and waited. Washington yearned to attack, but his more cautious lieutenants warned against an urban assault. The siege was at a standstill until the young, daring colonel Henry Knox turned the tide. After hearing of the capture of Fort Ticonderoga in upstate New York and the seizure of its artillery, Knox proposed to Washington an expedition to retrieve the guns and run the British out of Boston. In what became its own legendary mission, Knox delivered forty-six cannons from Fort Ticonderoga to the outskirts of Boston through winter blizzards, over steep mountains and across frozen rivers. Knox coined it "a noble train of artillery."[261] Invigorated with their newfound firepower, in a single night, the Americans built an entrenched battery on Dorchester Heights—high ground just outside the city—threatening the British army in Boston and the British navy in the

harbor. Compelled to abandon the city, General William Howe promised not to burn Boston to the ground if Washington's army allowed the British to leave in peace.[262]

The British made a quick, unharried departure. While a great triumph for the American cause, the manner of the victory merely delayed the fighting until a future date and an unknown location. Forced to guess where General Howe would send his army next, Washington left a small force to defend Boston and moved the bulk of his men to New York, a pivotal geographic location and the second-largest city in the colonies after Philadelphia. As Washington's troops took up residence in New York, the Continental Congress declared Americans a free and independent people on July 4, 1776, boosting morale to an all-time high. While the Siege of Boston had been primarily a New England affair, southern militias responded to the call to defend New York. Two colonies impressed Washington's ragged veterans: Delaware and Maryland. While all the colonies had formed militias, only these neighboring territories had bothered to drill, train and equip their troops before sending them for service. Thus, unlike the tattered New England militias, the Maryland troops arrived disciplined and in uniform.[263]

Even with Washington's army occupying the city, the situation in New York was perilous. While the troops were in high spirits and slept indoors for a change, the city was indefensible. Lacking a navy, the Americans could not control British naval movements in the surrounding waters, leaving the British too many strategic options for their impending assault. Most agreed the Patriots could not defend New York. Some recommended Washington burn the city to the ground and move his army elsewhere. But its strategic position at the mouth of the Hudson River convinced General Washington and the Continental Congress that New York *must* be defended. This misguided belief pulled the Continental army into its most disastrous defeat of the war.[264]

Determined to make a stand, the Americans began constructing entrenchments throughout Manhattan and Brooklyn. However, they were unable to check British naval movements. As a result, when British forces arrived from their encampment in Halifax, Nova Scotia, they landed untouched on Staten Island. Since their retreat from Boston, their numbers had swelled to twenty thousand British and Hessian troops. Relying on a combination of well-disciplined soldiers, experienced battle commanders and local Loyalists, the redcoats coordinated a surprise night attack from the south of Brooklyn, catching the Americans completely off guard.[265]

On August 27, 1776, the Maryland regiment was entrenched with Lord Stirling[266] and General John Sullivan in advance of the Brooklyn lines, in addition to troops from New York, Pennsylvania and Delaware.[267] The British sent a feint to the Americans' front. The Americans fought for hours, repelling multiple British attacks. With no situational awareness of their predicament, the militiamen believed they were winning the battle. But unbeknownst to them, British and Hessian forces were on a silent, all-night march, working their way around the Americans' left flank.[268] As the Hessians crashed into the Americans' side, Lord Stirling realized the British frontal assault was a mere diversion. He ordered his troops to retreat to the Brooklyn lines, but upon fleeing, they ran headlong into the British troops who had spent the night marching to the unit's rear. With Hessians to their left, British troops to their front and more redcoats on the road back to Brooklyn, cutting off their retreat, the Americans were trapped.[269]

The Continental army's only chance was a narrow marsh, open only at certain tides. Knowing the Maryland regiment to be his best soldiers, Lord Stirling ordered the battalion to form the rear guard. While the rest of the American infantrymen slogged through the marsh, a few hundred Marylanders formed a human speed bump. Not content to hold, Lord Stirling ordered the Marylanders to attack, bayonets fixed, leading the assault himself. In front of the Old Stone House, Marylanders and Hessians engaged in the fiercest fight of the day. Watching the Maryland regiment's last stand from the top of Cobble Hill, Washington made his famous statement, "Good God, what Brave Fellows I must this day lose."[270] Instead of using his best troops to win the war, he was sacrificing them in a futile defense. Decades later, American painter Alonzo Chappel captured the brutal scene on canvas in *The Battle of Long Island*. Of the Marylanders sent to defend the retreat, fewer than a dozen survived.

When told as a legend, two details are almost always changed. Instead of Lord Stirling, Washington himself gives the Maryland regiment its fatal orders. In reality, as the time and location of the attack were a complete surprise, Washington was cut off from direct communications. The second detail often included is that the Marylanders' action was in service to Washington's retreat and saved the Continental army. While the Maryland regiment did in fact save a large number of troops, much of Washington's army was elsewhere on Long Island, dug in behind the Brooklyn lines, in Manhattan, in other parts of New York or still in their home colonies. Washington's retreat from New York would come days later, in a surprise overnight withdrawal.

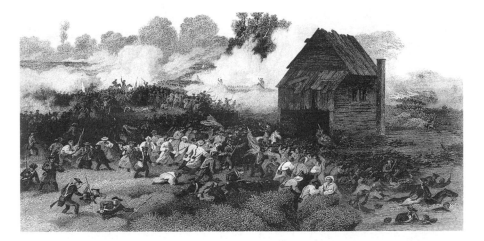

In Alonzo Chappel's painting, Maryland soldiers clash with British and Hessian troops in front of the Old Stone House in brutal hand-to-hand combat. *Library of Congress, Prints and Photographs Division.*

The Maryland troops' heroic deeds found their way into legend *and* the historical record. Stories made the newspapers soon after the battle, including firsthand accounts from the letters of impressed onlookers. One observer from the Brooklyn lines recounted the Marylanders' bravery:

> *Smallwood's Battalion of Marylanders were distinguished in the field by the most intrepid courage, the most regular use of the musket, and judicious movements of the body. All the other battalions behaved as became Americans and men of honour, fighting for their rights as free men. When our party was overcome and broken, by superior numbers surrounding them on all sides, three companies of the Maryland broke the enemy's lines, and fought their way through; the other attempted to cross a small creek, which proved fatal to several of them. I had not heard their loss, but presume it is very heavy, they being in a situation very much exposed, facing the enemy's cannon, in the open field for a considerable time.*[271]

The most famous observation of the battle, of course, was George Washington's. The origin of Washington's famous line about the Maryland troops is from a letter dated September 1, 1776. Penned by an unnamed Continental soldier who took part in the battle, his letter made the papers:

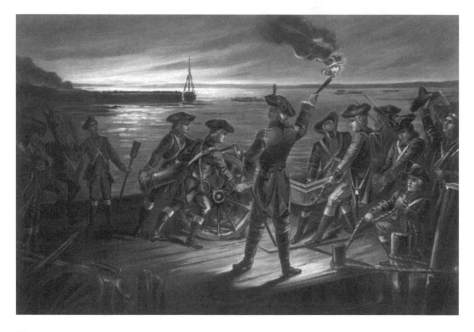

Though the Maryland troops are often credited with defending the army's retreat, the full-scale evacuation didn't happen until three days later. This painting depicts the Americans' hasty, successful nighttime withdrawal in *U.S. Army-Artillery Retreat from Long Island—1776*. *Library of Congress, Prints and Photographs Division.*

> *Most of our Generals were upon a high hill in our lines, viewing us with glasses. When we began our retreat, they could see the enemy we had to pass through, though we could not. Many of them thought we would surrender in a body, without firing. When we began the attack, General Washington wrung his hands, and cried out, Good God! What brave fellows I must this day lose!*[272]

In addition to the newspaper account, Washington's numerous biographers have included the quote in their narratives. For example, renowned American author Washington Irving preserved Washington's words in *The Life and Times of George Washington*. Irving's account sticks closely to the anonymous soldier's letter:

> *Washington, and some of his officers on the hill, who watched every movement, had supposed that Stirling and his troops, finding the case desperate, would surrender in a body, without firing. On the contrary, his lordship boldly attacked Cornwallis with half of Smallwood's battalion,*

while the rest of his troops retreated across the creek. Washington wrung his hands in agony at the sight. "Good God!" cried he, "what brave fellows I must this day lose!"[273]

Historian James McSherry recalls the legend of Maryland's First Regiment in *History of Maryland: From Its First Settlement in 1634, to the Year 1848*. Writing specifically for Marylanders, McSherry distinguishes the valiant Maryland regiment as, in fact, having almost won the battle if only the British had not been reinforced:

Five times this little band charged upon the powerful forces of Cornwallis; and each time driven back, again gathered their energies for a fiercer assault, until at last upon the sixth, the heavy column of the British reeled under the repeated shocks and began to give way in the confusion. But in the very moment that victory seemed within their grasp, Grant's brigade assailed them in the rear, and fresh troops, the Hessians of De Heister, came to the aid of Cornwallis in front. Already outnumbered more than ten to one, with their ranks thinned by the terrific slaughter, and worn down by long fighting, these devoted men could no longer make head against their foes... The loss of the Maryland troops in the long contested battle was murderous. From sunrise until the last gun was fired upon the field, they were hotly engaged; and, when the rest of the army had been routed or had fled, maintained the battle unaided, against two brigades of the enemy... To this day the people of Long Island point out to strangers, the spot, where half of the Maryland battalion stemmed the advance of the whole left wing of the British army when no other troops were left upon the field, and where the best blood of the State was poured out like water.[274]

The transformation from historical military deed to state nickname is an example of the social-psychological concept of "basking in reflected glory."[275] Basking in reflected glory comes about when a group attempts to "share in the glory of a successful other with whom they are in some way associated," even if they have "done nothing to bring about the other's success."[276] From the time that the earliest reports of the battle made the newspapers, through the nineteenth century and on to the present day, Marylanders have taken pride in the First Regiment's gallant sacrifices. The legend's growth from George Washington's anecdote to the regiment's unofficial distinction as the "Old Line" to Maryland's official designation as the "Old Line State" demonstrates this phenomenon at the statewide level.

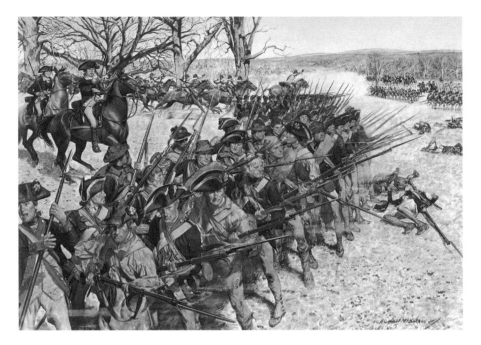

Suffering great losses at the Battle of Long Island, the First Maryland Regiment fought on. This painting depicts the rejuvenated regiment six years later, back in action at the Battle of Guildford Courthouse. *U.S. Army Center of Military History.*

Ryan Polk, an archivist with the Maryland State Archives, traced the rise of the nickname following the Battle of Long Island.[277] He writes, "After all of the immediate witnesses and survivors had passed, the name came to mean more as subsequent generations sought a connection to a proud past."[278] While its generation lived, the "Old Line" referred specifically to the unit that had served with distinction in Washington's service. But as the Revolutionary epoch passed, the name beckoned to "a common heritage, a symbol of continuity and identification for an increasingly heterogeneous population."[279] Washington never actually referred to Maryland as the "Old Line State," but he did refer to Maryland as the "line" and the "old line" in his personal papers. Regardless of precise historical documentation, the *Maryland Manual*, the official guide to Maryland and its government, has included the legend since 1975: "According to some historians, General George Washington bestowed the name 'Old Line State' and thereby associated Maryland with its regular line troops, the Maryland Line, who served courageously in many Revolutionary War battles."[280]

All early Maryland histories mention Maryland's actions in the Battle of Long Island, but none refer to Maryland as the "Old Line State."[281] On February 6, 1856, Senator Thomas Pratt honored the Maryland regiment from the Senate floor. One of several Revolutionary units heralded that day, only Maryland received the distinction of "old" before its name. One year later, Committee on Revolutionary War Claims member Senator Josiah Evans again praised "the Old Maryland Line," the only Revolutionary unit to receive an honorary byname. More widely circulated, the pro-Confederate "Maryland, My Maryland" (1861) mentions the "thunder-hum" of the "Old Line's bugle, fife, and drum." Archivist Polk shows "businesses incorporating with names like Old Line Real Estate, Old Line Legal and Reserve, and the Board of Natural Resources' published their newsletter, *Old Line Acorn*," in the late nineteenth century.[282] Polk suspects Matthew Page Andrews was the first writer to put the term in print in *History of Maryland Province and State* (1929).

In the twenty-first century, Maryland politicians often invoke the legend, combining a pride in Marylanders' selflessness and past accomplishments with their own political rhetoric. It is a favorite story of Maryland's sixty-first governor, Martin O'Malley.[283] While campaigning to unseat Republican governor Robert Ehrlich, O'Malley met with a small group of student supporters behind the University of Maryland's Comcast Center before a Terrapin basketball game. He asked if the students knew why Maryland was called the "Old Line." "The Mason-Dixon line?" the students guessed. "The First Maryland Regiment," O'Malley corrected.[284] Those intrepid Marylanders who stood fast in the face of determined opposition. Years later, firmly entrenched as Maryland's governor, O'Malley used the Old Line as a political metaphor. At the Democratic National Convention in Charlotte, North Carolina, on September 4, 2012, he made the legend central to his remarks:

> *Since the first days of the American Revolution, Maryland has been called the "Old Line State" because of this true story of a group of soldiers called the Maryland Line: immigrants and native born, black and white, volunteers all. It is August 27th, 1776—two months since our Declaration of Independence. Outnumbered and surrounded, Washington's army is about to be crushed forever at Brooklyn Heights. The British are closing in.*
>
> *With America's future hanging in the balance, word is passed up and down the Maryland Line: "Fix bayonets, we're moving forward." And they do. Into the breach. They hold off the British just long enough for*

Washington's army to escape and fight another day. Today there is a plaque by the mass graves of those citizen soldiers. It reads, "In honor of the Maryland 400, who on this battlefield saved the American army."[285]

O'Malley's version maintains all of the common motifs. The entirety of "Washington's army" is about to be "crushed forever" (rather than just the troops in advance of the line). Employing the passive tense, O'Malley is able to skip over exactly who sent the Marylanders "into the breach," but the governor is most interested in the idea of "moving forward." He uses the legend of the Maryland Line to bolster a political message: "In times of adversity—for the country we love, Maryland always chose to move forward." Tying the First Maryland Regiment's advance to his political platform of "progress," O'Malley concludes, "Progress is a choice. Job creation is a choice. Whether we move forward or back: this too is a choice. That is what this election is all about!"[286]

Although the origins of the "Old Line State" are not known to all, Marylanders who do know the legend of the First Maryland Regiment can take pride in the heroic backstory of the "Old Line State" nickname. The name does not come from the Mason-Dixon debacle but from Maryland's deeds in the American Revolution. Whether or not Washington dubbed Maryland's regiment the "Old Line" or Maryland the "Old Line State," the traditional nickname is based on a historical event that Marylanders have been referencing for a couple centuries. The name, through tradition, connects all Marylanders to those early, brave men who gave their lives for the American cause.

BRAVEST OF ALL
IN FREDERICK TOWN

Barbara Fritchie and the American Flag

*As long as the name of Frederick City lasts the poem of Barbara Frietchie will be
quoted in connection with it. This is immortality.*
—*J. Thomas Scharf*

*The story will perhaps live, as Mr. Whittier has boasted, until it gets beyond the
reach of correction.*
—*Confederate Major Henry Kyd Douglas*

John Greenleaf Whittier based his poem "Barbara Frietchie" on the
legendary actions of Frederick resident Barbara Fritchie.[287] Although a
historical person, Barbara Fritchie was unknown to Whittier until after her
death. The poet learned the legend of Fritchie's defiance from E.D.E.N.
Southworth, who herself learned it from a distant relative of Barbara
Fritchie's. Fritchie's relative first heard the tale when he visited Frederick
and attended Barbara's funeral in 1862. Whittier took the legend, which
paid tribute to patriotism and loyalty in the face of great personal risk, and
turned it into a ballad. Popular to this day, the poem's power comes not
from Whittier's poetic styling but from his ability to recognize, capture and
exhibit a remarkable legend in tight verse. The following is a summary of
Whittier's narrative.

The rural farming valley south of the Catoctin Mountains in Frederick,
Maryland, is famous for its "clustered spires," teeming steeples streaking the
skyline. On a September morning in 1862, General Thomas "Stonewall"

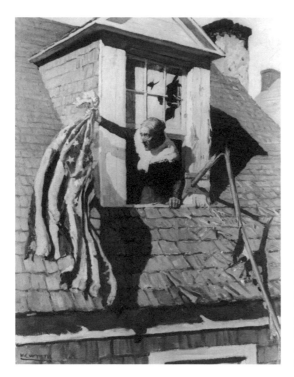

N.C. Wyeth's dramatic painting of the moment "Barbara snatched the silken scarf." The painting accompanied a reprinting of Whittier's poem in the book *Poems of American Patriotism. Library of Congress, Prints and Photographs Division.*

Jackson's Confederate brigade marched into Frederick, waving the Rebel flag en route to Harpers Ferry, South Mountain, Antietam and Shepherdstown. Marylanders were caught in a perilous struggle. Although a slave state, Maryland had not seceded. Its citizens showed loyalties to both the Union and Confederate causes. If Maryland were to secede, it would leave the nation's capital, Washington, D.C., in a precarious situation, cut off from the nation it administered.

As the Confederate troops marched through Frederick, much of its loyal citizenry hid themselves and their flags in fear. But one nonagenarian stood tall from the attic of her Frederick home, raising the American colors and taunting the Rebel lot. As Stonewall Jackson rode at the head of his column, his eyes met Old Glory, and he ordered his troops to halt. "Fire!" Jackson barked. The Confederate rifles roared, the staff broke and the Stars and Stripes fell. But as the colors dropped, Barbara Fritchie appeared at the windowsill, snatching up the fallen flag. Leaning out of her window, Fritchie waved the flag in the face of the Rebel ranks. "Shoot, if you must, this old gray head," she shouted down to the men below, "but spare your country's flag." As the Confederate soldiers turned to take Barbara up on her offer,

General Jackson had a change of heart. A flush shot through his face, perhaps a tinge of guilt for his part in the bloody affair that had wreaked havoc on the American continent over the last year and a half. "Who touches a hair of yon gray head dies like a dog," warned Jackson before ordering his men to "march on." The rest of the day, as masses of Confederate soldiers marched through Frederick, they did so under the American flag. Barbara Fritchie, a patriot as old as the country itself, proved herself the bravest person in Frederick that day.[288]

The transition from deed to legend to poem was rapid. Jackson's troops marched through Frederick in September. By December 1862, an account of Barbara's stubborn patriotism amazed a distant Fritchie relative.[289] This relative was a neighbor and friend of Georgetown novelist E.D.E.N. Southworth. As he regaled her with Fritchie's deeds, Southworth recognized the tale's literary and moral value. The tale, she knew, was perfect poetic fodder for her recent acquaintance, popular poet and fellow devoted Unionist John Greenleaf Whittier. Whittier met Southworth while he was the corresponding editor of *National Era*. Both were Quakers, both were abolitionists and both were skilled writers. On July 21, 1861, Southworth wrote Whittier's small town to ask for a home address:

> *I send this little note out merely in quest of you. If it should find you, please let me know your exact address, as I have a message to deliver you. You need only put your address in the inclosed envelope. When I get it I will write to you.*[290]

Whittier responded with his address in Amesbury, Massachusetts, and Southworth replied with the following account that would shape the Barbara Fritchie legend for years to come. Despite future criticism of his ballad for factual inaccuracies, Whittier's poetic narrative is nearly identical to Southworth's description of the event:

> *When Lee's army occupied Frederick, the only Union flag displayed in the city was held from an attic window by Mrs. Barbara Frietchie, a widow lady, aged ninety-seven years.*[291] *Such was the paragraph that went the round of the Washington papers last September. Some time afterwards, from friends who were in Frederick at the time, I heard the whole story. It was the story of a woman's heroism, which, when heard, seemed as much to belong to you as a book picked up with your autograph on the fly leaf. So here it is: Barbara Frietchie was born in 1766; she was ten years old at the*

135

breaking out of the revolutionary war, and was fifteen years old at its close; therefore at the most susceptible period of her life she must have drawn in from that heroic epoch the ardent spirit of patriotism which inspired her act.

When on the morning of the 6th of September, the advance of Lee's army, led by the formidable rebel general "Stonewall" Jackson, entered Frederick, every Union flag was lowered, and the halliards cut; every store and every dwellinghouse was closed; the inhabitants had retreated indoors; the streets were deserted, and, to quote the official report, "the city wore a church-yard aspect." But Mrs. Barbara Frietchie, taking one of the Union flags, went up to the top of her house, opened a garret window, and held it forth. The rebel army marched up the street, saw the flag; the order was given, "Halt! Fire!" and a volley was discharged at the window from which it was displayed. The flag-staff was partly broken, so that the flag drooped; the old lady drew it in, broke off the fragment, and, taking the stump with the flag still attached to it in her hand, stretched herself as far out of the window as she could, held the stars and stripes at arm's length, waving over the rebels, and cried out in a voice of indignation and sorrow: "Fire at this old head, then, boys; it is not more venerable than your flag." They fired no more; they passed in silence and with downcast looks; and she secured the flag in its place, where it waved unmolested during the whole of the rebel occupation of the city. "Stonewall" would not permit her to be troubled.

The rebel army evacuated Frederick on the 11th, and our troops, under General Burnside, entered on the 12th. "Then," to quote the document again, "flags of all sizes and from every conceivable place were displayed." But as for the heroic old lady, she died a few days after;[292] some thought she died of joy at the presence of the Union army, and some that she died of excitement and fatigue from the "lionization" she received; for those who could not emulate the old lady's courage did honor to her act.[293]

Within two weeks of receiving Southworth's anecdote, Whittier had completed "Barbara Frietchie." He wrote to Southworth on September 8, 1863, thanking her for the inspiration and giving her full credit for the poem:

I heartily thank thee for thy kind letter and its inclosed message. It ought to have fallen into better hands, but I have just written out a little ballad of "Barbara Frietchie," which will appear in the next "Atlantic." If it is good for anything thee deserve all the credit of it.[294]

The poem appeared in the October issue of the *Atlantic Monthly*, which also featured Henry David Thoreau's "Life Without Principle." Hugely popular, newspapers across the North reprinted it in their own pages. However, some took exception to the legendary poem, then and now, including the family of General Stonewall Jackson. Although his character is noble in the end, Whittier's fictional account shows Jackson momentarily wavering in his support of the Confederate cause. Furthermore, while Confederate soldiers may have appeared outside her window, historians have proven that Stonewall Jackson rode through Frederick by a different route.[295]

In addition, three of Fritchie's contemporaries objected to the poem, not from Confederate sympathies but because they believed themselves the rightful flag-waving heroines.[296] At the time, some in Frederick believed the elderly Barbara Fritchie too sickly for such flamboyant taunting. Three separate women claimed the honor of the poem for themselves. Private school teacher Mary Quantrell wrote to Whittier, insisting *she* was the flag-waving patriot. Confederate soldiers attempted to disarm Quantrell and her students of the colors, but a ranking officer stopped them. Like Fritchie's legend, Mary Quantrell's heroics never made the local papers. Another claimant and committed Unionist, Nancy Crouse, flew the Stars and Stripes high above her Middletown home, rankling a Confederate-sympathizing neighbor. As the Rebels marched into Frederick, Crouse's neighbor informed on her. Trekking to her house to tear down Old Glory, the Confederates found Nancy wrapped in the flag and refusing to give it up. Although the Rebels convinced her at gunpoint, the local paper reported Union soldiers recaptured Crouse's flag at the Battle of Antietam and returned it to her. In the spring of 1861, a third candidate, hotelier Susan Groff, began flying a huge Union flag for all to see. Her husband, a captain in the First Maryland Infantry, Potomac Home Brigade, carried the flag into battle.[297] All three women purportedly exhibited patriotism under duress, but none can be confused with Barbara Fritchie, a distinct local legend.

Eminent Maryland historian J. Thomas Scharf was one of the scholars to point out the historical inaccuracies in "Barbara Frietchie"—albeit delicately.[298] Writing in 1882, well after the event in question but still during Whittier's lifetime, Scharf attempted to set the record straight.[299] He addressed several points of contention: 1) Jackson's column marched through in the dark of night, unable to see such details as flags. 2) Jackson's men were well fed at the time. 3) Accusing him of blushing in shame at attacking the flag assumes that Jackson was not completely devoted to the Confederate cause. 4) Jackson was too smart of a commander to waste ball and powder on

such a trivial matter. Finally, Scharf assured his readers that Jackson passed "down Second Street, north of Patrick Street, his command having entered Frederick by way of Mill Alley from the north, reaching Patrick Street on the west side of Carroll Creek"—bypassing Fritchie's house.

General Robert E. Lee and his company, on the other hand, *did* march down West Patrick Street, halting in front of Barbara Fritchie's house. Fritchie's neighbor Esmeralda Boyle recalled waking up early to watch the troops march past, but she remembered no flag-waving.[300] Another of Fritchie's former neighbors, Frederick diarist Jacob Engelbrecht, also rose early to watch Lee's column march through. He later wrote: "All the time that Gen. Lee stopped in front of Mrs. Fritchie's house I saw no flag waving. If there had been I certainly would have seen it; and as for Gen. Jackson, he did not pass over the bridge, but passed up another street."[301] Jacob Engelbrecht noted in his diary a possible kernel of truth for the subsequent legend, postulating that Fritchie had indeed flown a Union flag from her second-story window when McClellan's Union army marched through Frederick:

> *While Gen. Reno, who was killed at South Mountain, was passing Barbara Freitchie's house with the United States troops, […] a little girl held at the window a small United States flag. Barbara Freitchie was at the window then, about ninety-six years old, and it is likely out of these facts the imaginative informant gave Whittier the ideas of the poem. All that relates to the Confederate general and his troops is pure fiction.*[302]

According to Major Henry Kyd Douglas, a horse-riding accident on September 6, 1862, kept Stonewall Jackson from marching through Frederick with his troops at all.[303] Douglas, a Jackson supporter and former subordinate, claimed that "Barbara Frietchie" was a lie, having "sprang full-armed from the loyal brain of Mr. Whittier."[304] Douglas also worried that "the story will perhaps live, as Mr. Whittier has boasted, until it gets beyond the reach of correction."

Whittier took exception to this denunciation, responding in the same magazine that published Major Douglas's article with a terse rejoinder:

> *The poem of Barbara Frietchie was written in good faith. The story was no invention of mine. It came to me from sources which I regard as entirely reliable; it had been published in newspapers,*[305] *and had gained public credence in Washington and Maryland before my poem was written. I had no reason to doubt its accuracy then, and I am still constrained to believe*

that it had foundation in fact. If I thought otherwise I should not hesitate to express it. I have no pride of authorship to interfere with my allegiance to truth.[306]

On another occasion, irked by criticisms and accusations of inaccuracies, Whittier responded: "That there was a Dame Frietchie in Frederick who loved the old flag is not disputed by anyone. As for the rest I do not feel responsible. If there was no such occurrence, so much the worse for Frederick City."[307] After a friend wrote questioning the veracity of the "Barbara Frietchie" poem, Whittier replied on October 19, 1890, writing that whether "she did all that my poem ascribed to her or not, she was a brave and true woman," and that he "followed the account given me in a private letter and in the papers of the time."[308]

Chris Haugh, a contemporary Barbara Fritchie researcher, holds a less skeptical position on the legend.[309] He believes the legend is embellished rather than fabricated. General Jackson and his column may not have passed Barbara Fritchie's house, but Confederate soldiers stayed in Frederick for several days, free to meander about town and onto Fritchie's doorstep. And while soldiers may not have opened fire, it is plausible that the ornery Fritchie could have squabbled with the Confederate soldiers over flying the Union flag.

Of course, the many historical "debunkings" of "Barbara Frietchie" fail to take into account the most important element of its creation: Whittier was working with *legendary* material from the beginning. Asking whether Barbara Fritchie was historical may not be as important as asking why Barbara Fritchie became folkloric. The Barbara Fritchie legend and then the "Barbara Frietchie" poem captured the sentiment of a distraught, stubborn, loyal Unionist in Frederick during the Confederate occupation, a situation shared by many in Maryland and other parts of the North. If the legend fails in capturing a historical moment, it succeeds in grasping a historical mood among an occupied group.

Barbara Fritchie is a model example of a popular legend.[310] Its existence is not solely literary or oral but instead relies on a fusion of the two. E.D.E.N. Southworth first learned of the legend in oral tradition and sent it on to Whittier, transforming the narrative into a literary legend. Ever since, there has been interplay between the legend and the poem—informing and strengthening each other.

In Frederick, residents have incorporated Barbara Fritchie into modern culture, bringing pride and notoriety to a town often overshadowed by

Since 1862, the legend of Barbara Fritchie has taken on a life of its own. Here, a cartoonist evokes Fritchie to make a political point. *Library of Congress, Prints and Photographs Division.*

nearby Baltimore and Washington, D.C.[311] Frederick County Public Schools include "Barbara Frietchie" as part of the curriculum. The Barbara Fritchie House[312] remains a notable tourist attraction. Sitting under the conspicuous, oversized candy cane on the Golden Mile,[313] the Barbara Fritchie Restaurant has served "home-cooked" meals and desserts since 1910. The Barbara Fritchie Classic—better known as "The Fritchie"—is a Fourth of July motorcycle race held at the Frederick Fairgrounds.[314] There is even a legend about a famous Barbara Fritchie House tourist. On May 17, 1943, Prime Minister Winston Churchill and President Franklin Delano Roosevelt stopped in Frederick on the way to Shangri-La (now Camp David) in the Catoctin Mountains. At the request of Churchill, the pair made a side trip to the Barbara Fritchie House. According to the legend, Winston Churchill awed his retinue by reciting the poem verbatim from memory.[315]

Before his thorough debunking, Scharf made a point to emphasize the excellence of Whittier's poem. It is Whittier's poetic gifts, Scharf argues, that make "Barbara Frietchie" special:

> *Such poetry is not only above criticism, it is of no use to criticize it. Occasions equally with places are embalmed by it. As long as the name of Frederick*

City lasts the poem of Barbara Freitchie will be quoted in connections with it. This is immortality—not of place, but of the poet's gift. It is part of the poet's power. He suffers, starves, is ignored, condemned, but something in his lines survives him, and that something, be it correct or incorrect, is too strong for criticism.[316]

Although Whittier's poem is a striking rendition of the legend, Southworth and Whittier both realized the universal appeal of the narrative before any lyrics were set to paper. In fact, some critics have argued that Whittier's poetry was not great but shallow and saccharine.[317] Whittier's genius in "Barbara Frietchie" was his ability to identify an extraordinary legend, capturing it in verse without blunting its raw power.

CHAPTER 15

A TRADITION NEVERMORE

The Edgar Allan Poe Toaster, 1949–2009

And then there stole into my fancy, like a rich musical note, the thought of what
sweet rest there must be in the grave.
—*Edgar Allan Poe, "The Pit and the Pendulum"*

In the early morning hours of January 19, 1949—the 140th birthday of poet and author Edgar Allan Poe following his mysterious death in October 1849—a heavily shawled man, dressed in black and carrying a silver-tipped cane, slipped into the Westminster Hall and Burying Ground at the corner of West Fayette and North Greene Streets in downtown Baltimore.[318] With great reverence and subtlety, he approached the site of Poe's original grave,[319] raised a glass of Martell cognac and whispered a few words of tribute. He left the half-finished bottle and an arrangement of three red roses before vanishing into the night. The tradition of the Poe Toaster was born.[320]

Every January 19th thereafter until 2009, the bicentennial of Poe's birth, this shadowy figure appeared, cloaked in all black, carrying a cane and wearing a wide-brimmed hat and a white scarf around his neck and face. And without fail, every year the Toaster raised a glass of Martell cognac (always leaving the unfinished bottle), murmured a brief toast and placed three red roses, believed to be in homage to Poe; his wife, Virginia; and his mother-in-law, Maria Clemm. Occasionally, the Toaster left notes. The content of these infrequent messages ranged from the romantically innocuous, such as "Edgar, I haven't forgotten you," to the more cryptic

A daguerreotype of Edgar Allan Poe in early summer 1849, just five months before his untimely death. *J. Paul Getty Museum.*

1993 decree "The torch will be passed," presumably indicating that a family member (one or two sons) of the Toaster would soon carry on the tradition. A note left in 1999 explicitly confirmed this suspicion.[321] The prose of post-1999 notes seemed out of the character of earlier ruminations, instead raising petty critiques of current events in sports and politics. For some, this signaled that the Toaster's successor(s) did not relish the role they inherited. Nevertheless, out of respect (and perhaps awe), onlookers never hindered the Toaster's ritual through the years, nor did they reveal his true identity.[322] Most preferred the mystery.

From 1977 until October 2012, Jeff Jerome, curator of the Edgar Allan Poe House and Museum, gathered together groups of fellow Poe enthusiasts to stake out the annual visit of the Poe Toaster.[323] Each year, participation in the vigil grew, especially after the publication of a July 1990 *Life* magazine article about the Toaster, which included the only known photograph of the veiled man in the act. As annual crowds swelled, Jerome managed to arrange the Toaster's unabated entrance to the gravesite by developing secret signals and entry points designed to circumvent onlookers and prevent his close interaction with them. In practice, the ritual was meant to remain intimate and singular, despite the tradition's larger appeal. But even though the Poe Toaster abandoned his annual act of devotion after January 19, 2009, and the tradition was officially declared dead by Jerome in 2012, crowds have continued to gather annually around the catacombs of the Westminster Hall and Burying Ground in the hopes that the *real* Toaster will reemerge, instead of the many imitators or "Faux Toasters," as they are dismissively known, who have tried in vain to assume the role.

Why has the tradition of the Poe Toaster resonated so strongly within the Baltimore community? Edgar Allan Poe is one of the most beloved and widely read writers in American literary history and one of the few to have called Baltimore home.[324] But more importantly, the macabre nature of Poe's writings themselves—often creeping around themes of death, decomposition and madness—has greatly contributed to the brooding allure the writer has come to enjoy in his eternal rest. The site of a graveyard, much less the one preserving the corpse of a literary legend, is embedded with its own wealth of symbolic significance and innate allusions to the cradle of death that seems to naturally attract visitors.[325] Combined with the backdrop of historic downtown Baltimore and the delightfully whimsical congregation of Poe and Toaster enthusiasts, the annual tradition took on a multilayered meaning for participants and the community at large.[326] What began as a singular act grew into a public event. Through the powerful veil of tradition

Edgar Allan Poe's famous gravesite, where the Toaster visited annually on January 19th from 1949 to 2009. *Courtesy of Aaron Patrick Vowels.*

and the performative rituals that made it unique, the Poe Toaster served as a catalyst for returning the nostalgia of Edgar Allan Poe's work and legacy to the hearts and minds of Baltimoreans and Marylanders alike. And while the tradition's apparent conclusion leaves a void, its sixty-year history has brought tremendous intrigue and wonderment to Poe's gravesite and the man entombed therein. It would indeed appear, in the fitting words of Poe himself, that "even in the grave, all is not lost. Else there is no immortality for man."[327]

Notes

Introduction

1. Furthermore, contrary to popular belief, legends are actually crafted, disseminated and meant to be interpreted as plausibly real, which we will extensively document throughout this book. See Dorson, "Legends and Tall Tales," and Carey, *Maryland Folklore and Folklife*, 32–42.

2. A number of scholars have produced fine publications aimed at illuminating the ins and outs of the folklore discipline for general audiences. For newcomers to the study of folklore, especially those interested in exploring the discipline beyond the state boundaries of Maryland, we highly recommend Lynne S. McNeill's *Folklore Rules*. See also Georges and Jones, *Folkloristics*, for a more expansive text. For a concise overview of the debates surrounding the definition and evolving scope of the folklore discipline, see also Blank, *Folklore and the Internet*. Finally, see Simon J. Bronner's bibliographic essay, "Folklore and Folklife Studies: The Discipline of Analyzing Traditions," in the May 2013 issue of *Choice*, which provides a very thorough annotated list of dozens of folkloristic publications organized by genre.

3. The "folk" have been defined by the late folklorist Alan Dundes as "*any group whatsoever* who share at least one common factor" in any social grouping (emphasis in original). Dundes, "Who Are the Folk?" 6–7.

4. For the purposes of this book, we will be (unsurprisingly) focusing our attention on Maryland as a regional context for the proliferation of legends.

5. Think of the children's game of "Telephone," in which the first player whispers a phrase or keyword to see how the message is humorously jumbled at the end of the line. While it is not a perfect analogy, it does underscore the innovative nature of sharing folklore in human communication: we borrow, we adapt and we advantageously craft our outward expressions of creativity to maximize their benefits in an interactive situation.

6. One of the lasting definitions of "folklore" came from Dan Ben-Amos, who in 1971 famously opined that folklore was "artistic communication in small groups." Ben-Amos, "Toward a Definition of Folklore," 13. While the folklore discipline eventually embraced a more inclusive definition, Ben-Amos's emphasis on communication remains a vital part of understanding what constitutes folklore.

7. See Blank, *Last Laugh*.

8. For more on Testudo and this particular tradition, see chapter 7.

9. Of course, this is merely one example of noteworthy campus traditions that can be found in existence throughout the state of Maryland and beyond. For an extensive study on the history and cultural significance of campus traditions in the United States, see Bronner, *Campus Traditions*.

10. See Bronner, *American Folklore Studies*. For an excellent overview of the historical arch of the folklore discipline within the United States, including its struggles for academic identity and legitimacy, see Bronner, *Folk Nation*.

11. The three books are similar in material. For those especially interested in Maryland folklore, there is also the *Final Report of the Study Commission on Maryland Folklife: With an Introductory Guide*, prepared by George Carey as part of a state-funded survey.

12. Carey, *Maryland Folk Legends*, vi.

13. Carey also had the Maryland Folklore Archives in College Park available to him, but that repository was in its nascent stage at the time of his writings.

14. Carey, *Maryland Folk Legends*, 71.

15. Ibid., vi.

16. See Helsel and Blank, *Spring Grove State Hospital*.

CHAPTER 1

17. A great deal has been written about legend tripping and ostension in folklore. Folklorist Linda Dégh is often credited with first bringing attention to the concept ("Haunted Bridges," especially 77–81). See also Bird, "Playing with Fear"; Dégh, "Does the Word 'Dog' Bite?"; Ellis, "Death by Folklore"; Holly and Cordy, "What's in a Coin?"; and Lindahl, "Ostensive Healing," for additionally thoughtful case studies and analyses of the form and functions of legend tripping. Additionally, see Koven, "*Most Haunted*."

18. Michael Duck, "The Story Beneath the Ruins: A History of St. Mary's College in Ilchester; Part I: From Tavern to Seminary," *The View* (Ellicott City), October 19, 2000. See also Lake, *Weird Maryland*, 233.

19. Duck, "Story Beneath the Ruins." Also, it bears noting that George Ellicott, Jr. went on to become the first mayor of the newly christened Ellicott City in 1867.

20. See Maryland Historical Trust, "Saint Mary's College," which includes detailed architectural information. Interestingly, the report notes the buildings to still be largely in "excellent" condition, a mere seven years after the institution had closed.

21. Ibid. See also Duck, "Story Beneath the Ruins" (Part I), and "The Story Beneath the Ruins: A History of St. Mary's College in Ilchester; Part II: Hell House," *The View*, October 26, 2000.

22. This particular arrangement lasted until 1907, when Ilchester became the site of the area's Novitiate, where it remained until 1972.

23. Some of these tales confused details and occurrences with concurrently circulating folklore about the nearby Patapsco Female Institute, which also was a large, abandoned building overlooking Ellicott City from atop a hill. Locals held that the Patapsco Female Institute opened in 1839 as a boarding school for wealthy young girls from the South who were to be taught how to act like proper southern ladies (in truth, it operated more like a Normal school, but there was indeed an effort to recruit students from both the North and South). Constructed of brilliant yellow granite and feathered with exquisite ornamentation and bold columns, it remained in operation until the 1890s. During World War I, the grounds served as a hospital and later a theater, and now they are partially restored as a historic park for preservation and community-use purposes at 3655 Church Road in Ellicott City, with tours running on Saturdays and Sundays at 1:30 p.m. from April through October. It is rumored that a former student,

Annie Van Derlot, died of pneumonia during her time as a student at the Patapsco Female Institute after her many letters home about the institute's deplorable living conditions went unnoticed by her parents down South. "Little Orphan Annie," as she is sometimes called, is said to still haunt the grounds to this day, and her story has further intrigued legend trippers while also confusing some through its unintended attribution to St. Mary's College. For more on the Patapsco Female Institute, see Lake, *Weird Maryland*, 191, and Varhola and Varhola, *Ghosthunting Maryland*, 296–97. See also www.friendsofpfi.org for more information on the community group that works to preserve the Patapsco Female Institute.

24. For the purposes of the story, disregard the incongruity of nuns working at a seminary instead of a convent. However, this incongruity further speaks to the folk confusion about intersecting details of St. Mary's College and the Patapsco Female Institute.

25. Many locals swear that they have seen corroborating news documentation of this grisly story, although no reputable examples appear to exist. Others say that the Catholic Church covered up the story and crime scene.

26. Indeed, making it to the upper house's second floor was often the ultimate test of bravery for legend trippers in the time that it was still standing.

27. See Jennifer Gunter, "Fire Destroys Historic Seminary in Ilchester," *Viaduct*, December 1997–January 1998. The article is largely a reprint of a November 16, 1997 letter to the editor published in the Howard County edition of the *Baltimore Sun* that briefly details the history of St. Mary's College and its later folklorization as "Hell House"—a local site for legend tripping. See also Maria Archangelo and Susan Thornton, "Old St. Mary's School Draws Teen Daredevils," *Columbia Flier*, May 23, 1996; Duck, "Story Beneath the Ruins" (Part II); and Varhola and Varhola, *Ghosthunting Maryland*, 66–78.

28. See Lake, *Weird Maryland*, 234, which briefly echoes narratives the authors have collected over the years.

29. Ibid. As the repetition of citations suggest, any discussion of legend tripping at Hell House invariably requires the mentioning of the caretaker in relation to the site's folklore. However, it should be noted that the materials presented about Mr. Hudson are extracted from newspaper reports and numerous vernacular accounts of legend trippers that do not necessarily reflect a complete or fair picture of the seemingly complex individual.

30. Archangelo and Thornton, "Old St. Mary's School." See also Varhola and Varhola, *Ghosthunting Maryland*, 71–72.

31. See Jean Thompson, "Caretaker in Ilchester Is Charged in Shooting," *Baltimore Sun* (Howard County edition), May 12, 1996, 6c.

32. For example, an unfounded rumor from 1997 suggested that the caretaker's dogs had been shot dead after the caretaker sicced them on Howard County police officers who found human remains (namely a skull) while investigating a complaint at the property.

33. Tanya Jones, "Suspicious Fire Destroys Former Seminary, College: Five-Story Structure in Ilchester Had Been Vacant Since 1970s," *Baltimore Sun*, November 2, 1997. See also Duck, "Story Beneath the Ruins" (Part II).

34. Varhola and Varhola, *Ghosthunting Maryland*, 72–77.

35. Motz, "Practice of Belief," 342; see also de Certeau, *Practice of Everyday Life*, 105–26.

36. See Holly and Cordy, "What's in a Coin?" for additional discussion on the important material culture aspect of legend tripping.

Chapter 2

37. It reached thirty-two acres in size by the time of its closing and was as large as fifty-two acres at one point.

38. Four generations of Harrisons worked at the Enchanted Forest during its run, and some other employees at the park also had a stable of family members who worked there over the years.

39. See Kusterer and Clark, *Enchanted Forest*, for a visually satisfying and readable history of the Enchanted Forest that includes many firsthand accounts of working and/or visiting the park. Their fine book is the lone contemporary (and accessible) publication pertaining to the Enchanted Forest available today. See also Lake, *Weird Maryland*, 228–29.

40. One blogger for the website io9 poetically described the abandoned grounds of the Enchanted Forest as "Candyland after a neutron bomb." See Kusterer and Clark, *Enchanted Forest*, 106–8, for a few narratives of vandalism taking place at the park—even while it was still in operation.

41. Kusterer and Clark, *Enchanted Forest*, 123–36.

CHAPTER 3

42. In Jewish folklore, for instance, a golem is an inanimate creature that transforms into an animated anthropomorphic being. One of the classic writings about this famed creature is Rosenberg, *Golem and the Wondrous Deeds*. For a more extensive academic treatise on the golem in Jewish folklore, see Idel, *Golem*.

43. Both Adams and Saint-Gaudens had remarkable public lives that greatly influenced American intellectual thought. Notably, Henry Adams penned the indispensable autobiography (written in third person) *The Education of Henry Adams* in 1905, which chronicles his life as a member of the Adams political family at the dawn of the twentieth century. For more on Augustus Saint-Gaudens and his distinguished career as a sculptor, see Wilkinson, *Life and Works of Augustus Saint-Gaudens*.

44. The University of Maryland Libraries' Special Collections are home to the Felix Agnus papers, which house a fine collection of various documents, correspondence and photographs from his life (especially surrounding his exploits as an officer during the Civil War); many of the materials have even been digitized. See hdl.handle.net/1903.1/1746 to view the abstract and other detailed information pertaining to the collection.

45. As a matter of course, Felix Agnus went on to successfully sue Eduard Pausch for misrepresenting his work as original.

46. Clearly, the statue was a major influence on local folk culture in the 1950s and '60s especially. To that point, the May 29, 1957 issue of the *Baltimore Sun* (page 26) features a brief story about four members of the "Black Aggies" gang who were imprisoned in youth court following their convictions of armed robbery. Interestingly, the article specifically notes that the gang was known for holding "nocturnal initiations in cemeteries."

47. George Carey (*Maryland Folklore and Folklife*, 35) shares a Black Aggie story collected in the late 1960s that asserts running around the statue three times will result in death two weeks later.

48. There are hundreds of individual accounts about Black Aggie that incorporate numerous variations of these narrative motifs; many are documented in the Maryland Folklore Archives at the University of Maryland Libraries' Special Collections. For some very brief personal narratives about Black Aggie, see Carey, *Maryland Folklore*, 93–97, and Lake, *Weird Maryland*, 14–17. See also Varhola and Varhola, *Ghosthunting Maryland*, 48–56, for discussion on both Black Aggie and the Druid Ridge Cemetery itself.

49. While the legend of Black Aggie is specific to Maryland, there are numerous other eerie statues across the country that have also attracted hordes of adolescent followers who make very similar claims about glowing eyes and harming pranksters. See Bird, "Playing with Fear," and Clements and Lightfoot, "Legend of Stepp Cemetery."

CHAPTER 4

50. See Brunvand, *Vanishing Hitchhiker*, 22–24, and especially Sanderson, "Folklore of the Motor-Car."
51. Dundes, "On the Psychology of Legend," 25.
52. Apparently in response to the number of tragedies occurring on the road, the state has installed guardrails and other safety measures in recent years.
53. These details have been verified, with minor variations, by dozens of informants throughout the area between 2004 and 2013. See also Lake, *Weird Maryland*, 180–81, and Varhola and Varhola, *Ghosthunting Maryland*, 298.
54. It is worth noting that many locals now report a much stronger police presence at night on College Avenue/Seven Hills Road as part of an effort to crack down on speeding through the area. So while the threat of a demon car may not slow down a thrill-seeker, the threat of a ticket and possible jail time for reckless driving may do the trick.
55. See chapter 5 of this book, which also details haunted places that specifically require a vehicle to enact the legend.
56. For more on the Toad Road legend, see Puglia, *South Central Pennsylvania Legends*, 138.
57. There is also a common variant where the gang member has to shoot the first motorist who flashes his or her lights.
58. See Brunvand, *Encyclopedia of Urban Legends*, 241–42, and Mikkelson, "Flashing Headlights."
59. The suspenseful deployment of high beams by a closely following unknown driver is also central to the plot of the urban legend "The Killer in the Backseat" (see Brunvand, *Vanishing Hitchhiker*, 52–53; Brunvand, *Encyclopedia of Urban Legends*, 229–30; Cord, "Further Notes"; Drake, "Killer in the Backseat"). Cars are often key actors in urban legends. Other noteworthy examples include, among others, "The Vanishing Hitchhiker"

(Bennett, "Vanishing Hitchhiker"; Brunvand, *Vanishing Hitchhiker*, 24–46) and "The Hook" (or "The Hook Man"), one of the more analytically dissected tales by folklorists. See Brunvand, *Vanishing Hitchhiker*, 48–52; Brunvand, *Encyclopedia of Urban Legends*, 199–201; Dégh, "The Hook"; Dundes, "On the Psychology of Legend," 29–31; and Ellis, "'The Hook' Reconsidered."

60. Outside of the main narrative with the demon car, some individuals have also reported seeing apparitions dressed in Victorian-era clothes standing on the side of the road. Such spectral sites have also been reported in Damascus, Gaithersburg, Hyattstown, Laytonsville and Urbana but without any connection to a particular site or local legend. There have been sightings of individuals in older-styled clothing around Governor's Bridge near Bowie who have apparently vanished when a car approaches (see chapter 5). It is likely that sightings of ghosts in Victorian garb extend far beyond one geographic part of the state—or country, for that matter.

Chapter 5

61. These patterns align with folklorist Linda Dégh's observation that legends about bridges often include stories of a mother and child killed on a bridge, either by suicide or murder ("Haunted Bridges," 83–86). Dégh also notes that train or automobile accidents are very common sources for bridge legends and ghost stories.

62. Dégh observes that the visit to a crybaby bridge "is a kind of test, one of the initiation rituals among the many [youths] have to pass as they leave childhood and make their way toward adulthood" ("Haunted Bridges," 81). See also Bird, "Playing with Fear."

63. To that point, the Aarne-Thompson (AT) *Motif Index of Folk Literature* correlates several themes found in legendary folklore about bridges, including: E332.1, "Ghost appears at bridge"; E334.2.2, "Ghost of person killed in accident seen at death or burial spot"; E334.4, "Ghost of suicide seen at death spot or nearby"; and E337.1.1, "Death sounds of mother and baby re-enacted," among others. These motifs are also briefly discussed in Dégh, "Haunted Bridges," 88. A free, online version of the index can be found at www.ualberta.ca/~urban/Projects/English/Motif_Index.htm.

64. See Lake, *Weird Maryland*, 176–79.

65. The threat of the severed hand was likely a folkloric deterrent aimed at youths who regularly parked off the road to go party or create mischief in the surrounding woods. In addition to these tales, the bridge is supposedly also a favorite spot of the Goatman (see chapter 11). For more on Governor's Bridge Road, including a brief version of the classic "Vanishing Hitchhiker" story set at the bridge site, see Lake, *Weird Maryland*, 168–69. See also Bennett, "Vanishing Hitchhiker," and Brunvand, *Vanishing Hitchhiker*, 24–46, for additional reading on the legend.

66. See Opsasnick, "Crybaby Bridge."

67. A few other locations throughout St. Mary's County boast strikingly similar versions of the legend that are attributed here to the Leonardtown crybaby bridge.

68. A variation has the man returning home from World War II and calling his wife to surprise her about his arrival. In an excited hurry, she wraps up their baby and heads out to the dark country road to greet him, but in his haste to get home—and the evening's poor visibility—he crashes into them; the wife dies instantly, and the baby goes flying into the stream below the bridge, setting up the legend.

69. Varhola and Varhola, *Ghosthunting Maryland*, 195–96. See also Lake, *Weird Maryland*, 179.

70. The original wood bridge has since been replaced with modern concrete, but the bridge has maintained its reputation nonetheless. See Braden, "Haunted Places," for additional insights into Carroll County's crybaby bridge.

71. Another site of legend tripping that also requires the use of a car takes place off Gapland Road in Burkittsville (Frederick County), which is home to "Spook Hill." Thrill-seekers drive to the site, place their cars in neutral and then eerily begin to feel their vehicles slowly coasting uphill. At night, some visitors pour baby powder or flour over their rear bumpers before going to Spook Hill; it is believed that doing so will reveal the tiny handprints of dead babies and children who were actually pushing the car. Some variations, particular only to the Frederick County area, suggest that the handprints are those of dead Civil War soldiers who perished nearby. These kinds of rituals and stories associated with cars drifting in defiance of the laws of physics have a long tradition throughout the United States; Maryland is merely home to a handful of so-called gravity hills or gravity roads, like the ones found in Burkittsville, Walkersville, Boonsboro and Soldier's Delight Park in Owings Mills. See Lake, *Weird Maryland*, 185–87, and for a Pennsylvania connection, Puglia, *South Central*

Pennsylvania Legends, 139–43. In any event, the common ritual of searching for dead baby handprints is reminiscent of crybaby bridge traditions and is thus worthy of mention.

72. It bears noting that this very bridge is rather close to a number of the legendary sites profiled in this book, including Hell House, Seven Hills Road and the Ilchester train tunnel mentioned in note 76. Ellicott City is well known for attracting ghouls and ghosts as part of its local folklore and celebrated heritage.

73. Lake, *Weird Maryland*, 180; Varhola and Varhola, *Ghosthunting Maryland*, 295.

74. The legend is also spelled "Bigg Lizz" to emphasize the headless slave ghost's impressive size. For additional versions of the tale, see Carey, *Maryland Folklore*, 39; Lake, *Weird Maryland*, 20–21; and Okonowicz, *Big Book of Maryland Ghost Stories*, 46–50. George Carey specifically cites "Gum Briar swamp" as Liz's main dwelling, but most informants associate her with Greenbriar swamp today.

75. The era varies from teller to teller; some place the story of Big Liz during the Revolutionary War, although the Civil War setting seems to be most popular.

76. Or vice versa (lights flashed six times, the horn honked three times). The prescribed number of honks and light flashes varies by teller, but three is a common thread in most variations. The beeping of the horn and/or lights three times is explicitly noted in an example of legend tripping at a haunted Indiana bridge by Dégh ("Haunted Bridges," 80). This correlation speaks to the traditionality of enacting these gestures at bridge sites as part of the legend rituals' ostensive action. Another local folk belief that requires a car for enactment takes place by the bridge near the Ilchester train tunnel in Howard County. Drivers who park at the site, turn off their cars and then beep their horns and flash their headlights three times will supposedly hear a train's horn but never see a train coming.

77. As it turns out, Maryland has an extensive history of folk narratives about headless ghosts. See Whitney and Bullock, *Folk-Lore from Maryland*, 183–84, entries 2712–2715, who report the widespread belief held throughout the state of Maryland that headless men inhabit nearly every alley in cities and that they appear in groves, ridges and bridges in the countryside. Tales of a headless horseman appearing as an omen of impending death were also reported in the early twentieth century. Carey, *Maryland Folklore and Folklife*, 34; Carey, *Maryland Folklore*, 39–40; and Varhola and Varhola, *Ghosthunting Maryland*, 297, recall the story of the Peddler's Run in Hartford County, where, after burying the beheaded corpse of a man found under nearby

rocks, a headless ghost was reportedly seen pushing a stick in the ground, perhaps looking for his missing cranium. See also Lake, *Weird Maryland*, 190. With regard to the treasure element of the Big Liz story, some motifs echo those of the Blue Dog legend described in chapter 8.

78. See also Okonowicz, *Big Book of Maryland Ghost Stories*, 40–41. In accounts from the 1960s onward, the suicides were usually prefaced by the victim parking his car on the bridge before taking his own life. The vast majority of these reported suicides were carried out by males.

79. The Suicide Bridge moniker has resonated so powerfully in Dorchester County that the road leading up to the Cabin Creek Bridge is officially called Suicide Bridge Road. And a local waterfront restaurant, serving up delicious, native Maryland cuisine, is proudly called the Suicide Bridge Restaurant. Now that's food for thought.

80. *Washington Post*, "Man in Bunny Suit Sought in Fairfax," October 22, 1970, B2; *Washington Post*, "The 'Rabbit' Reappears," October 31, 1970, B1.

81. Additional reports appeared in the *Washington Post* a short time after the initial story was printed, such as "Bunny Man Seen" (November 4, 1970) and "Bunny Reports Are Multiplying" (November 6, 1970).

82. Still, it is worth noting that Northern Virginia renditions of the Bunny Man legend include significantly deeper historical ties and claims and a wealth of additional beliefs that never took hold on the Maryland side of the Potomac River. Murder, for instance, is far more central to the Bunny Man legend as told in Virginia. See Conley, "Bunny Man Unmasked," for the most complete summary of the legend in both Maryland and especially Virginia.

83. Patricia C. Johnson's complete research materials can be found under "The Bunny Man" (May 12, 1973) in the Maryland Folklore Archives, Box 32, housed in the University of Maryland Libraries' Special Collections, College Park, MD. See also Lake, *Weird Maryland*, 12–13.

84. For more on Tucker Road, mostly in relation to the legend of Goatman, see Lake, *Weird Maryland*, 172–73, and chapter 11 of this book.

Chapter 6

85. Smith, "Read All About It!" 45.
86. *Baltimore Sun*, "A Haunted Vessel," January 8, 1855.
87. Ibid., "A Cecil County Ghost," June 18, 1883.

88. Ibid., "Cecil County Ghosts: Quickly Disappearing When a Little Sunlight Was Thrown on the Town," July 5, 1883.
89. A "purser" was the sailor responsible for handling the ship's money.
90. *Baltimore Sun*, "Frightened by a 'Ghost': Officers of Steamer *St. Mary's* Play Practical Joke on Companions," January 31, 1904.
91. Between the printing of the first and second stories, Leach ran down a thief. See *Baltimore Sun*, "Not a Ghost This Time: First Mate Leach Chases and Captures an Alleged Burglar," March 4, 1904.
92. *Baltimore Sun*, "This Steamboat Haunted? Officer of the *St. Mary's* Startled by Apparition in His Stateroom," October 23, 1904.

Chapter 7

93. Bronner, *Campus Traditions*, 27–28.
94. Ibid.
95. Hall and Martin, *University of Maryland Traditions*.
96. Tucker, *Haunted Halls*, 4.
97. Variants of this legend can be found in Okonowicz, *Big Book of Maryland Ghost Stories*, 218–19; and Swayne, *America's Haunted Universities*, 80.
98. Haunted Maryland Morrill Hall interview with Anne Turkos, October 2006. www.youtube.com/watch?v=buQKbZYNUj8.
99. For an accurate write-up, see Lake, *Weird Maryland*, 21. Our one contention is that students colloquially refer to the "Point of Failure" as the "Acropolis," even if that doesn't make as much sense.
100. This legend is tame and uplifting enough that the university actually encourages its telling. It is listed in the tour guide training manual, and prospective students will often hear it within the first fifteen minutes of the tour.
101. Variants of this legend can be found in Okonowicz, *Big Book of Maryland Ghost Stories*, 217–18, and Swayne, *America's Haunted Universities*, 81–82.
102. Haunted Maryland Rossborough Inn interview with Anne Turkos, October 2006. www.youtube.com/watch?v=buQKbZYNUj8.
103. Variants of this legend can be found in Okonowicz, *Big Book of Maryland Ghost Stories*, 216–17, and Swayne, *America's Haunted Universities*, 187.
104. While the Len Bias legend is not as likely to be included in campus tours because of its sad and disturbing content about a promising young man (in contrast to the cuter, older Marie Mount), it is in active circulation

on the campus. The University of Maryland did give a nod to this legend in the "Dorms of Doom" section of its "Mysterious Maryland" exhibit. Variants can also be found in Okonowicz, *Big Book of Maryland Ghost Stories*, 215, and Varhola and Varhola, *Ghosthunting Maryland*, 138.

105. "All About Testudo," University of Maryland. www.umd.edu/testudo.html.

106. The Spartans use this defensive formation to defend against a barrage of Persian arrows in the film *300* (2006). After the Persians threaten to "blot out the sun," Leonidas orders his men to "fight in the shade"—the testudo formation—by yelling "turtle."

107. *The Diamondback*, "Testudo Catches on Fire," December 18, 2013.

108. *Baltimore Sun*, "Hopkins-Maryland Series Has Turbulent History," April 11, 2009.

109. Ibid.

110. See Bronner, *Piled Higher and Deeper*, 179–85; Dorson, *American Folklore*, 254–55; and Mikkelson, "Statue Cue."

111. *The Diamondback*, "Making Love in McKeldin Library," November 22, 2010.

112. Ibid., "Library Is a Place of Learning, and Recently, Indecent Exposures," October 15, 2002.

113. No pun intended.

114. *The Diamondback*, "College Park Perversions," September 30, 2007.

115. Ibid., "Man Masturbates on Shuttle-UM Bus," February 6, 2007.

116. Ibid., "Student Groped by Masturbator," October 8, 2008.

117. See Bronner, *Campus Traditions*, 202–3.

118. Mikkelson, "Playboy's Party Schools."

119. Dorson, "Defining the American Folk Legend," 3–14. See also chapter 9 of this book.

120. To review the entire story in its original, literary version, see Donald Pease's gray paper "I'd Rather Be Studying: The True Story of Sarah Bellum," www.docstoc.com/docs/2291118/ID-RATHER-BE-STUDYING-The-True-Story-of-Sara-Bellum. Another version appeared in *The Diamondback*, "To Be, or to Study," October 3, 1988.

121. Author David J. Puglia is proud to say he took the same course with the same professor twenty-four years later and did not die.

122. This is a fairly common occurrence in the college classroom, usually due to too much drink, not enough sleep and no breakfast. Thankfully, none of our students have ever died. The less dramatic ones endear themselves to their classmates by vomiting into the classroom trashcan, usually on Friday mornings.

CHAPTER 8

123. The essay was penned by Moncure D. Conway and titled "The Pedigree of the Devil: Traced on the Tercentenary of Mephistophiles [*sic*]."

124. "American Fact Finder," United States Census Bureau. factfinder2. census.gov/faces/nav/jsf/pages/index.xhtml.

125. Most versions of the Blue Dog legend hold that the phantom ghost is a bluetick coonhound, a hunting breed known for its great scent-hunting nose and bluish coat due to its inherited "ticking" pattern; the bluish hues are supposedly even more evident when the beast is guarding his master's treasure. That said, others have speculated that the breed was an English mastiff, a giant dog known for its fierce loyalty. The proprietors of a local Port Tobacco restaurant, aptly named the Blue Dog Saloon, even commissioned a painting by a local artist to encapsulate the legend's essence, and an English mastiff is featured. These derivations are significant in that they underscore the evidence for repetition and variation, which are so central to diagnosing the folkloric qualities of a narrative.

126. The home has had many owners over the years, including Confederate spy Olivia Floyd in the late 1800s. Floyd reported to a local newspaper in 1897 that she personally saw the ghostly Blue Dog roaming her property on numerous occasions, lending further credence to the legend's veracity.

127. For another variant example, see "The Blue Dog of Rose Hill," as mentioned in Carey, *Maryland Folk Legends*, 53–54. While Carey's collection is brief, it nevertheless reveals the continuity of the legend into the present and thus connotes its traditionality. See also Varhola and Varhola, *Ghosthunting Maryland*, 196–98, and Whitney and Bullock, *Folk-Lore from Maryland*, 184, entries 2717–2720. Whitney and Bullock report on several stories of a black "Phantom Dog" in Emmitsburg, Maryland (Frederick County), and claim that the "Phantom Dog has been known in this region for a hundred years or more," adding that the pooch is supposed to be the spirit of a cruel man who previously owned the land. It is impossible to detect if there are direct correlations between the ghost dogs of Emmitsburg and Port Tobacco, but in the interest of documenting repetition and variation, they are important similarities and geographic proximities worth noting. Cannon and Whitmore, *Ghosts and Legends*, 51–53, do seem to conflate these two stories' relationship, and they curiously retell the legend of the Blue Dog using the backdrop of Frederick County instead of Port Tobacco.

128. In following the Aarne-Thompson (AT) *Motif Index of Folk Literature*, we can see that the Blue Dog legend embodies several distinct narrative patterns traditionally found in folklore, such as AT B153, "Dog indicates hidden treasure." It is also pertinent to note that the Blue Dog legend follows AT E574, "Appearance of ghost serves as death omen," and AT E575, "Ghost as omen of calamity or ill fortune" are of English and Scottish origin (and indeed, the Blue Dog story may have originated there before morphing in the colonies); the specter in this tale is an animal. Of course, there are endless motifs with this tale—as with many of the narratives profiled in this volume—that can be aligned with derivatives found in the *Motif Index of Folk Literature*. See also chapter note 63.

CHAPTER 9

129. The Bill Gifferson story is also retold in Boyton, *Snallygaster*, 13–14, 63–64; and Cannon and Whitmore, *Ghosts and Legends*, 54.

130. See Boyton, *Snallygaster*, 18; Cannon and Whitmore, *Ghosts and Legends*, 55; Fair, *Mysteries & Lore*, 16; and Lake, *Weird Maryland*, 72–73, for cross-referenced accounts of these details. It is also worth noting that in April 1909, shortly after the end of his second term as president, Teddy Roosevelt, along with his son, Kermit, and a small team of naturalists and journalists, did indeed set out for Africa to hunt big game, interact with native tribes throughout the Dark Continent and collect specimens for the Smithsonian Institution. In his travels, Roosevelt bagged over 1,100 specimens, which included lions, rhinoceros and elephants; he heartily chronicled his adventures in the book *African Game Trails: An Account of the African Wanderings of an American Hunter-Naturalist* (1910), which has since been reprinted many times over.

131. Boyton, *Snallygaster*, 15–16.

132. In addition to primary sources, see Boyton, *Snallygaster*, 28; Cannon and Whitmore, *Ghosts and Legends*, 56; and Fair, *Mysteries & Lore*, 18, for further documentation of these reported claims and descriptions.

133. Some speculation, largely propagated by local Frederick newspapers, suggested that the slain Snallygaster of 1932 managed to lay eggs before meeting its end, even reasoning that its spawn could be born earlier than the necessary twenty- to twenty-five-year span on account of extremely hot temperatures befalling the region in the mid-1930s. For specific examples of random Snallygaster sightings from the time of its supposed

death in December 1932 through August 1953—before the legend began to merge with public perceptions about the burgeoning Dwayyo—see Boyton, *Snallygaster*, 35–39.

134. *Baltimore Sun*, "Flying Saucers Pretty Tame Beside Flying Snallygaster," July 8, 1947, 30–31. The article highlights how Marylanders interpret the threat presented by flying disks and saucers as laughable in comparison to the flying monster they have already come to know. This sentiment was further espoused in the July 8, 1947 edition of the *Frederick News*, which also scoffed that talk of flying saucers cause "little reaction in Middletown valley" considering that residents "have had snallygasters to talk about since 1909."

135. *Baltimore Sun*, "Could It Have Been a Snallygaster?" July 28, 1949, 14.

136. See also George May, "You'd Better Watch Out: 'Dwayyo' Could Be a Modern Snallygaster," *Frederick News*, December 3, 1965, 1; *Baltimore Sun*, "Between 'Dwayyo' and 'Snallygaster': Sykesville 'Thing' Sought," June 12, 1973, C6; and *(Hagerstown) Morning Herald*, "Mystery Monster Reappears," June 12, 1973, 1.

137. The famed "Patterson-Gimlin film," which purports to show the first substantial video evidence of the elusive cryptid Bigfoot, was released in 1967. It sparked significant interest in tracking and documenting the existence of Bigfoot into the 1970s (and to a lesser extent into the present). The short film has had a sustained influence on generations of believers who often credit the clip as being the most conclusive proof of Bigfoot's existence in North America ever captured. Skeptics, of course, think this is all silly.

138. See Gordon Chaplin, "The Grand Bicentennial Washington Post/ Potomac Expedition to Darkest Maryland in Search of the Monstrous Snallygaster," *Washington Post*, October 10, 1976. Chaplin's snarky report chronicles the *Washington Post*'s grand expedition into Baltimore and Anne Arundel Counties in search of the Snallygaster during the fall of 1976. The dispatch is an unabashed attempt at gonzo journalism, clearly modeling the Snallygaster of 1976 after the increasingly ubiquitous Bigfoot; the two creatures are even directly described as sharing similar apelike qualities, including shaggy hair. The *Post*'s hunt is also profiled in Boyton, *Snallygaster*, 43–52.

139. Once removed from its role as a community menace, the Snallygaster also found a niche within popular culture as the name of a Mountain Dew and vanilla ice cream float advertised in the 1960s (this concoction was to be distinguished from the Snow White, a float composed of vanilla

ice cream and either Sprite or 7-Up). The reptilian bird even had a cameo in a Flintstones' children's book in 1972, albeit in the form of a backward-flying lion with very sharp claws and an airplane propeller for a nose that supposedly lives in old bowling alleys. More recently, on October 19, 2013, Washington, D.C., played host to "Snallygaster," a self-described gargantuan beer jamboree that raised money for the Arcadia Center for Sustainable Food and Agriculture in nearby Alexandria, Virginia.

140. Fair, *Mysteries & Lore*, 21; see also Boyton, *Snallygaster*, 59.

141. Fortunately, Maryland voters rejected the proposed amendment later that year.

142. Boyton, Snallygaster, 64–65.

143. See Schultz, *First Settlements of Germans*. The Library of Congress has recently made this historical title available for free download at archive. org/stream/firstsettlements00schuitz.

144. Over time, this creature came to be known as the "Jersey Devil" and still persists in state folklore today. For a thorough academic analysis of the Jersey Devil with folkloristic considerations, see Gillespie, "Jersey Devil." See McCloy and Miller, *Jersey Devil* and *Phantom of the Pines*, for two popular collections of the beast in regional folklore.

145. As briefly discussed in the "Studying to Death" section of chapter 7.

146. Adding to this definition, Dorson asserts, "These productions are not collected in the field but are rewritten from earlier literary and journalistic sources in an endless chain of regurgitation" ("Fakelore," 60); see also Dorson, "Folklore and Fake Lore." As the main proponent for snuffing out fakelore, Dorson published a number of articles and later expanded his argumentation in book form (*Folklore and Fakelore*). See Dundes, "Nationalistic Inferiority Complexes," for a critique of Dorson's conceptualization and subjugation of fakelore.

147. Dorson, "Response to Perdue's Review," 86.

148. Although the creation of the Snallygaster was fabricated by unscrupulous businessmen, there is room to appreciate the stories' deployment of traditional motifs and ability to inspire oral tradition. To be sure, the various reports of the Snallygaster were routinely well written and highly entertaining. As bodies of fiction, there is scarce room for complaint. However, as materials packaged as genuine folklore from north central Maryland, the texts are problematic.

Chapter 10

149. Dahlgren, *South Mountain Magic*, 40–47.

150. See chapter 9 of this volume.

151. Whitney and Bullock, *Folk-Lore from Maryland*, 183–85.

152. Opsasnick, *Maryland Bigfoot Digest*.

153. This is a true account of an authentic experience from a real person. Author David J. Puglia interviewed Debbie Kettles in Frederick, Maryland, on November 25, 2013.

154. Referring to Frederick's local paper at the time as the *Frederick News-Post* is technically an anachronism. At the time of the Dwayyo reports, there was a morning paper, the *Frederick Post*, and an evening paper, the *Frederick News*, authored and published by the same company. The two later combined into the *Frederick News-Post*. As distinguishing between the two in the text would add little but confusion, we will refer to the paper and its journalists as the *News-Post*, a convenience the staff used at the time. It would later become the paper's official title. Throughout our notes, we have distinguished between morning (*Post*) and evening (*News*) printings for citation clarity.

155. *Frederick News*, "Unknown Animal Battled by Anonymous Gladiator," November 30, 1965.

156. *Frederick Post*, "'Dwayyo' Monster Is Still Running Loose," December 2, 1965.

157. Ibid.

158. Ibid.

159. Ibid.

160. Note the similarities to Debbie Kettles's report made approximately twenty years later.

161. *Frederick Post*, "Elusive 'Dwayyo' Still Uncaptured," December 3, 1965.

162. Ibid.

163. The Dwayyo may look like a big dog when on all fours, or this may be a separate legendary creature, the Snarly Yow, reported around the South Mountain area for decades.

164. *Frederick News*, "'Dwayyo' Could Be a Modern Snallygaster," December 4, 1965.

165. See also chapter 9 of this volume.

166. *Frederick Post*, "Dwayyo Hunt Planned," December 7, 1965.

167. Ibid.

168. Ibid.

169. *Frederick Post*, "Dwayyo Hunt Flops," December 10, 1965.

170. Ibid., "Dwayyo for Christmas?" December 16, 1965.

171. Dorson's final book (*Man and Beast in American Comic Legend*) was devoted to American comic creatures.

172. Dorson, *Man and Beast in American Comic Legend*, 4–5.

173. *Frederick News*, "Unknown Animal Battled."

174. *Frederick Post*, "'Dwayyo' Monster Is Still Running Loose."

175. *Frederick Post*, "Dwayyo Hunt Planned."

176. Ibid.

177. The poem can be read in its entirety in the second epigraph at the beginning of this chapter. It was composed anonymously by a Frederick woman at the American Optical Plant.

178. Dorson, *Man and Beast in American Comic Legend*, 4–5, notes the difficulty of finding traditional legend texts for American cryptids, since "they rarely do anything; the narrative action is lacking." In their case, "what counts is the mere existence of these grotesque species, verified in terms of their appearance and habits. So descriptions of the beasts easily take the form of loose paraphrase or generalized accounts."

179. Dégh and Vázsonyi, "Dialectics of the Legend," 37.

180. Ibid.

181. Smith, "Read All About It!" 42–44. The Internet now tops them all.

182. See Dorson, "Defining the American Folk Legend," 160.

183. Dundes, "Foreword," xvii.

184. Ibid.

Chapter 11

185. An expanded version of this chapter essay will appear in a forthcoming issue of *Contemporary Legend: The Journal of the International Society for Contemporary Legend Research* under the title "Getting Maryland's Goat: Origin, Dissemination, and Meaning of Prince George's County's Goatman," by David J. Puglia.

186. The most comprehensive research to date is Opsasnick, "Horror on Fletchertown Road." Lake, *Weird Maryland*, 77–79, 170–73, is helpful as well.

187. George Lizama, "The Goatman of Tucker Road," 1971, Maryland Folklore Archives (Maryland Room, Hornbake Library, University of Maryland).

188. Karen Hosler, "University Archives Reveals: Boaman, Goatman, and Ghosts Still Haunt Area," *Prince George's County News*, October 27, 1971.

189. Ibid.

190. Karen Hosler, "Residents Fear Goatman Lives: Dog Found Decapitated in Old Bowie," *Prince George's County News*, November 10, 1971.

191. Opsasnick, "Horror on Fletchertown Road," 72.

192. Less than two weeks after her first story, Karen Hosler reported again. This time the headline read "Residents Fear Goatman Lives: Dog Found Decapitated in Old Bowie."

193. Clay Schofield, "Legends of Bowie," 1972. Maryland Folklore Archives (Maryland Room, Hornbake Library, University of Maryland).

194. von Sydow, "Geography and Folk-Tale Oicotypes," 139.

195. In the traditional "Boyfriend's Death" narrative, a couple is on the way to a party when their car breaks down. They are on a dark, secluded road a couple miles from the nearest service station. The boy tells his girlfriend that he will go for help. He insists that while he is gone she should stay in the backseat with a blanket over her. They establish a code. When the boyfriend returns, he will knock three times. Otherwise, the girl should remain hidden. Soon after her boyfriend leaves, the girl hears a scratching on the roof of the car. Frightened, she stays hidden. She soon falls asleep, only to wake to the sound of knocking. Thinking it is her boyfriend, she springs up to find a police officer peering through the window. He tells her to step out and walk directly to his car, explicitly commanding her to only look straight ahead after exiting the vehicle. Unable to resist, she turns around to see what the police are hiding from her. Hanging from a tree at the side of the road, her dead boyfriend swings in the wind, the tips of his feet scratching the roof of the car. See Brunvand, *Vanishing Hitchhiker*, 5–10, for a more thorough overview of the "Boyfriend's Death."

196. Anne Duley remembers parking did not happen on Tucker Road during her teen years. Her recollections have been preserved in the Maryland Folklore Archives. Rose Anne Duley, "Goatman Tales," 1975. Maryland Folklore Archives (Maryland Room, Hornbake Library, University of Maryland).

197. Ivan G. Goldman, "A Legendary Figure Haunts Remote Pr. George's Woods," *Washington Post*, November 30, 1971.

198. Trish Wilson, "Bowie Legends," 1990. Maryland Folklore Archives (Maryland Room, Hornbake Library, University of Maryland).

199. See Carey, *Maryland Folklore and Folklife*.

200. By comparison, the present-day status of the legend compelled the author of *Weird Maryland* to dedicate three separate sections to the Goatman and include an illustrated rendition of him on the title page (Lake, *Weird Maryland*, 77–79, 170–73).

201. Trish Wilson, "Bowie Legends," 1990. Maryland Folklore Archives (Maryland Room, Hornbake Library, University of Maryland).

202. Karen Hosler, "Pranksters and Thrill-Seekers: The Real Monsters of Fletchertown Road," *Prince George's County News*, November 24, 1971.

203. Goldman, "Legendary Figure Haunts."

204. Karen Hosler, "University Archives Reveals: Boaman, Goatman, and Ghosts Still Haunt Area," *Prince George's County News*, October 27, 1971.

205. Paul Smith discusses the possibility that a newspaper legitimizes a legend simply by putting it in print (see "Read All About It!" 66).

206. This information was gleaned from an article titled "Body Found in Stream." It was found as a clipping in the Maryland Folklore Archive, and while we have been unable to establish its exact source or date, it had to be published prior to June 28, 1974.

207. Eugene L. Meyer, "Lottsford Road: Local Legend Says It's a Trail of Terror," *Washington Post*, October 1, 1984.

208. Ibid.

209. As recorded by Carolyn Hoffman, "Local Legends of Lottsford Road Area," 1974, Maryland Folklore Archives (Maryland Room, Hornbake Library, University of Maryland).

210. Ibid.

211. Ibid.

212. Duley, "Goatman Tales."

213. There seems to be a partial, unconscious reference to Spiderman's origin story, developed the previous decade for teenagers and popular among that demographic. For more, see Wright, *Comic Book Nation*, 223.

214. Mark Lawler, "Legends of Bowie Maryland," 1983, Maryland Folklore Archives (Maryland Room, Hornbake Library, University of Maryland).

215. By 1986, University of Maryland student Ian McKeller had collected several examples of "The Boyfriend's Death" legend circulating in Prince George's County. Labeled "Goatman" stories, McKeller's narratives only had an implied relationship. One legend teller began with the caveat that he could not remember if they blamed his recited story on Goatman or not. For more, see Ian McKeller, "The Goatman and Crybaby Bridge: Local Legends of Lottsford Road," 1986, Maryland Folklore Archives (Maryland Room, Hornbake Library, University of Maryland).

216. Wilson, "Bowie Legend."
217. Goatman Hollow is a theatrical haunted house attraction in Prince George's County. It has faced financial instability the last few years.
218. The surprise hit film *The Blair Witch Project* (1999) is a pseudo-documentary set in Burkittsville, Maryland, about a "Maryland legend" with no actual basis in oral tradition. Regardless, the filming technique—students with handheld cameras—allowed for an easy hybridization of two of Maryland's best-known legends, one folk and one popular. YouTube hosts dozens of homemade productions of Goatman/*Blair Witch Project*, the quality varying from handheld camera at best to cellular telephone at worst.
219. The Greek god Pan also fits this description.
220. Jenkins, "Goatman of Prince George's County."
221. Matthew 25:41, Holy Bible (King James Version).
222. See Siddle, "Goats, Marginality."
223. Ibid., 521, 524.
224. Ibid., 527.
225. Ibid., 530.
226. Lizama, "Goatman of Tucker Road."
227. Goldman, "Legendary Figure Haunts."
228. Jenkins, "Goatman of Prince George's County."
229. For more on this type of interpretation, see Dundes, "Projection in Folklore."
230. In addition to the collections at the Maryland Folklore Archives, former local residents Mark Opsasnick (2007) and Father Joe Jenkins (1998) remember the time fondly.
231. For more on why individuals hunt, see Bronner, "'This Is Why We Hunt,'" 27.

CHAPTER 12

232. Wilson, "Deeper Necessity," 400.
233. Kurin, "Folklife in Contemporary Multicultural Society," 251.
234. Tucker, *Haunted Halls*, 4–5.
235. For more on the idea of legend as news, see Oring, "Legend, Truth, and News." See also Brunvand, "Folklore in the News," and Smith, "Read All About It!"

236. The nickname "Peeping Tom" is derived from the story of Lady Godiva, wherein a male voyeur watches the naked Godiva ride on horseback from an undisclosed distance. Today, the label refers primarily to a male who, from afar, secretly watches a woman in various stages of undress or sexual activity.

237. For one, cuddling sounds cute, when the man is, in fact, a sex offender.

238. *Washington City Paper*, "The Washington Post Goes Cuddler," January 11, 2010.

239. The incidents made the campus newspaper *The Diamondback* several times. These include "Peeping Tom Causes Residents to Take Precautions," January 26, 2007; "'Peeping Tom' Strikes Again," January 27, 2007; and the "Police Try to Combat Peeping Tom," February 2, 2007.

240. *The Diamondback*, "Four Sex Crimes Reported Downtown," September 14, 2007.

241. To respect the privacy of the victim, the police and journalists sometimes mentioned "sexual assault" without going into specifics.

242. *The Diamondback*, "City 'Cuddler' Assaults Two Women," March 3, 2008.

243. Ibid., "Sex Offense and Burglary Reported in Leonardtown Apartment," September 9, 2011.

244. Site proprietor Sarah Tincher deleted the comment, but in her guest column, she reprinted it. See *The Diamondback*, "Secret Cuddler Hoax," February 9, 2012.

245. The Zodiac Killer—a serial murderer never caught by law enforcement—taunted the San Francisco Bay area media with letters and cryptograms in the late 1960s.

246. *The Diamondback*, "Secret Cuddler Hoax," February 9, 2012.

247. Not that these "associations" are often accurate anyway. See "How Some Children Played at Slaughtering" and "The Juniper Tree," collected by the Brothers Grimm, for two fairy tales distinctly lacking in cuteness.

248. The legendary McKeldin Masturbator in chapter 7 serves the same function.

Chapter 13

249. The "Bay State," on the other hand, refers to Massachusetts.

250. Maryland, of course, was a slave state in the pre–Civil War era. Coined by *Baltimore Sun* editor Hamilton Owens, the "Free State" moniker refers to Prohibition, not slavery.

251. This nickname refers to the state's geographic diversity. See the foreword for folklorist Charles Camp's musings on "Little America."

252. Walsh, *Handy-Book of Literary Curiosities*, 842.

253. Beach and Rines, *Encyclopedia Americana*, no page numbers, entry listed alphabetically under "Old Line State."

254. Harbottle, *Dictionary of Historical Allusions*, 179.

255. These were at least strategic victories for the Americans, if Pyrrhic victories for the British.

256. To read more about *only* 1776, see McCullough, *1776*.

257. The British took the hill but at a great cost and little strategic value. It was a moral victory for the Americans.

258. For more on the Battle of Bunker Hill, see Ellis, *Battle of Bunker Hill*.

259. For more about the daily life of the soldier in the American Revolution, see Volo and Volo, *Daily Life*.

260. The officer in question was James Grant, a member of Parliament at the time. He would later participate in the Battle of Long Island.

261. Fiore and Schruth (*Noble Train of Artillery*) commit an entire book to Knox's "Noble Train of Artillery."

262. Many American historians have told the story of the Siege of Boston and the Battle of Long Island. Two good, modern starting points for an overview of the American Revolution in 1775–76 are Fischer, *Washington's Crossing*, and McCullough, *1776*. For firsthand soldier accounts, see Fields, *Battle of Long Island*, 313–535.

263. Specifically on the impressive, disciplined and well-armed Maryland troops, see McCullough, *1776*, 185.

264. For an overview of the role of New York in the American Revolution, both inside and outside 1776, see Roberts, *New York in the Revolution*, and Abbott, *New York in the American Revolution*.

265. For a good review of the British movements, see Fischer, *Washington's Crossing*, 77–84.

266. Yes, one self-styled "Lord" fought for the American cause.

267. Fields, *Battle of Long Island*, 475.

268. The British used local Loyalist farmers as guides.

269. Although the reader can glean the facts of the American Revolution from numerous secondary sources, those particularly interested in the Battle of Long Island are encouraged to review the voluminous primary documentation available. In the days before and after the Battle of Long Island, troops on both sides wrote an abundance of letters. These extracts are compiled in volumes. Reading the soldiers' letters, especially the Americans'

immediately following, evokes a rare, visceral sense of history. Although an enlisted soldier's situational awareness during a battle is limited, read in quantity, the larger narrative of the battle comes through well. To pull specific details for the battle, we used Fields, *Battle of Long Island*, 313–535.

270. Although often evoked to show how impressed he was with the Maryland line, Washington's tone was most certainly somber. He had just wasted his best troops in a futile defense.

271. Fields, *Battle of Long Island*, 475.

272. Ibid., 528.

273. Irving, *Life and Times of George Washington*, 265.

274. McSherry, *History of Maryland*, 201–3.

275. See Cialdini et al, "Basking in Reflected Glory," 366.

276. Ibid.

277. See Polk, "Holding the Line," for a review of his archival research. Polk thinks "Old Line State" existed in the early nineteenth century but only in oral tradition. In his research, Polk tracks the growth from oral tradition to documented speech to the written word over a period of seventy-five years.

278. Polk, "Holding the Line."

279. Ibid.

280. The *Maryland Manual* tells the legend to this day. The *Maryland Manual*'s rendition of the legend is available in its online form at msa.maryland. gov/msa/mdmanual/01glance/html/nickname.html.

281. Polk, "Holding the Line."

282. Maryland's folklore journal, on the other hand, chose to go with *Free State Folklore*. The quote is from Polk, "Holding the Line."

283. Martin O'Malley was elected governor of Maryland in 2006. He was reelected in 2010.

284. Author David J. Puglia was there to experience this firsthand.

285. A transcription of Governor O'Malley's speech is available online at martinomalley.com/2012/09/04/dnc2012.

286. Ibid.

CHAPTER 14

287. "Freitchie" is the Germanic spelling of "Fritchie."

288. Again, this is a summary of the narrative of the poem "Barbara Frietchie," as told by John Greenleaf Whittier.

289. Although factual, the exact path from Frederick to E.D.E.N. Southworth varies from historical account to historical account. For two early, well-written, similar but ultimately different accounts, see Dall, *Barbara Fritchie*, and Nixdorff, *Life of Whittier's Heroine*.

290. Pickard, *Life and Letters of John Greenleaf Whittier*, 454.

291. Even among historical accounts, Barbara Fritchie's age fluctuates between ninety and ninety-nine. The one consistency is that Barbara Fritchie is always a nonagenarian and, therefore, always older than the United States.

292. This is not true. Barbara Fritchie died on December 18, 1862, a full three months later.

293. Pickard, *Life and Letters of John Greenleaf Whittier*, 454–56.

294. Ibid., 456–57.

295. For two accounts disputing that Jackson passed Barbara Fritchie's house, see Scharf, *History of Western Maryland*, 566, and Douglas, "Stonewall Jackson in Maryland."

296. *Frederick News-Post*, "The Ballad of 'Barbara Frietchie': Is Her Story Truth, Fiction or Somewhere in Between," July 1, 2012.

297. Ibid.

298. In the nineteenth century, a local historian did not remain in his position by robustly criticizing his constituency. Scharf took great care to assure his readers that his historical analysis of "Barbara Frietchie" was merely an academic exercise and in no way was meant to detract from the greatness of the poem.

299. Scharf, *History of Western Maryland*, 565–66.

300. Ibid.

301. Quoted in Scharf, *History of Western Maryland*, 566.

302. This fragment of Jacob Engelbrecht's diary is quoted in Scharf, *History of Western Maryland*, 566.

303. Douglas, "Stonewall Jackson in Maryland."

304. Ibid., 286.

305. It hadn't, but Whittier was under that impression from E.D.E.N. Southworth's account.

306. Whittier, "Correction from Mr. Whittier," 783. Whittier's last sentence is probably a subtle dig at Major Douglas's allegiance to Stonewall Jackson.

307. Pickard, *Life and Letters of John Greenleaf Whittier*, 457.

308. Ibid., 458.

309. *Frederick News-Post*, "Ballad of 'Barbara Frietchie.'"

310. Dorson, "Defining the American Folk Legend," 160.

311. David J. Puglia argues that one of the primary functions of local legendry is to help "explain why a town is important, no matter how small," calling this the "Horton Effect" ("Toying with Corporate Narratives," 85).

312. The Barbara Fritchie House is a popular tourist attraction, but the house is, in fact, a replica. A flood swept away the original long ago.

313. A part of Route 40 West, the Golden Mile was the traditional retail hub of Frederick into the 1990s. The changing economy has had a negative effect on the area in recent years.

314. Although used for a variety of occasions, the Frederick Fairgrounds' most important function is as home to the annual Great Frederick Fair.

315. Depending on the source, Churchill recited somewhere between eight lines and the entire poem. For example, see Gardella, *American Civil Religion*, 85; Heidenrich, *Frederick*, 119; and Schildt, *Frederick in the Civil War*, 76.

316. Scharf, *History of Western Maryland*, 565.

317. For example, Nathaniel Hawthorne said about an earlier work, "Whittier's book is poor stuff! I like the man, but have no high opinion either of his poetry or his prose." Later, Karl Keller, commenting on the depth of Whittier's poetry, said, "Whittier has been a writer to love, not belabor." Hawthorne is quoted in Woodwell, *John Greenleaf Whittier*, 252; and Keller is quoted in Gioia, "Longfellow," 80.

CHAPTER 15

318. January 19, 1949, wasn't just noteworthy for being Poe's 140th birthday; it importantly marked the centennial birthday following Poe's death. The symbolic allure and significance of the "100 years" span undoubtedly contributed to the timing behind the burgeoning tradition's first observed enactment.

319. Poe's remains were moved to a new, larger monument (as pictured) also at Westminster Hall and Burying Ground. The new arrangement was dedicated on November 17, 1875. The remains of Poe's wife and mother-in-law were also eventually brought to Baltimore so that the three family members could be alas reunited in death. A marker at the site of Poe's original burial ground distinguishes the location.

320. It is important to note that some fans of the Poe Toaster argue that the tradition began sometime in the 1930s, but supporting evidence is lacking. The ritual has definitely been observed and documented since at least

1949, which is why the date has been deemed more accurate. See James H. Bready, "Westminster Presbyterian Church Marks Two Milestones This Year," *Baltimore Evening Sun*, September 22, 1950, 31. The article briefly profiles the apparent "jokester" who had at that time been leaving annual tributes at Poe's gravesite for the last two years.

321. This note also revealed that the original Toaster had passed away but that the family tradition would remain intact.

322. That being said, several individuals have come forward to stake a claim, only to be largely discredited.

323. See Maura Judkis, "Edgar Allan Poe 'Toaster' Tradition Is No More," *Washington Post* (The Style Blog), January 19, 2012.

324. After all, Poe's impact on both the Baltimore region and broader American culture was significant enough even to inspire the Baltimore Ravens football team to adopt its namesake from his wildly popular poem "The Raven" in 1996.

325. See Varhola and Varhola, *Ghosthunting Maryland*, 34–45. Holly and Cordy, "What's in a Coin?" extensively discuss how cemeteries have been repeatedly designated as locations for symbolic interaction by various social groups and how the impetus for their collective activities is often directly related to activity at a specific marker or location within the graveyard.

326. This would further explain the appearance of the "Faux Toasters," whose desperate longing for the theater of performative tradition to continue compels them to assume the Poe Toaster's rituals in the absence of their authentic enactment by the mystery tributary. This would also explain why the community at large has roundly rejected the inauthentic reenactment of the tradition by these Faux Toasters.

327. From "The Pit and the Pendulum."

BIBLIOGRAPHY

Abbott, Wilbur Cortez. *New York in the American Revolution*. New York: C. Scribner's Sons, 1929.

Beach, Frederick Converse, and George Edwin Rines, eds. *The Encyclopedia Americana*. Vol. 11. New York: Americana Company, 1904.

Ben-Amos, Dan. "Toward a Definition of Folklore in Context." *Journal of American Folklore* 84, no. 331 (1971): 3–15.

Bennett, Gillian. "The Vanishing Hitchhiker at Fifty-Five." *Western Folklore* 57, no. 1 (1998): 1–17.

Bird, S. Elizabeth. "Playing with Fear: Interpreting the Adolescent Legend Trip." *Western Folklore* 53, no. 3 (1994): 191–209.

Blank, Trevor J., ed. *Folk Culture in the Digital Age: The Emergent Dynamics of Human Interaction*. Logan: Utah State University Press, 2012.

———, ed. *Folklore and the Internet: Vernacular Expression in a Digital World*. Logan: Utah State University Press, 2009.

———. *The Last Laugh: Folk Humor, Celebrity Culture, and Mass-Mediated Disasters in the Digital Age*. Madison: University of Wisconsin Press, 2013.

Blank, Trevor J., and Robert Glenn Howard, eds. *Tradition in the Twenty-first Century: Locating the Role of the Past in the Present*. Logan: Utah State University Press, 2013.

Boyton, Patrick. *Snallygaster: The Lost Legend of Frederick County*. N.p.: published by author, 2011.

Braden, Scott. "Haunted Places of Carroll County." *Carroll Magazine*, October 17, 2012. www.carrollmagazine.com/articles/haunted-places-of-carroll-county.html.

Bronner, Simon J. *American Folklore Studies: An Intellectual History*. Lawrence: University Press of Kansas, 1986.

———. *Campus Traditions: Folklore from the Old-Time College to the Modern Mega-University*. Jackson: University Press of Mississippi, 2012.

———. *Folk Nation: Folklore in the Creation of American Tradition*. Lanham, MD: Rowman and Littlefield Publishers, 2002.

———. *Piled Higher and Deeper: The Folklore of Student Life*. Little Rock, AR: August House Publishing, 1995 [1990].

———. "'This Is Why We Hunt': Social-Psychological Meanings of the Traditions and Rituals of Deer Camp." *Western Folklore* 63, nos. 1–2 (2004): 11–50.

Brunvand, Jan Harold. *Encyclopedia of Urban Legends*. New York: W.W. Norton & Co., 2002.

———. "Folklore in the News (and Incidentally, on the Net)." *Western Folklore* 60, no. 1 (2001): 47–76.

———. *The Vanishing Hitchhiker: American Urban Legends and their Meanings*. New York: W.W. Norton & Co., 1981.

Cannon, Timothy L., and Nancy F. Whitmore. *Ghosts and Legends of Frederick County*. Frederick, MD: Studio 20, Inc., 1979.

Carey, George G. *Maryland Folk Legends and Folk Songs*. Cambridge, MD: Tidewater Publishers, 1971.

———. *Maryland Folklore*. Centreville, MD: Tidewater Publishers, 1989.

———. *Maryland Folklore and Folklife*. Cambridge, MD: Tidewater Publishers, 1970.

Cialdini, Robert B., Richard J. Borden, Avril Throne, Marcus Randall Walker, Stephen Freeman and Lloyd Reynolds Sloan. "Basking in Reflected Glory: Three (Football) Field Studies." *Journal of Personality and Social Psychology* 34, no. 3 (1976): 366–75.

Clements, William M., and William E. Lightfoot. "The Legend of Stepp Cemetery." *Indiana Folklore* 5, no. 1 (1972): 92–141.

Conley, Brian A. "The Bunny Man Unmasked: The Real Life Origins of an Urban Legend." *Fairfax County Public Library*, 2002. www.fairfaxcounty. gov/library/branches/vr/bunny.

Conway, Moncure D. "The Pedigree of the Devil: Traced on the Tercentenary of Mephistophiles [sic]." *The Cosmopolitan* 5, no. 3 (1888): 171–84.

Cord, Xenia E. "Further Notes on 'The Assailant in the Back Seat.'" *Indiana Folklore* 2, no. 1 (1969): 47–54.

Dahlgren, Madeleine Vinton. *South Mountain Magic: Tales of Old Maryland*. Maple Shade, NJ: Lethe Press, 2002 [1882].

Dall, Caroline Wells Healey. *Barbara Fritchie, A Study*. Boston: Roberts, 1893.

de Certeau, Michel. *The Practice of Everyday Life*. Translated by Steven Rendall. Berkeley: University of California Press, 1984.

Dégh, Linda. "Does the Word 'Dog' Bite? Ostensive Action: A Means of Legend-Telling." *Journal of Folklore Research* 20 (1983): 5–34.

———. "The Haunted Bridges Near Avon and Danville and Their Role in Legend Formation." *Indiana Folklore* 2, no. 1 (1969): 54–89.

———. "The Hook." *Indiana Folklore* 1, no. 1 (1968): 92–100.

Dégh, Linda, and Andrew Vázsonyi. "The Dialectics of the Legend." *Folklore Preprint Series* 1, no. 6 (1973).

Dorson, Richard M. *American Folklore*. Chicago: University of Chicago Press, 1959.

———. "Defining the American Folk Legend." In *American Folklore & the Historian*. Chicago: University of Chicago Press, 1971, 157–72.

———. "Fakelore." *Zeitschrift für Volkskunde* 65 (1969): 56–64.

———. "Folklore and Fake Lore." *The American Mercury* 70, no. 315 (1950): 335–43.

———. *Folklore and Fakelore: Essays toward a Discipline of Folk Studies*. Cambridge, MA: Harvard University Press, 1976.

———. "Legends and Tall Tales." In *Our Living Traditions: An Introduction to American Folklore*, edited by Tristram Potter Coffin. New York: Basic Books, 1968, 154–69.

———. *Man and Beast in American Comic Legend*. Bloomington: Indiana University Press, 1982.

———. "Response to Perdue's Review of *Folklore in the Modern World*." *Journal of American Folklore* 94, no. 371 (1981): 86–87.

Douglas, Henry Kid. "Stonewall Jackson in Maryland." *The Century Illustrated Monthly Magazine*, June 1886, 285–95.

Drake, Carlos. "The Killer in the Backseat." *Indiana Folklore* 1, no. 1 (1968): 107–9.

Dundes, Alan. "Foreword." In *Man and Beast in American Comic Legend*, by Richard Dorson. Bloomington: Indiana University Press, 1982.

———. "Nationalistic Inferiority Complexes and the Fabrication of Fakelore: A Reconsideration of Ossian, the Kinder-und Hausmärchen, the Kalevala, and Paul Bunyan." *Journal of Folklore Research* 22, no. 1 (1985): 5–18.

———. "On the Psychology of Legend." In *American Folk Legend: A Symposium*, edited by Wayland Hand. Berkeley: University of California Press, 1971, 26–29.

———. "Projection in Folklore: A Plea for Psychoanalytic Semiotics." *MLN* 91, no. 6 (1976): 1500–33.

———. "Who Are the Folk?" In *Interpreting Folklore*, edited by Alan Dundes. Bloomington: Indiana University Press, 1980, 1–19.

Ellis, Bill. "Death by Folklore: Ostension, Contemporary Legend, and Murder." *Western Folklore* 48, no. 3 (1989): 201–20.

———. "'The Hook' Reconsidered: Problems in Classifying and Interpreting Adolescent Horror Legends." *Folklore* 105 (1994): 61–75.

Ellis, George E. *Battle of Bunker Hill*. Scituate, MA: Digital Scanning Inc., 2008.

Fair, Susan. *Mysteries & Lore of Western Maryland: Snallygasters, Dogmen and Other Mountain Tale*. Charleston, SC: The History Press, 2013.

Fields, Thomas W., ed. *The Battle of Long Island with Preceding and Subsequent Events*. Brooklyn, NY: Long Island Historical Society, 1869.

Fiore, Jordan D., and Susan Schruth. *The Noble Train of Artillery: 200 Years Ago Today*. Boston: Commonwealth of Massachusetts Bicentennial Commission Publication, 1976.

Fischer, David Hackett. *Washington's Crossing*. Oxford, UK: Oxford University Press, 2003.

Gardella, Peter. *American Civil Religion: What Americans Hold Sacred*. New York: Oxford University Press, 2013.

Georges, Robert A., and Michael Owen Jones. *Folkloristics: An Introduction*. Bloomington: Indiana University Press, 1995.

Gillespie, Angus Kress. "The Jersey Devil." *Journal of Regional Cultures* 5 (1985): 59–73.

Gioia, Dana. "Longfellow in the Aftermath of Modernism." In *The Columbia History of American Poetry*, edited by Jay Parini. New York: Columbia University Press, 1993.

Hall, Margaret, and Linda Martin. *University of Maryland Traditions*. College Park: University of Maryland Press, 2011.

Harbottle, Thomas Benfield, ed. *Dictionary of Historical Allusions*. London: S. Sonnenschein, 1903.

Heidenrich, Chris. *Frederick: Local and National Crossroads*. Charleston, SC: Arcadia Publishing, 2003.

Helsel, David S., and Trevor J. Blank. *Spring Grove State Hospital*. Charleston, SC: Arcadia Publishing, 2008.

Holly, Donald H., Jr., and Casey E. Cordy. "What's in a Coin? Reading the Material Culture of Legend Tripping and Other Activities." *Journal of American Folklore* 120, no. 477 (2007): 335–54.

Idel, Moshe. *Golem: Jewish Magical and Mystical Traditions on the Artificial Anthropoid*. Albany: State University of New York Press, 1990.

Irving, Washington. *The Life and Times of George Washington*. New York: G.P. Putnam & Co., 1876.

Jenkins, Joseph. "The Goatman of Prince George's County." In "Father Joe: From Silly to Sacred, a Priest Speaks…" fatherjoe.wordpress.com/stories/the-goatman-of-prince-georges-county.

Koven, Mikel J. "*Most Haunted* and the Convergence of Traditional Belief and Popular Television." *Folklore* 118, no. 2 (2007): 183–202.

Kurin, Richard. "Folklife in Contemporary Multicultural Society." In *Folk Nation: Folklore in the Creation of American Tradition*, edited by Simon J. Bronner. Wilmington, DE: Scholarly Resources, Inc., 2002, 249–64.

Kusterer, Janet, and Martha Anne Clark. *The Enchanted Forest: Memories of Maryland's Storybook Park*. Charleston, SC: The History Press, 2013.

Lake, Matt. *Weird Maryland: Your Travel Guide to Maryland's Local Legends and Best Kept Secrets*. New York: Sterling Publishing Co., Inc., 2006.

Lindahl, Carl. "Ostensive Healing: Pilgrimage to the San Antonio Ghost Tracks." *Journal of American Folklore* 118, no. 468 (2005): 164–85.

Maryland Historical Trust. "Saint Mary's College & Chapel [HO-392]." State Historic Site Survey (November 1979). Available at msa.maryland.gov/megafile/msa/stagsere/se1/se5/015000/015900/015963/pdf/msa_se5_15963.pdf.

McCloy, James F., and Ray Miller. *The Jersey Devil*. Moorestown, NJ: Middle Atlantic Press, 1987.

———. *Phantom of the Pines: More Tales of the Jersey Devil*. Moorestown, NJ: Middle Atlantic Press, 1998.

McCullough, David. *1776*. New York: Simon & Schuster, Inc., 2005.

McNeill, Lynne S. *Folklore Rules: A Fun, Quick, and Useful Introduction to the Field of Academic Folklore Studies*. Logan: Utah State University Press, 2013.

McSherry, James. *History of Maryland; From Its First Settlement in 1634, to the Year 1848*. Baltimore, MD: John Murphy, 1849.

Mikkelson, Barbara. "Flashing Headlights Gang Initiation." Snopes: Urban Legends Reference Pages, October 17, 2013. www.snopes.com/crime/gangs/lightsout.asp.

———. "Playboy's Party Schools." Snopes: Urban Legends Reference Pages, June 9, 2011. www.snopes.com/college/admin/playboy.asp.

———. "Statue Cue." Snopes: Urban Legends Reference Pages, June 23, 2011. www.snopes.com/college/halls/virgin.asp.

Motz, Marilyn. "The Practice of Belief." *Journal of American Folklore* 111, no. 441 (1998): 339–55.

Nixdorff, Henry M. *Life of Whittier's Heroine, Barbara Fritchie: Including a Brief but Comprehensive Sketch of Historic "Old Frederick."* Frederick, MD: W.T. Delaplaine & Co, 1887.

Okonowicz, Ed. *The Big Book of Maryland Ghost Stories.* Mechanicsburg, PA: Stackpole Books, 2010.

Opsasnick, Mark. "Crybaby Bridge." *Strange Magazine* 21 (2000). www.strangemag.com/strangemag/strange21/crybabybridge21.html.

———. "Horror on Fletchertown Road: The Goatman of Prince George's County, Maryland." In *The Real Story Behind the Exorcist: A Study of the Haunted Boy and Other True-Life Horror Legends from Around the Nation's Capital.* Bloomington, IN: Xlibris, 2007, 59–68.

———. *The Maryland Bigfoot Digest: A Survey of Creature Sightings in the Free State.* Bloomington, IN: Xlibris, 2004.

Oring, Elliott. "Legend, Truth, and News." *Southern Folklore* 47 (1990): 163–77.

Pickard, Samuel T. *Life and Letters of John Greenleaf Whittier.* 2 vols. Boston: Houghton, Mifflin & Co., 1894.

Polk, Ryan. "Holding the Line: The Origin of 'the Old Line State.'" Archives of Maryland Online, 2005. aomol.msa.maryland.gov/html/oldline.html.

Puglia, David J. "The Folklife Archives at Western Kentucky University: A Special Collection." *Kentucky Libraries* 75, no. 4 (2011): 16–19.

———. "Getting Maryland's Goat: Origin, Dissemination, and Meaning of Prince George's County's Goatman Legend." *Contemporary Legend: The Journal of the International Society for Contemporary Legend Research*, forthcoming.

———. *South Central Pennsylvania Legends and Lore.* Charleston, SC: The History Press, 2012.

———. "Toying with Corporate Narratives: The Genesis of Mick(e)y Mouse." *New Directions in Folklore* 11, no. 2 (2013): 84–95.

Quynn, William R., ed. *The Diary of Jacob Engelbrecht.* 3 vols. Frederick, MD: Historical Society of Frederick County, 1976.

Roberts, James Arthur. *New York in the Revolution as Colony and State.* New York: Weed-Parsons Printing Company, 1897.

Rosenberg, Yudl. *The Golem and the Wondrous Deeds of the Maharal of Prague.* Translated by Curt Leviant. New Haven, CT: Yale University Press, 2008.

Sanderson, Stewart. "The Folklore of the Motor-Car." *Folklore* 80 (1969): 241–52.

Scharf, J. Thomas. *History of Western Maryland.* 2 vols. Philadelphia: Louis H. Everts, 1968 [1882].

Schildt, John W. *Frederick in the Civil War: Battle and Honor in the Spired City.* Charleston, SC: The History Press, 2011.

Schultz, Edward T. *First Settlements of Germans in Maryland*. Frederick County Historical Society and the Society for the History of Germans in Maryland. Frederick, MD: David H. Smith, 1896.

Siddle, David. "Goats, Marginality and the 'Dangerous Other.'" *Environment and History* 15 (2009): 521–36.

Smith, Paul. "'Read All About It! Elvis Eaten by Drug-Crazed Giant Alligators': Contemporary Legend and the Popular Press." *Contemporary Legend* 2 (1992): 41–70.

Swayne, Matthew L. *America's Haunted Universities: Ghosts that Roam Hallowed Halls*. Woodbury, MN: Llewellyn Publications, 2012.

Tucker, Elizabeth. *Haunted Halls: Ghostlore of American College Campuses*. Jackson: University Press of Mississippi, 2007.

Varhola, Michael J., and Michael H. Varhola. *Ghosthunting Maryland*. Covington, KY: Clerisy Press, 2013 [2009].

Volo, Dorothy Denneen, and James M. Volo. *Daily Life During the American Revolution*. Westport, CT: Greenwood, 2003.

von Sydow, Carl Wilhelm. "Geography and Folk-Tale Oicotypes." In *International Folkloristics: Classic Contributions from the Founders of Folklore*, edited by Alan Dundes. Lanham, MD: Rowman & Littlefield Publishers, 1999, 137–51.

Walsh, William S. *Handy-Book of Literary Curiosities*. Philadelphia: J.B. Lippincott Company, 1892.

Whitney, Annie Weston, and Caroline Canfield Bullock. *Folk-Lore from Maryland*. Memoirs of the American Folklore Society, vol. 18. New York: G.E. Stechert and Co., 1925.

Whittier, John Greenleaf. "A Correction from Mr. Whittier." In *The Century Illustrated Monthly Magazine May 1886 to October 1886*, 1886.

Wilkinson, Burke. *The Life and Works of Augustus Saint Gaudens*. Fort Washington, PA: Eastern National Publishing Company, 2006.

Wilson, William A. "The Deeper Necessity: Folklore and the Humanities." *Journal of American Folklore* 101, (1988): 156–67.

Woodwell, Roland H. *John Greenleaf Whittier: A Portrait in Paradox*. New York: Oxford University Press, 1967.

Wright, Bradford W. *Comic Book Nation: The Transformation of Youth Culture in America*. Baltimore, MD: Johns Hopkins University Press, 2001.

INDEX

ABOUT THE AUTHORS

T REVOR J. BLANK, PhD, is a folklorist and assistant professor of communication at the State University of New York at Potsdam. A native of Damascus, Maryland, he is the author of *The Last Laugh: Folk Humor, Celebrity Culture, and Mass-Mediated Disasters in the Digital Age*; editor of the volumes *Folklore and the Internet* and *Folk Culture in the Digital Age*; and co-editor of *Tradition in the Twenty-first Century*. He lives in upstate New York with his wife, Angelina, and their beagle, Penny. You can follow him on Twitter at @trevorjblank.

D AVID J. PUGLIA is a PhD candidate and lecturer at Penn State Harrisburg, where he teaches Introduction to American Folklore and American Popular Culture and Folklife. Born in Baltimore and raised in Frederick, he decided to become a folklorist after taking Barry Lee Pearson's Introduction to Folklore course at the University of Maryland. He is the author of the book *South Central Pennsylvania Legends & Lore* and articles in *Contemporary Legend*, *New Directions in Folklore* and *The Folklore Historian*. He lives in Middletown, Pennsylvania, with his wife, Mira. If you would like to contact David, you can reach him at dpuglia@psu.edu.